Participation
Production

KU-752-754

Preface

Jörg Huber, Heike Munder

The symposium on which this book is based, and from which it takes its name, took place at the end of November 2009, organized jointly by the Institute for Theory (ith) at Zurich University of the Arts and the migros museum für gegenwartskunst. This work on the special role of furniture in design and art, both in discourse and in individual approaches, was initiated by the Institute's *Prototyp* research project (2008–2011).

The goal of the ith as a research institute is to promote the formulation of theory in the context of design and art, and more generally to develop theories of aesthetics and culture. The Institute carries out fundamental and applied research in the fields of aesthetic theory, everyday culture, media culture, visual culture, and the culture of the senses (aesthetics in its broadest definition). In this context of project-based research, aesthetic theory establishes fields of observation; it analyzes specific structures of the aesthetic and draws attention to corresponding issues. The *Prototyp* project exemplifies this approach: the themes focused on

include the fundamental issue of the concept of the "work" and its links to related discourse; how this reveals the questionable nature of drawing lines between art and design; the mutual borrowings of "high" art and applied art, white cube and everyday culture; the structural frameworks that shed light on links between production, reception, and display, between ways of life, life-world, social status, and cultures of taste. By examining specific objects and by more general theoretical modeling, the project explores the ways humans and objects interact and how art, aesthetic praxis, the development of subjects, and the shaping of societies take place in discursive praxis and in action.

Since its founding in 1996, the migros museum für gegenwartskunst, too, has been particularly concerned with viewing contemporary art in relation to its societal context, becoming part of a lively exchange between production, theory, and study. Consequently, the increasing dissolution of established borders between art and design since the 1990s has influenced the museum's collecting and exhibition concept. Projects and works by artists including Atelier van Lieshout, Douglas Gordon, Marc Camille Chaimowicz, and Peter Saville address the influence exerted by design on art, and vice versa. It is thus a special pleasure for the migros museum für gegenwartskunst to be able to publish this book jointly with the ith. Happily, it was also possible to make a link between the symposium and the solo show by Franco-Italian artist Tatiana Trouvé taking place at the same time, and thus with the exhibition program. Trouvé's work deals with the psychological function of spaces that she constructs using doors, walls, windows—and furniture. These added a visual dimension to the idea of a change in concepts of the work in art and design. A network of copper wires integrated by the artist into the exhibition space, suggesting something akin to the white cube's nervous or electrical system, served as a frame for the symposium, which took place at its center.

Our thanks go to all involved—especially Burkhard Meltzer, Tido von Oppeln, and the contributing authors—for launching and being part of this exciting discussion.

Foreword

Burkhard Meltzer, Tido von Oppeln

A look at the words "commode" and "commodity" reveals—besides their shared Latin root in *commoditas* (comfortable, spacious)—a direct link between the semantics of the item of furniture that provides a containing space to be filled, and commercial goods in general, whose value is established by means of negotiation. The German word for furniture, *Möbel* (from French, *meuble*, from Latin, *mobilis*), links to a range of meanings that play a key role in discussions of concepts of the work of art in philosophy, law, and art history, as well as the establishment of a concept of the work of design. Furniture as a category of objects can be discussed in sociological, economic, and aesthetic terms. And the ways we relate to furniture are correspondingly varied: from the buyer's view of a product, via practical use as part of a lifestyle, through viewing an object as a work in the context of art, or even in the context of design.

The title of this publication is borrowed from an artwork by Basque artist Xabier Salaberria. His installation *It's Not a Garden Table* comprises his own version of a classic modern furniture design and a poster with the title in mirrored lettering. The object that is "not a garden table" here refers to Marcel Breuer's design from 1929—itself far removed from serious functionality, since putting down a flowerpot involved careful positioning to avoid it falling between thin aluminum struts. In his version, Salaberria reinforces this impression by scaling up the object and using the kind of tubular stainless steel now often used in street furniture. The result can be assigned neither to a clear purpose nor to a specific space. In exemplary form, this peculiar object brings together various contexts of perception that have shaped the relationship between design and art since the 19th century: items of practical use both public and private; the display situations of trade fairs, museums, and department stores.

In recent years, a number of publications and exhibitions have dealt with these relationships. In view of a concept of design that has been expanded to include exhibition scenarios and "critical praxis," and a broad reception of design in artistic works, many observers have focused on the dissolution of boundaries between disciplines. This publication, on the other hand, wishes to examine the distinctions that continue to exist between them in spite of the points of overlap. The notion of a field expanded to include specific practices refers to Rosalind Krauss's essay on "Sculpture in the Expanded Field."[1] At the end of the 1970s, Krauss attempted to do justice to a broadening of the sculptural without leaving the historical category of sculpture. The "expanded field" of sculpture paved the way for the popular concept of the installation—a presentation format that now dominates exhibitions in both art and design. In this "expanded field," and in

spite of the differences between the disciplines, a common history of exhibition display becomes apparent.

Marcel Breuer, Garden table, 1929

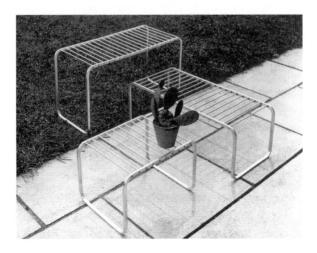

Xabier Salaberria, *It's Not a Garden Table*, 2006

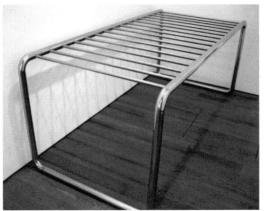

Questions related to the expanded field of design and its reception in art are discussed in this book by writers, designers, artists, philosophers, and sociologists, who approach these issues from three thematic angles.

Distinction: Essays by Klaus Spechtenhauser and Mateo Kries reflect on the emergence of a model for design exhibitions using the example of the Prague Cubists in the 1910s and Le Corbusier's "modern cabinet of curiosities" in the 1920s. Sven Lütticken traces semiotic influences of design

on art since post-war modernism, addressing the permanent negotiation within the cultural economy between use value and aesthetic value. Tido von Oppeln formulates a concept of the autonomous work of design, oriented in its structure towards the corresponding notion for works of art, but differing fundamentally in its points of reference. Burkhard Meltzer's essay situates the role of design in self-critical art practice.

Production: Interviews conducted with artists and designers as part of the *Prototyp* project explore the consequences of this distinction for the production of works and exhibitions in both disciplines. The choice of works and interview partners reflects the breadth of sociological, economic, and aesthetic interest in furniture as a category of objects.

Participation: The aesthetic praxis of artists and designers—especially in cases of the exhibition of furniture—often raises the question of audience participation. To what extent is it possible to *participate* in art or design? In his essay, Alexander García Düttmann offers a definition of participation in art and questions the possibility of participating in design at all. This opens up a further thematic frame where art and design are defined as fields of action. From a sociological viewpoint, Monika Kritzmöller examines the lifeworld as furniture's usual location, not only exploring the significance of furniture in everyday settings, but also considering the links between our dealings with furniture and the work of constructing identity. At a certain remove in time, works of art involving interior situations that explicitly call on the audience to participate can pose fresh challenges to a museum collection, as Judith Welter shows using examples

from the collection of the migros museum für gegenwartskunst. Jennifer Allen points to links between representations of furniture in art and design and a society's linguistic customs, showing how closely the habits of a media-influenced culture of participation are tied to economic conditions. In a public debate, curator Max Borka, designer Frédéric Dedelley, and artist Martin Boyce discuss the potential difficulties of participating in one discipline within the context of the other.

We are grateful to all authors, to all those who took part in discussions, to all of the project's academic and business partners for their contributions, and to the Swiss National Science Foundation for its generous funding of the *Prototyp* research project.

1 Rosalind Krauss, "Sculpture in the Expanded Field," in: *October*, Vol. 8 (Cambridge 1979) pp. 30-44.

Distinction

Historically speaking, there have always been points of contact between the fields of art, craft, and design. The emergence of a concept of the autonomous artwork in the course of the growing distinction and separation between art and material product culture in modern times can be understood as a focusing and specialization of the way art has been treated. Due to similar production methods, art and craft are far closer to the pre-modern experience than industrially manufactured goods. Beginning in the nineteenth century, however, the production of commodities was increasingly performed by industry, displacing the craft methods previously used to produce items for practical use. Just as Karl Marx observed an alienation from work, one can also speak of an alienation from objects of everyday use: on the one side, the autonomous artwork, and on the other, the industrial product. Both are alienated from the everyday praxis of their times. In this light, it is no surprise that design pioneers like William Morris in nineteenth-century England attempted

to prevent a distancing between art and craft, seeing links to craft within the discipline of design as a chance to bring art and life closer together.[1] Whatever value is given to it, this transition can be considered as the birth of design as a discipline.[2]

Design is characterized by the drawing up of drafts and plans for objects, making its results essentially repeatable. Craft, by contrast, is geared towards unique items. Being separate from design, it was untouched by the twentieth century's revolutions in production and distribution, merely forfeiting its former importance. Craft continues to exist, basically unchanged, and is often confused with the subject of this essay. But design is an entirely new discipline that emerged in the modern age, and it is concerned directly or indirectly with giving form to industrially manufactured objects.[3]

In the German-speaking world, the institutionalization of design began with the Werkbund, which established design as a discipline in its own right at colleges of applied arts.[4] Like the arts and crafts movement, the Werkbund favored a joining of engineering and art, of function and form—but one involving industrial mass production. This notion of a joining of art and life, as later aspired to by the Bauhaus, contrasts with the concept of the autonomous artwork.[5] Perhaps this is why questioning of the self-evidence of art's importance to life remained topical almost throughout the twentieth century. However much a closeness between everyday objects and art objects has been searched for and seemingly found, art depends on the two being kept distinct and separate.

It is not surprising, then, that discourse concerning the field of art has become a collection of recurring wishes and utopian scenarios. In my view, however, rather than a longing for the lost significance of art in material culture, this reflects a claim to produce work about life within the framework of art via the medium of the everyday object. This being the case, appeals for a

merging of everyday life and art should be understood not as a decline in art's sphere of importance, but an expansion into all areas of life.[6] Art was to move out of the museums and galleries and into social life, or, better still, to actually take place there. At no time, however, has this implied a questioning of the concept of autonomy; instead, art understands itself as critical of institutions, as well as practicing differentiated self-criticism. Out of this interest in everyday life, it is only logical for art to develop a heightened interest in the material world in which this life takes place.[7] Objects such as accessories, furniture, and other fragments of fittings that represent domestic life become, in the context of exhibitions and museums, components and props of art.

In the context of art installations, for example, design used as a prop in this way often has the function of a counter-image to a particular set of living conditions, a critical argument manifested in material or object form. Discussions of craft or design tend to foreground concepts such as utility and functionality. One can thus speak of "art that makes itself useful,"[8] bringing design closer in conceptual terms to the term Applied Art that features in the name of many museums. But against the backdrop of a discourse dominated by art history where the status of an autonomous work is reserved primarily for art, the concept of an autonomous work of design has yet to emerge.

In the following, I would like to propose and define such a concept of the work of design as a way of more precisely describing recent developments in design over the past 25 years, but also in order to formulate particular areas of possibility for the discipline of design and to give these possibilities a theoretical home. In this context, it seems to me to make sense to reexamine several fundamental questions concerning applied art. Of course, important phases of design history are now marked by objects accessioned

by museums. And in these cases, the objects in question can certainly be called *works of design*. But the consequences of my claim are more far-reaching than this.

A work in the sense I intend here is associated with the idea that design has brought forth its *own* concept of the work. The autonomous status of such works is as established in standard praxis as it is in art. Design now occupies an incontestable place in the canon of high culture, but as an object of practical use it nonetheless remains something other than art. Although I believe that the relationship between art and design has changed over the last 25 years, one cannot say that design is the future of art, nor do the two merge with each other in objects. Instead, such a claim to autonomy on the part of the work of design could mean that art is no longer alone. By analogy with the idea of *l'art pour l'art*, one could speak of *design for design's sake*. In spite of the structural similarity with the concept of the autonomous artwork, I would therefore like to distinguish works of design from artworks.

What characterizes a concept of the work in design, and what are the conventions governing our dealings with such a concept? In answering this question, I will begin by citing aspects of the conceptual framework for the work of art and comparing these with structures applying to design. Art theory distinguishes between aesthetic perception and the status of art objects as works. The status as a work is defined as a property of the object. This means that a thing cannot be art per se; instead, art *as a property* causes it to appear as a work. Furthermore, a work is perceived and viewed as art and communicated as such by an author or an institution. And this only occurs if the object possesses the quality of being defined as a work. This circular argument is the precondition and functioning principle for a concept of the work.

The work as a concept

A much-quoted basis for theories of art perception was developed by Immanuel Kant at a time of massive increases in production, especially in the textiles industry. In his *Critique of Judgment* (1790), Kant contrasts "disinterested pleasure" in an art object with economic or functional interest in a profane product. For Kant, art is only an object of aesthetic experience where it serves no purpose—when no profane interest is attached to it.

This simple distinction still serves as a discursive signpost, and in the 1960s it prompted Theodor W. Adorno to fear that art might be corrupted by the "culture industry" and society as a result of art becoming functional and thus devaluing itself.[9] Concerning the relationship between the concepts of the work in art and design, it is interesting here that Kant's more general model of "interest/disinterested" is extended to include the profile of a potential culprit. According to Adorno, the viewer and society repeatedly put art at risk of being co-opted, thus rendering it profane. In the logic of Kant and the warning of Adorno, the reason given for this downfall is the emergence of an interest in exploiting the work. Although there are many possible driving forces behind such interest, it is usually illustrated with examples from applied art and so-called objects of practical use.[10] Kant's definition of aesthetic perception and Adorno's later modification can be combined in a single thesis: works have an inherent resistance to usage, to being marketed, and to the purely functional quality of commodities.[11]

For a long time, Walter Benjamin shaped discourse with his notion of an immaterial aura that surrounded the artwork, forming a kind of sphere of influence. Benjamin defines this aura as a constitutive property of the work. But the work only acquires this aura by being perceived as a work of art and via the treatment it receives as a result. For Benjamin, the *original* artwork, which was increasingly called into ques-

tion by procedures of industrial manufacturing in the twentieth century, has its basis in an established ritual and cultural praxis of the western world.[12] "But the instant the criterion of authenticity ceases to be applicable to artistic production, the total function of art is reversed. Instead of being based on ritual, it begins to be based on another practice—politics."[13]

As a consequence of this rootedness in politics, the significance attributed to the autonomous work is no longer metaphysical, but social. Having lost its aura, a work no longer leads the viewer to contemplation, it loses its religious impact. No longer personally affected by the work, a viewer is free to look at the world as the work refers to this world. In this way, criticism also becomes an essential feature of the artwork. A similar argument to Benjamin's is put forward by Arthur C. Danto with his notion of art as "aboutness." Danto distinguishes between works that are *about something* and objects that are merely used *for something*.

According to Danto, works have a content or theme that they address; they deal in the broadest sense with our thoughts or living conditions. A concept of the work must therefore be capable of making a link in terms of content. The work is "about something" and is a commentary--or a critique "on something."[14]

In his search for the *Origin of the Work of Art*, Martin Heidegger explains that in art "the truth of being has set itself to work."[15] He emphasizes that the work "belongs uniquely within the region it itself opens up." Heidegger thus defines the work as an entity that is independent of context but which also constitutes a context.

Having introduced this notion of context, Heidegger discusses several ideas concerning the world that might constitute such a context. He defines being as the realm of real existing objects and world as something brought forth by the work, which is also what the work is about. This distinction between world and being is something we will be returning to later.

For Heidegger, "to be a work means: to set up a world." This world is a self-imagined spatio-material dimension. It is "more fully in being than all the tangible and perceptible realm in which we take ourselves to be at home."[16] "The stone," Heidegger writes, "is worldless. Similarly, plants and animals have no world." World emerges from the open meaning attributed by us to the work. In the case of the work of art, it provides a space for the "things" which "gain their lingering and hastening, their distance and proximity, their breadth and their limits" only in the world "opened" by the artwork.[17]

In his concept of work and world, Heidegger develops an interpretative context without which the work cannot be perceived as a work. This refers to a specialized cultural context, a world of notions concerning what the work is about. With this interpretative context referred to as "world," Heidegger shows the importance of the context from within which a work can be understood. He also illustrates the affinity that the work is capable of establishing, via this world, with individual subjects. Following this argument, as well as being "about something," the work also operates within its own world, i.e., in relation to its own context.

Works of design – Jasper Morrison, Jurgen Bey, Front, Martino Gamper

In a space the size of a trade fair booth, Jasper Morrison places the *Plywood Chair* at center stage with a number of other objects positioned around it. Unlike most trade fair booths, however, this presentation may not be entered. It is what is known in the performing arts as a scene, in fine art as an installation. The situation looks abandoned. It is a room, an austere and understated interior. On the walls are drawings of shelves, books, and architectural elements. Although this installation refers to the soberly functional aesthetic of modernism, Morrison does not show his *Plywood Chair* as a func-

tional object. The focus here, it seems to me, is not on functionality at all,[18] but on an attempt to find a formal idiom that is both contemporary and reduced. With *Some New Items for the Home*, Morrison devised a different notion of reduction.[—> p. 59] Whereas designers like Max Bill, Dieter Rams, Wilhelm Wagenfeld, or Herbert Hirche wished to reduce their designs to function, Morrison is aware that in the information age, function and use value are no longer adequate points of reference.[19] In his work he concentrates on something akin to an "essence" of the item of furniture in question— in the case of this installation, then, on the archetype of a chair. In contrast to a reduction to function, Morrison goes in search of the chair's "being." "Art is the work that lets the thing be a thing,"[20] Heidegger writes. By this definition, Morrison's *Plywood Chair* would be 100% chair. By assuming this character, it transforms itself into something different again: it becomes a work in the context of this staged scene.

In *Some New Items for the Home*, what a piece of furniture may signify is expanded to include the status of being a work. To achieve this, Morrison doesn't even have to forego an instruction manual or mass production. Instead, the pictorial quality of the installation and the staging of the objects can be seen as an implicit claim to and constituting of an independent concept of the work. In terms of content, Morrison's installation refers to the essence of domesticity (home). But rather than a functional setting, what the work displays is a relatedness to the history of furniture and design. The self-referential object, pointing to the history of furniture or design, facilitates critical engagement with the past of the discipline to which the work itself belongs. This circular argument can be perceived as a characteristic for the establishment of an independent claim to meaning on the part of a *work of design*.

In current discourse on the relationship between the disciplines of design and art, the view has been gaining ground that "design is the future of art"[21] or

that it "will merge with art."[22] As early as 1999, Rainer K. Wick advocated a differentiation between the disciplines, but he sees the New German Designers of the 1980s as "artist designers" operating "as creative anarchists of form."[23] And the emergence of entirely new objects that are both the one (art) and the other (design) also seems rather doubtful in view of their still separate contexts and object categories.[24] In fact, it is hard to make a case for such a merging. Each discipline has drawn on the creative repertoire of the other. Design adopted working methods from art, and artists borrowed themes and strategies from design. Consequently, works—and the work that produces them—have certainly become more similar, and in formal terms there is little to distinguish design objects and artworks from one another.

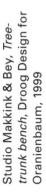

Studio Makkink & Bey, *Tree-trunk bench*, Droog Design for Oranienbaum, 1999

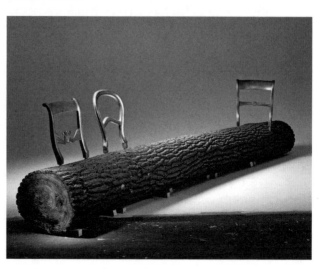

Ten years after Jasper Morrison's installation, which coincided roughly with the founding of design museums in Germany and Britain, Dutch designer Jurgen Bey presented his *Tree-trunk bench*, a bench with three bronze backrests set in a tree trunk. The tree itself is part of the design, but it must be provided by the buyer.[25]

With the *Tree-trunk bench*, Bey refers to the history of furniture and its origins in craft trades. The tree trunk can be read as a direct metaphor for carpentry and cabinetmaking, while bronze, as a material more typical of sculpture, represents the tradition of art. One might say that Bey combines the material source of furniture with the material source of art here to create a piece of craftwork. Finally, however, the bench is not a piece of craftwork, as its craft-like appearance only serves to highlight the distance between the design and a conventional piece of furniture as commodity. Its resistance to usage is evident in the fact that a tree must be felled and a backrest mounted before the product can be used at all. Moreover, the result of this elaborate process offers little more comfort than simply sitting on the tree trunk itself. Instead, to use Heidegger's terminology, the *Tree-trunk bench* sets design to work, thus reflecting design's engagement as a discipline with its own history and essence. The piece's resistance to usage and commodification is a clear indication of it being a work "about" the history of furniture. In the sense intended by Danto, Bey's bench is concerned more with design history than with serving the purpose of sitting. Describing the bench as a work of art, as a sculpture, seems to make little sense on account of its lack of reference to art. The fact that it has yet to enter art discourse confirms this. Furthermore, Bey himself explicitly positions his work in the field of design rather than art: "Sometimes we get categorized in the realm of Critical Design and I like that. But I don't think that means to be always critical about things. I would rather say, that we are critically looking at things, to see if it can't be done better in a different way. And I'd rather have it written under my name than ArtDesign, because then you are not able to address what it is. There are many possibilities of function."[26]

In 2007, Martino Gamper was invited to the DesignMiami fair as a "designer of the future." This fair has only existed for a few years and presents

galleries which, as well as offering design classics for the collector's market, focus primarily on contemporary Critical Design or ArtDesign and limited editions. Gamper showed the performance *If Gio Only Knew*, in which he saws up a hotel interior by architect and designer Gio Ponti, reassembling the pieces into cubist-looking furniture.[27] [—> p. XXVIII] A project from the same year entitled *100 Chairs in 100 Days* features a similar approach. Out of found chairs, Gamper put together a series of one hundred objects that bring together many design references and comments on design history. Moreover, Gamper organizes events that create a need for which he builds and uses the furniture. As a result, the furniture is seemingly inserted into the classical economic logic of demand and its satisfaction by commodities. But rather than truly needing the furniture, the events take shape as a performance staged around it.

Martino Gamper, *If Gio Only Knew*, Furniture series from design performance at DesignMiami, Basel, 2007

In its works, the design collective Front, founded in 2003 in Stockholm, reflects on the conditions and strategies of the creative process in design, which are almost inevitably based on compromise between economic, technical, and aesthetic factors. This prompts the group to integrate into their work factors that have nothing to do with the discipline. *Design by Animals* explicitly involves animals in the creative process as a way of addressing the relative quality of authorship in the design process. In this case, the work is the result

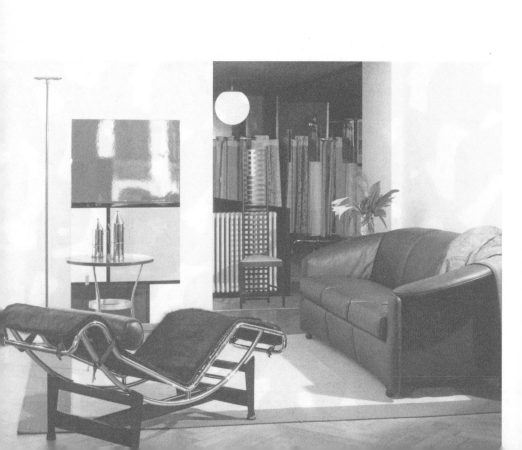

of critical engagement with decision-making processes in the development of design projects. Animals play the part of unpredictable and (as far as the design itself is concerned) uninvolved teammates who nonetheless have a crucial impact.

Martino Gamper, *Barbapapa* and
Bare Light (100 Chairs in 100 Days),
2006

In the case of a piece for Tensta Konsthall (2004), it was the museum visitors who similarly slipped into the role of inadvertent protagonists. A basket with self-adhesive hooks in the museum's coat check prompts visitors to stick things to a wall, defining its appearance. Self-reflexive components have become an established part of Front's working method. In an interview, Front designer Sofia Lagerkvist says: "So we work a lot like a fine artist, in a way. Fine artists look at what an artist is or what an artist does. We're looking at design in the same kind of way but from the designer's point of view. We look at what kind of qualities and things the designer adds to the process or projects, and what kind of tools we're working with as designers."[28]

<u>An expanded field for design</u>
In order to classify and define the concept of the work of design, I have isolated three characteristics of the work of art that point to a structural similarity with the work of design. Firstly, with reference to Kant and

Adorno, the work can be described as resistant to usage, being marketed, and the purely functional quality of commodities. Secondly, the texts by Benjamin and Danto point out that a work is "about something" and can be a commentary or a critique of that something. Thirdly, according to Heidegger's definition, it is self-referential and refers to its own world, a world it creates for itself. Four prominent positions from the past quarter-century of design provided clear evidence of a deliberate self-referentiality in design via formats chosen for presentation and the constitution of a distinct context.[29]

Front Design, *Wallpaper By Rats (Design by Animals)*, 2003

Front Design, *Tensta Cloakroom*, Installation view, Tensta Konsthall, Stockholm, 2004

These examples showed that design does not manifest itself as art or "almost art," and that there is no mixing of the two contexts. But these positions cannot be adequately described using the conventional

concepts available to us for design. In recent years, attempts have been made to expand the field of discourse on design with terms such as ArtDesign or Critical Design. Anthony Dunne and Fiona Raby's concept of critical design already points to critical engagement with design as a discipline. The works of designers such as Jurgen Bey, Martino Gamper, Jerszy Seymour, or Martí Guixé and Julia Lohmann, too, must be understood as self-referential in the context of their own discipline, and are thus tied neither to usage nor to technical issues. Moreover, the entry of design into museums at the end of the 1980s created a context for these works in which they create their own world in the Heideggerian sense. The market and its conventions have already responded to the arrival of the autonomous work of design by creating design fairs and limited editions. As a theoretical figure, however, it has yet to be explicitly formulated. The aim of this essay is to fill this gap in design theory, and to launch a discussion on the concept of an autonomous *work of design*.

1 Richard Sennett, *The Craftsman* (New Haven 2008), pp. 288-289.

2 A distinction was later made between design and industrial design, but in the 19th century this was not yet relevant.

3 This definition of design is, of course, overly narrow, not including disciplines such as "web design" or "interaction design." For the present argument referring to material culture, however, these omissions are not significant. Moreover, from today's point of view, the 19th century industry in question was still strongly craft-oriented. I'm thinking, for example, of Thonet and Kohn.

4 German Werkbund founded 1907, Swiss Werkbund, 1913, Austrian Werkbund, 1912.

5 Birgit Recki, *Aura und Autonomie* (Würzburg 1988), p. 77.

6 Theodor W. Adorno, *Aesthetic Theory* (1970), (London 2004), pp. 335 ff.

7 This aspect is dealt with in more detail in Burkhard Meltzer's essay "Design As Self-Criticism of Art," see pp. 90-107 in the present volume.

8 "Kunst, die sich nützlich macht," the title of an exhibition at the Neue Sammlung in Munich with a catalogue by Hans Wichmann.

9 Adorno, *Aesthetic Theory*, op. cit., p. 393.

10 Ibid., p. 284.

11 For Adorno, this quality begins with decoration.

12 Walter Benjamin, "The Work Of Art in the Age Of Mechanical Reproduction," in *Illuminations* (New York 1969), pp. 221-225.

13 Ibid., p. 224.

14 Arthur C. Danto, *After the End of Art* (Princeton 1997).

15 Martin Heidegger, "The Origin of the Work of Art," (1935/36), quoted in Martin Heidegger, *Off the Beaten Track*, trans. & ed. Julian Young & Kenneth Haynes (Cambridge 2002), pp. 16-20.

16 Ibid., p. 23.

17 Ibid., p. 23.

18 Before this, he was featured at documenta VIII with the *Reuters News Center*. Two years later, with *Some New Items for the Home II* for Vitra at the Milan Furniture Fair, he showed the radical opposite of many designers of his time.

19 Function is not relational, and can therefore no longer be taken as the point of departure for current discourse on design since Memphis and Droog.

20 Heidegger quoted in Hartmut Böhme, *Fetischismus und Kultur* (Berlin 2006), p. 86.

21 Philip Ursprung, "Disziplinierung: Absorbiert das Design die Kunst?," in: Gerald Bast, Krüger & Pardeller, Monika Pessler (eds.), *Das Phänomen Raum in Kunst, Architektur und Design* (Vienna 2009), pp. 144-148.

22 Martino Gamper and Christian Brändle, "Interview," in: Katya García-Antón, Emily King, Christian Brändle, *Wouldn't it be nice... wishful thinking in art and design* (Zurich 2007), p. 209.

23 Rainer K. Wick, "Im Rückspiegel," in: Susanne Anna, *Global fun: Kunst und Design von Mondrian, Gehry, Versace and Friends* [exhibition catalog, Städtisches Museum Leverkusen] 1999, pp. 11 ff.

24 The fantasies of fusion alluded to here are from various articles from broadsheet arts and culture pages, but also from academic texts such: Mateo Kries, "Zur Symbiose von Design und Kunst seit Jasper Morrison," in: Markus Brüderlin (ed.), *Interieur/Exterieur, Wohnen in der Kunst* (Ostfildern 2008), pp. 225-230, or Katya García-Antón and Emily King in cooperation with Christian Brändle, "Wouldn't it be nice... wishful thinking in art and design," in: Jean Pierre Greff (ed.), *AC/DC Contemporary Art Contemporary Design* (Zurich 2007), p. 120.

25 With this work, Bey is probably referring to the Portuguese/Brazilian designer Joaquim Tenreiro (1906–1992), who in the 1950s presented the *Tree Trunk Chair*. He is considered a classic modern designer, contributing, among others, to Oskar Niemeyer's Brasilia.

26 Jurgen Bey's position on Critical Design: see interview on pp. 33-35 in the present volume.

27 This piece is described in more detail in Klaus Spechtenhauser's essay "From discontent to complexity," see pp. 70-89 in the present volume.

28 See interview with Sofia Lagerkvist on pp. 132-134 in the present volume.

29 In the context of elaborating a concept of the work, Morrison is taken as an example. It would have been possible to choose earlier examples, e.g., from the Radical Design of the early 1960s, although the founding of design museums supports the theses put forward here and makes them seem more appropriate. Nonetheless, Radical Design can certainly be understood as having helped to prepare the ground for a concept of the work in design.

Scenarios and Social Sculptures
Jurgen Bey

The interview was conducted by telephone on June 12, 2009.

Tido von Oppeln You have been showing *Social Sculptures* in a gallery. Are they still meant to be useable furniture?

Jurgen Bey Yes. I don't believe in unusuable furniture at all!

Tido von Oppeln So there is no difference between ordinary furniture and what you are doing.

Jurgen Bey No, not for me. I only think of design as usable tool. As long as I am a designer, I would say they are tools. I am not going to say they're making your life easier, because I don't think furniture is mainly about that. But they are tools, they're for you to be able to do your work and feel a bit more relaxed. I am very much a product designer, I am not doing things that don't have a use.

Tido von Oppeln But there is still the term "sculpture" in your title.

Jurgen Bey Yes, because we don't want to call it either a chair or a table. But it is a place to work. It's a place where you meet people more informally and speak to each other. But it is not a sculpture—definitely not. I feel this tension between art and design. And I see a lot of designers who want to be seen as artists, but I know that artists do something completely different from what I do.

Tido von Oppeln You said that you are a designer and you are making objects to use. But your objects are obviously different from what we know as design. Is there a link between your work and the work of an artist?

Jurgen Bey I see the work of artists almost like the work of scientists. They are asking the world questions and really digging deep without thinking what you get out of it in the end. And in applied art, we are thinking how can we make it useful. So, for example, it moves from a science to a device where you can listen to music. And you can skip immediately from one track to another. I need an assignment and artists don't. I'm so happy that we have industrial designers who look on ergonomics and think of a chair that fits the body. Either make a thing adjustable or make yourself adjustable in different contexts and you will get different answers. So, in that sense, that's the reason why I feel liberated to be more open in my work, because I know somebody else is taking care of the other questions. And that is so interesting in design, because the whole field is growing so enormously. Functionality in design has become a discipline of its own. And the so-called ArtDesigners are also establishing one discipline. But the only word a lot of young designers use is "installation" or "it is inspired by"—that says nothing. An installation—and that's it. You cannot ask anything, you can't think any further. That's all a dead end. The specific part of ArtDesign has been really good because it has developed a sort of abstraction, but it is now time to reevaluate these things. And if installation is the last word, how do we go further in design?

Tido von Oppeln To be honest, it's really the word that comes to one's mind when describing the visual impression of a cluster of objects. Sometimes the only thing you can be sure

about is that it is an installation. And it connects design to the contemporary display of an art space or a gallery.

Jurgen Bey I have that verbal play a lot with students. You just say museum or installation—and that's it. Or you say social museum installation. But a museum is much more than an installation, it is an historical book in three dimensions. Or it is a total laboratory, there are a lot more things to say about the museum. It's not just an installation. That's why we need very good writers, good curators and editors, so they can show us why somebody did that thing during that period. And then design can really be put into a perspective, but also it can show where small holes already are that are going into the next thing. And I think we should develop it from there in all other directions— whether it has been done because somebody has been writing about it or it happened in art or even in daily life. But it should be addressed to us, so that we can go further than the word "installation."

Tido von Oppeln There is a reading table combined with a table and a carpet that you showed at Mitterand+Cramer Gallery.[—> p. XXXII] And if I understand you correctly, it is an arrangement of a table and a carpet, but it is not an installation.

Jurgen Bey Yes. I've tried to develop a studio in which we do a lot for public space. When we do these things, it's like in fashion, where you have a big group and they can really make designs. This is a kind of investigation and we have to find ways to get it financed. And the system of galleries is a possibility for it. I'm not thinking "Yes, let's have a small factory" and then they'll make thousands of them. The world

wouldn't make any progress. In my studio it's a bit like growing your own vegetables, and you make soup and you can ask the question whether the soup is so great or not. It's a whole culture of seeing vegetables growing: you see them every morning. Then I do a project for a factory and I can use that method as a way of getting the projects going for the factory. You're not feeling, Oh, we're just a production machine. No, you're in a landscape as a living organism. So in that sense, the *Crate Furniture* is a bit like camping equipment.[—> p. VIII]

Tido von Oppeln Is it more a sketch?

Jurgen Bey I think sketch is a nice word. Prototype means that it's not finished yet, it should be something else. And I think that's not true, I think it's a sketch that can stand on its own. And because it's like a sketch and there are only eight pieces of it, we don't have to create a whole market, because you only need eight people in the whole world to have the finished project. And thousands of people can have it as an image, and another thousand as a thought. It's not the way one has to go, but I think that might be a very nice direction.

Tido von Oppeln Is this a strategy to develop design in general? And are these pieces coming out of the research as an example?

Jurgen Bey Yes, but if you're talking about a strategy, then it's like you've been sitting and planning. But what I like about the sketch is that it's a way of doing. You just make it and get it to places and get actively involved, and then you get reactions and questions and you're developing through that. I like to throw myself from a rock and as I'm falling I think: I have to do something.

Tido von Oppeln When you start working on an object, do you consider any kind of use?

Jurgen Bey We think in scenarios. For example, we might have to make a space to work in. Then you think: it's related to time. And then, what kind of an object could come out of the process? For instance: If you believe in the office as a landscape, somewhere you like to live, it's not about just going to work. It's like going to the beach, going to my office, and thinking about a great environment, where you find the concentration to do your work. It should really feel like going out of the house and not like going to work. It shouldn't be like going to Lunapark, not at all. I want concentration there, I want to develop my knowledge. But it is a bit like fairy tale design when we've been following scenarios, where we've been thinking how to address this in a functional world.

Tido von Oppeln Are your scenarios changing the functional world?

Jurgen Bey Sometimes we get categorized in the realm of Critical Design and I like that. But I don't think that means to be always critical about things. I would rather say, that we are critically looking at things, to see if it can't be done better in a different way. And I'd rather have it written under my name than ArtDesign, because then you are not able to address what it is. There are many possibilities of function. Sometimes I get irritated looking at advertisements, it seems that the only way to communicate with people is making jokes. Nobody is putting himself on a stand anymore and saying what they can really do well. They just say "I am very funny. Let's do it with me." And in design it's the same: there are all these tricks—a little bit

of electronics and you are the magician and then you'll be able to do things. I would address design with a bit more seriousness. So I think we are discussing function on different levels.

Tido von Oppeln Is it possible to use the furniture in your exhibitions?

Jurgen Bey Yes, it is. But it is always a bit tricky in galleries, because people think, when it's called design you can try out what it can stand than really taking care of things. It's a long time since we made all these educational museums usable. So you have all the buttons to push and things to handle. And through that we developed an audience that does that. And there is this whole idea with art getting popular: We should all be able to use it and understand it. I think that's wrong. We don't think like that about science, because we know that there are laboratories where we have no idea what they are doing. But we also have the idea that sometimes you get a CD-player from it or a new television. And that is why we probably think it's good. I think it is so important to communicate and to understand that you need diversity, and as a culture you have to be generous about the things that you don't understand.

Typical Affair – Matthew Smith

The interview was conducted at Café Hoxton Square in London on May 22, 2009.

Burkhard Meltzer I think your work has a lot to do with the issue of furniture.

Matthew Smith There are some works that seem to be furniture-based, but I don't know whether an idea of furniture per se is the reason for the works. I suppose it falls within a wider economy of objects that circulate around the practice. I always kind of use recognizable objects. And obviously I know that there is a shelving system and somebody has designed it before. But I think it's apparent that I use quite standardized designs.

Burkhard Meltzer It's interesting how the recognition of objects of everyday life seems to be like a kind of method of access both for designers and artists in their work. In one work with the shelves and the duvets (*Untitled*, 2008), you used prefabricated parts.

Matthew Smith The material was a sort of laminated chipboard, a very cheap material that bedroom furniture is often made out of. At first I was interested in why you couldn't just have shelves as a work, because as well as being a functional object it's also a regulated pattern of stripes that reminded me a bit of Daniel Buren. It was important for me that it could look like an object you'd find in someone's house. So it's kind of an instantly recognizable material. At one point I was trying to make objects that appear to be part of a particular person's existence, perhaps.

Burkhard Meltzer The material is used mainly for cheap furniture in the context of mass production.

Matthew Smith I often tend to be drawn to cheap-looking materials, because they are never perfect, always sort of blemished or not evenly colored, or even dirty. I don't use materials like this all the time, but I like the idea of using a cheap material for something that looks more expensive. Or in a wider sense, in design or architecture I like it when cheap materials become something that looks more expensive. Maybe it's just about cheap materials becoming a kind of sophisticated aspect of something.

Burkhard Meltzer There's a way of looking at the work through the language used in the titles.

Matthew Smith The title *Typical Affair* came more from the idea of states of affairs. I am really interested in Wittgenstein and his early ideas about how reality is configured. I can't pretend to really understand the *Tractatus*, but I like the idea of reality as "states of affairs." I think that this kind of title came from that idea. I wanted each of the elements of the work to be a kind of circumstance that reveals a whole, a kind of state of affairs.

Tido von Oppeln Did you ever think of producing some kind of edition out of those pieces?

Matthew Smith I had intended to make a series of table works,[—> p. XXVI] but in a smaller number, probably in pairs. For me, the color of the cloth becomes a central issue with those works, whether the color impacts the table being a recognizable object. They're the kind of object you find at weddings or official ceremonies, conferences, etc. And it was

that "official" quality that I was trying to hold onto, the way that, from one aspect, the tables are a kind of presentable surface for something, but from behind you can see underneath, you can see the structure. I wonder what happens to that sense of "officiality" if you change the color to pink, or orange.

Tido von Oppeln So, the context of use is always central?

Matthew Smith Specific kinds of location have informed the work in the past, yes. I've been particularly interested in squat culture, and student housing. Also perhaps ideas of TV set design. But the problem for me always comes back to representation, which is something I've always sought to avoid at all costs. I am interested more and more in using the work as a way of revealing a sense of uncertainty, and also trying to understand how that uncertainty might become a kind of positive critical value. So specific contexts are becoming less and less useful, I think. I'm really interested in the work of an artist called Carl Plackman. There's a short text he wrote about a sense of confidence which he observes in others, but lacks himself, and it made me think about how that awkwardness could become something critical.

Burkhard Meltzer The impression of unfinished surfaces could be read in contrast to an image of the perfect, untouched object.

Matthew Smith At the time of making *Typical Affair* I think I was particularly drawn to broken objects, domestic objects that are somehow diminished by time or use. The work is based around a sort of broken shelf, but it's kind of impossible to produce something that is, at the same time, broken. I guess the work becomes

a kind of "mini-drama" that somehow represents something.
The temptation is often to try to re-order the world in the way that I feel confident, and that raises all sorts of fundamental problems for me. It's rather that I want to take these real things and configure them in a way that reveals a sense of uncertainty. I think I'm beginning to tackle a notion of "idealism" at the moment, to try to make environments that feel less "staged" perhaps.

Burkhard Meltzer So you would say your earlier works put objects in a kind of stage-like situation?

Matthew Smith You could read that into it, I suppose. That was a problem for me with the table works, that they suggest that they are in use or waiting to be used, and I didn't want that to be a part of the work. So it's always about trying to make people look at what the object is. I have always been interested in arguing that objects are more than their function in a space or more than their associations.

Tido von Oppeln That relates more to Heidegger's concept of "Wesen" than Wittgenstein's concept of "Use." I always have to laugh when reading this epilogue of the *Philosophical Investigations*, because Wittgenstein mentioned that he has nearly solved all problems, but nothing has happened, he is still at the same point. And what is even more interesting is that he is always trying to explain his language terms with examples of furniture.

Matthew Smith For a long time I was interested in the idea of trying to remove a certain value from objects, a sense of meaning perhaps, which I think is completely possible to do.

Tido von Oppeln If you say a "trace," is it the word, or something that is related to the use or related to the trace as an existing thing? Is it just as we discuss those issues in language or can it be found in material existence? That would be exactly the difference between the Heidegger and Wittgenstein discussion.

Matthew Smith I think what interests me about "the object" is that... perhaps you can do certain things to it, position it in a particular way, so that it's still completely recognizable, but in some way it begins to reveal the mechanisms of how it exists, how it becomes visible. I've always liked the idea of shaking something very slightly, so that it begins to fall apart a little. And I think that this impacts on what is made, what the art object is...in some ways I have to allow myself not to set out to make art.

Burkhard Meltzer What do you mean by that?

Matthew Smith It's important to say that to myself, because I'm trying not to live up to any expectation of what art might be. If it's going be about positioning objects or placing them together somehow, it can be about that. It's important for me to start my work every single time from the beginning. Every time a new object comes into my practice, I have to start from scratch and learn how to use the object. I tend to spend long periods of time in the studio just looking at objects, staring at them even, trying to identify ways of using them.

Total Trattoria – Martino Gamper

The interview was conducted at Martino Gamper's studio in London on May 21, 2009.

Martino Gamper The social aspect was always quite important for me. I don't believe that designing furniture is about making furniture for display. I mean, people buy furniture that looks good. I think there is also a certain social interaction that furniture should create. In that sense I like to re-use a lot of already used furniture parts from the cooking events—the *Trattoria* project. And they have another life afterwards. The chairs or the stools start as something else and then they might become a product. So a lot of times I like to use what I've done for a project or for myself or for an exhibition instead of giving it directly to the market. It's a bit boring with that limited edition thing where they come with a concept and say: I could make ten of them. I have a bit of a difficulty with that, even though I do work with galleries and earn some of my living through selling quite exclusive pieces of furniture. But somehow at least I try to use them before for my own sake or with other people.
We are doing an event next week with the *Trattoria*. It's a big townhouse, huge. It's a one evening event together with some charity and the Anthropology Society, and so they invite people to meet and they want us to come with the food and the furniture. I said we can only do 100% of the whole thing, there can't be a caterer. I realized there are all these doors in that space. So we were gonna unhinge the doors and make tables out of them. After that the doors were going back, so there was no need to create objects for tables. In that sense

I very much enjoy the fact that the project has got different formats— sometimes we spend a lot of effort making all these tables and things, and sometimes it's just what we find at locations.

Tido von Oppeln There are different perspectives on an object—so that it sometimes carries a sculptural quality or a functional one as a chair or stool.

Martino Gamper I think "using" is quite important. There is a lot of confusion out there about ArtDesign— I mean, when you look at a chair, is it art, and when you sit down is it design? I still think "using" is quite a different experience than just looking at it, but then there are a lot of functional sculptures, there are a lot of works that you can use. So maybe the question is not about this and that, maybe it's more about how does it affect people. And what kind of experience does it create, do we learn more about our human behavior. For me it's more important, that whatever the artist or designer creates, they are somehow engaged.

Burkhard Meltzer It seems that you relate this kind of process much more to a certain history of art than to industrial design.

Martino Gamper I worked in Milan in an industrial design office and I designed coffee machines and pottery, toilets and whatever. I was quite young and it was an amazing experience. I don't know, everything seemed to be so complex with the whole market research and consumer groups, and at the end of the day it is very simple. A coffee cup, a plate, or cutlery. I could not imagine that they wasted so much money by paying a marketing department and a trendsetting department.

And at the end of the day 60 % of the projects never went anywhere. That was a big frustration and I said: that is not the way I really want to work. So maybe that formed a little bit the idea that I would like to engage with people. I wanted to work on a level that I could control much more—I mean, control the situation, control the experience, control the outcome process.

Tido von Oppeln Is there a product for the market at the end of your working process?

Martino Gamper I'm not running around and saying, Here is a product, but there are some products in the end. But I don't sell a lot. You know, it appears in a show and people see it. Then I was playing around with it, I did that backrest for it. On one hand it's not an industrial product, but on the other hand it's not a limited edition.
But, for example, the stools are something else. They came about from an urban regeneration project at Arnold Circus. At that time people were dealing drugs and hanging out there, so nobody really used that space. It was kind of a no-go area. So, quite a few locals and myself and some of my friends, we got together and we formed "the friends of the circus." We tried to organize events like a picnic, we'd go there on a Sunday and we'd have a picnic, and the more people came the more the place became a public space again. We were using it as a public space instead of leaving it to the drug dealers—organizing events like a band and so on. For that, we needed some kind of furniture, and my friends said, OK, we need to buy some chairs. And I said, No way, we are not going to buy some cheap IKEA chairs, because we know that they get broken. I said, You give me the money that we can spend,

and I invested it and we did a reproduction mold. Somehow, from a basic need for furniture it becomes a product and that interests me. So that means the way I come to a product is not that I just want to do one-offs. I have a bit of a problem with these companies that just ask you as a designer to do something. Would you design something for us? Then I ask, OK, what do you need? Hmm. Not sure, just come up with some ideas. That's really weird for me. I can't really follow that way of thinking. It's quite important that there is a direct need, not some kind of market, where you have to create a need for it. So there is a chair that was used in public and then people buy it for their kids because they can use it as a bin. It's a different way to get to your product.

Burkhard Meltzer Is there a strong relationship between the object and a place or need or occasion?

Martino Gamper Yes. For instance, the place where the Manifesta 7[—> p. 80] exhibition in 2008 was taking place, it was built in 1830, when they could have used that kind of Thonet chair. And I wanted somehow to add something a bit contemporary, but that had a relevance for me. So it was a bit of mixing the old Thonet chairs and some new elements. And I created some objects, which are ambiguous enough that people could think: Maybe it's art. But then I did so many that one could see that it's a chair.

Burkhard Meltzer As far as I remember there were some sound pieces installed in the spaces with your chairs. And they had a very ambiguous effect. But are the chairs displaying themselves as well?

Martino Gamper They were to invite people to sit down. Maybe you're

not quite sure, it makes you think, it makes you observe. Yeah, it is a kind of confusion but I would prefer curiosity. All of the sound pieces were quite long. I felt like without the chairs nobody would spend more than one or two minutes. So the chair was also for sitting down and looking at the architecture. Some kind of rest. But there was definitely a sculptural effect, some people were confused. But the atmosphere was in between a bit functional and a bit sculptural. Maybe it was reacting to the space itself. It was a huge building, so the idea was that people could also pick their chair and bring it somewhere. So they could make groups, for example.

Tido von Oppeln Right, the Thonet chair was maybe the first industrial chair, made for moving around, and it made sitting quite flexible.

Martino Gamper Exactly. I have been twice now to that factory, and I am re-reading and finding other bits of this "universe of design." It's incredible that this chair is so ingenious—it is super light and super easy to transport. It's simple to assemble. It has hardly any edges. You can kick it.

Burkhard Meltzer So the parts were new chairs from the factory?

Martino Gamper Yes. The strange thing was, that they wouldn't sell me parts of the chair. So I had to buy the whole chair. Because they were afraid that when I got the parts I would do something with them, maybe copy the chair in a different way, and sell them.

Tido von Oppeln I always thought that the 100 Chairs in 100 Days (2006–2007) project was also some kind of critique of a design canon.[—> p. 79]

But it seems now that it is much more about finding a different form to re-arrange a well-known bent-wood construction.

Martino Gamper That project was actually quite applied. The 100 Chairs project is something where I had no idea in the beginning where I was going. It was just "making." This was in 1999 and in that case it was really important for me that the chairs were used. We had three events: one concert, an area for just sitting and reading, and at the opening people sat on the chairs as well. So for me it was quite important that it was possible to sit on the chairs. But at the same time I wanted to play a bit with the idea: Can you sit or can't you sit. The application of functionality interested me a lot. It shouldn't be only pieces to look at. But at the same time I try to play around with that ambiguity. I mean, they are chairs. That's what I make them for: to sit down.

Until 1989, the first specialized design museums were still modeled on 20th-century art exhibitions, especially the notion of the white cube.[1] In the view of many curators, design objects needed the most neutral and reduced setting possible in order to be recognized as museum-worthy. Objects were arranged in such a way as to set them clearly apart from the traditionally gimmicky and commercial presentations at trade fairs and in design shops. And there they stood, tubular steel furniture, post-war classics, Memphis designs on white plinths, silent witnesses to dusty permanent displays in design departments and museums of applied art—and to an understanding that viewed design as an isolated discipline, detached from other parts of society, concerned with bringing forth classics.

Since 1989, this praxis has undergone fundamental changes. Moreover, it is becoming increasingly clear that we only do justice to design's social significance when we show it in all its complex interconnectedness with other parts of society—from technical

developments, artistic movements, and industrial aspects, through social and ecological issues that design today must address.[2] In recent years, this has led to the rise of a paradigm for showing design that privileges complexity over reduction, contextualization over isolation. This form of exhibition is not actually new; its genealogy can be traced back to the prototype of the museum, the cabinets of curiosities in which "artificialia," "exotica," and "scientifica" were displayed side by side.[3] But after the modernization of the museum in the 19th and 20th centuries, with emphasis now placed on specialized modes of display and presentation, this paradigm was slow to regain any significance. Renewed interest in it can be linked to two individuals, who also mark the time-span of the renaissance of design exhibitions as "modern cabinets of curiosities": Le Corbusier and Jasper Morrison.

From industrial art to an art industry

As a young architect, Le Corbusier developed an exhibition ideal which initially set him apart, as the avant-garde of his time favored specialized museums and exhibitions. In the longer term, however, it made him a key precursor of today's design shows. As a reader of international art and interior design magazines, with which he was supplied as a student by his teacher Charles L'Eplattenier, Le Corbusier was aware of the major exhibitions of his time.[4] These included the spectacular Exposition Universelle in Paris (1889), the World's Fairs in Turin (1900) and St. Louis (1902), but also the show by German Jugendstil artists at the Mathildenhöhe in Darmstadt (1898), the regular spring and fall salon in Paris, and the influential first German arts and crafts exhibition in Dresden (1906) which prepared the ground for the founding of the German Werkbund (1907). In 1925, in his book *The Decorative Art of Today*, Le Corbusier included images of the "Hamburg Hall" designed by Peter Behrens for the Turin World's Fair, captioning them "The Innovators."[5]

Le Corbusier's travels of the years 1907 through 1911 gave him the opportunity to visit important exhibitions and museums in major European cities.[6] In 1908/09, he spent several months in Vienna; in 1909 six months in Paris; and in 1910/11 almost a whole year in Germany. In Paris, he worked for Auguste Perret within walking distance of the Trocadéro, whose large ethnographic museums he visited many times. In Germany, he studied the close links between exhibitions and the goals of economic policy and propaganda, as well as the organizational and logistical possibilities for extending their sphere of influence. He became acquainted with a public cultural sector which, under the influence of the empire and new bodies like the Werkbund, was so rationally organized that Le Corbusier praised the resulting exhibitions, by analogy with his concept of the "machine for living," as "machines for seeing" that were able to convey their message with a maximum of rationality, controlling the perceptions of the visitor and of the public in general. All this went into his *Study of the Decorative Art Movement in Germany* (1912), in which he gives a detailed description of how, towards the end of the Hohenzollern empire in Germany, the young discipline of "industrial art" gave rise to a veritable "art industry"—a process fostered at the time by economic policymakers like Friedrich Naumann and the young Theodor Heuss in the same way as the "creative industries" are promoted today.[7]

It seems as if, via this phase of French and German exhibition culture, Le Corbusier adopted the kind of "exhibition mentality" attributed to the late 19th century by Walter Benjamin.[8] At the same time, Le Corbusier had already shown an interest in a "spectacularization" of exhibitions having more to do with the vividness and sensuality of early cabinets of curiosities and the glittering crystal palaces of the 19th century than with the reductionist exhibition ideal of the European avant-garde. Writing about the impressive

Wertheim department store in Berlin, he first formu-
lated the principles of an "art of display:"

> "To attract the client with the seduction of com-
> fort, of luxury, of beauty, to open its doors to the
> crowds that surge in, to display beautiful mate-
> rials in excessive detail, that is to say, to put them
> in the hands of the onlooker so that he receives
> some physical impression, a sensual contact, to
> intoxicate him, and to tempt him—that is the
> new tactic of the merchant. Astonishingly taste-
> ful window displays in the most intense centers
> of life arrest the hurried crowds. The doors are
> actually heavenly portals. There are free eleva-
> tors; the complete neutrality of the salesmen
> never makes one feel pressured. But, so that this
> often fantastic display in immense halls flooded
> with light never becomes wearisome as in an
> Oriental bazaar, it needed an order, an organiza-
> tion, a rhythm, a feeling for color; the exploi-
> tation of decorative resources inherent to mer-
> chandise needed tact, taste—style if you will—
> the art of display."[9]

The museum of the present
On moving to Paris in the winter of 1916/17, Le
Corbusier began to organize more complex exhibitions
of his own—he was, after all, completely unknown in
the city and needed to make a name for himself (not
least via the medium of the exhibition). After several
smaller shows, he organized a spectacular appearance
at the fall salon of 1922, where he presented his revo-
lutionary *Ville contemporaine pour 3 millions d'habitants*,
turning him overnight into a spokesperson for the
architectural avant-garde. The next step in this develop-
ment came in 1924 when, in the magazine he had
founded under the title *Esprit Nouveau*, he outlined his
ideal of a "museum of the present," which can be read
as the leitmotif for all his subsequent exhibition and

museum concepts. In this text, Le Corbusier formulated a fundamental critique of conventional exhibition and museum models, strongly influenced by Paul Valéry.[10] In 1923, Valéry published "Le problème des musées," in which he complained: "Just as a collection of pictures constitutes an abuse of space that does violence to the eyesight, so a close juxtaposition of outstanding works offends the intelligence."[11] As Niklas Maak has shown, Le Corbusier was in contact with Valéry and probably knew this text, so that his own text, which a year later also formed the programmatic opening of his book *The Decorative Art of Today*, must be read as a response to and development of Valéry's ideas.[12] Unlike Valéry, Le Corbusier by no means fundamentally rejected the institution of the museum or the principle of collecting; instead he proposed a more differentiated position:

> "In order to flesh out our idea, let us put together a museum of our own day with objects of our own day; to begin: A plain jacket, a bowler hat, a well-made shoe. An electric light bulb with bayonet fixing; a radiator, a table cloth of fine white linen; our everyday drinking glasses, and bottles of various shapes (Champagne, Bordeaux) in which we keep our Mercurey, our Graves, or simply our *ordinaire* … A number of bentwood chairs with caned seats like those invented by Thonet in Vienna, which are so practical that we use them as much ourselves as do our employees. We will install in the museum a bathroom with its enameled bath, its china bidet, its washbasin, and its glittering taps of copper or nickel. We will put in an Innovation suitcase and a Roneo filing cabinet with its printed index cards, tabulated, numbered, perforated, and indented, which will show that in the twentieth century we have learned how to classify. We will also put in those fine leather armchairs of the types developed by Maple: beneath them we might place a

label saying: 'These armchairs, invented at the beginning of the XXth century, were a real innovation in the art of furniture design; furthermore, they were a good example of intelligent research into comfort.' [...] Clearly, this museum does not yet exist. Such a museum would be truly dependable and honest; its value would lie in the choice that it offered, whether to approve or reject: it would allow one to understand the reasons why things were as they were and would be a stimulant to improve on them."[13]

Just one year after formulating these ideas, Le Corbusier was given the opportunity to put them into practice, staging his first major solo show with the *Pavillon de l'Esprit Nouveau* at the 1925 Exposition des Arts Decoratifs in Paris. The shell of the pavilion consisted of one module from the *Immeubles Villas* developed in 1921/22, accessed via an entrance at the rear of the building.[14] From here, the visitor first entered the zone furthest away from the entrance, where Le Corbusier again showed his latest town-planning projects in the form of a diorama. They were based on the *Ville contemporaine pour 3 millions d'habitants* he had exhibited in 1922, but renamed and developed into the *Plan Voisin*, a tribute to the automaker Voisin whom Le Corbusier hoped to win over as a financier for the implementation of his plan.[15] The dioramas were lit by daylight entering through the open ceiling of the space, and surrounded, as in 1922, by simple, cuboid shells. Following the curves of the space in which the dioramas were shown, the visitor left the enclosed part of the pavilion and entered an outdoor terrace. At the center of this terrace stood a tree around which Le Corbusier had simply built the pavilion, framing it with a circular opening in the roof of the loggia so that it looked like an exhibit. From the terrace, visitors accessed the main zone of the pavilion, a model apartment with a fully-fitted interior.

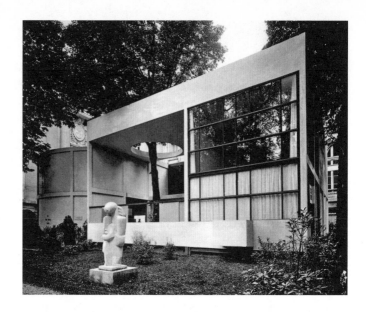

On entering this apartment, visitors were immediately faced with the most spectacular view of the interior, looking through the whole two-story living space to the gallery at the back of the room. The constructed illusion of a domestic situation extended from individual pieces of furniture and a Berber rug through the artworks on the walls, the flowers in the vases, and the magazines on the table, which were of course issues of *Esprit Nouveau*.[16] The furniture designed by Le Corbusier himself was limited to his *casiers standard* (plain cubic containers) and a simple table with a steel frame. For seating, Le Corbusier used industrially mass-produced items such a Thonet chair, a 19th century chair made of bent iron rods, and two leather armchairs by Maple. The inventory also included a model airplane attached like a picture to the wall, a butterfly display case, and a globe on a steel frame, all shown in the more private area under the gallery behind the *casiers standard*. On the wall above the dining table hung the paintings *Le Balustre* (1925) by Fernand Léger and *Nature morte* by Le Corbusier himself (1924); the room also contained a relief by Jacques Lipchitz and other small paintings.[17]

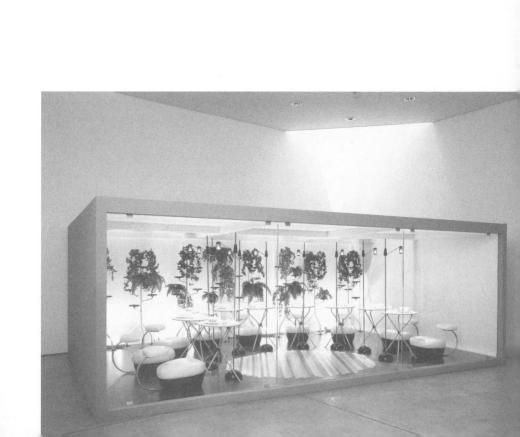

Le Corbusier, *Pavillon de l'Esprit Nouveau*, Interior view, Paris, 1925

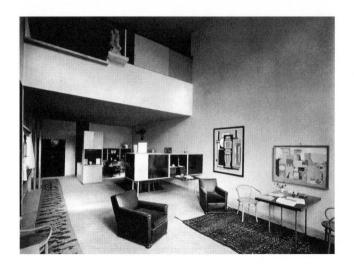

Whereas Le Corbusier's previous exhibitions—except the diorama of 1922—had been dominated by the conventional media of models, drawings, and photographs, the presentation in the *Pavillon de l'Esprit Nouveau* was the first to offer a totally autonomous visual world with its own rules that went far beyond the hanging of paintings or the presentation of models. At almost the same time, Le Corbusier addressed these rules in *The Decorative Art of Today*, which appeared as a kind of catalogue to the 1925 exhibition, bringing together his articles in *Esprit Nouveau* dealing with everyday objects, applied arts, exhibitions, and museums.[18] In this work, he formulated his views on what he called the "objets types," drew comparisons between modern industrial art and that of classical antiquity, as well as including everyday objects with popular and non-European origins in his visual cosmos. The sources of inspiration for the concepts implemented in the *Pavillon de l'Esprit Nouveau* clearly include the motif of the cabinet of curiosities from the early history of the museum. Especially in the more intimate zone under the gallery, labeled in the exhibition plan as the "workplace" of the imaginary inhabitant, the objects like the butterfly case, the globe, and the model plane display the same linking of theoretical reflection and per-

sonal delight in telling stories, of rational order and spatial presentation found in the juxtaposition of "scientifica," "naturalia," and "artificialia" in cabinets of curiosities. At the same time, the pavilion proved to be a kind of psychological profile and imaginary museum of its creator, as every visitor could easily identify the imaginary inhabitant as Le Corbusier himself, whether he was in the work area thinking about the links between art, technology, and natural science, or leafing through the copies of *Esprit Nouveau* in the living room. Long before the concept of the "musée imaginaire" was introduced by André Malraux in 1947, when Le Corbusier also added it to his vocabulary, this show anticipated Malraux's basic idea that in modern design, mental structures and orders can merge seamlessly with spatial arrangements—and vice versa.[19]

Webs of connections, spectacular spaces
The influence of Le Corbusier's exhibitions was slow to show itself, as the avant-garde of the interwar years was more interested in the constructivist-rationalist style associated with the de Stijl movement and the Bauhaus. By comparison, Le Corbusier's installations looked like eclectic throwbacks to the interior tastes of the bourgeoisie and the fairground gimmicks of the 19th century. Only when the dogmas of the avant-garde began to be called into question in the late 1930s, starting in the United States, did the impact of Le Corbusier's exhibition models become clear, and they became an important point of reference. Examples in the United States include the exhibition curated by Friedrich Kiesler at Peggy Guggenheim's gallery in New York in 1942 under the title *Art of This Century*, a dense collage of pictorial works and furniture in which the formal relationships between the objects were emphasized by the striking struts of the exhibition architecture. A similar approach was taken in the *First Papers of Surrealism* show designed by Marcel Duchamp at the Whitelaw Reid Mansion, also in New York, where

threads were stretched throughout the exhibition space, turning the perusal and viewing of works into something of an obstacle course.[20] The dense weave of visual and formal links between art and everyday objects presented by Le Corbusier in his exhibitions (constituting an alternative model to rationalist exhibition theory based on "autonomous" and independent artworks) was extended in these two New York shows to include a physically present matrix. The agitative, even polemic side of Le Corbusier's exhibition praxis was also reflected in these installations, which deliberately planned the irritation of the audience as part of the experience of exploring the exhibition.

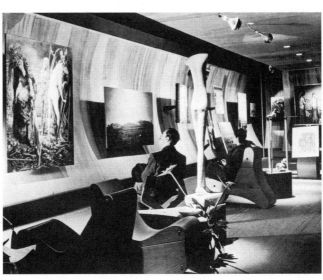

Frederick Kiesler, *Art of This Century, Surrealist Gallery,* Exhibition view, 30 West 57th Street, New York, 1942

In Europe, the influence of Le Corbusier's exhibitions began to make itself felt in the post-war period, when there was also a critical review of rationalist modernism, with artists, designers, and architects increasingly taking an interest in the semantic aspects of spatial installations. One example is the *Parallel of Life and Art* show at London's Institute of Contemporary Arts, organized in 1953 by several artists and architects associated with the Situationists and operating together as the Independent Group. They included

Nigel Henderson, Eduardo Paolozzi, and Peter and Alison Smithson, all of whom knew Le Corbusier personally[21] from the context of the CIAM.[22] In their acclaimed exhibition, they combined artworks with everyday objects, newspaper clippings, and objets trouvés. The exhibits reached to the ceilings and gave the exhibition spaces a conceptual character, the same effect aimed for by Le Corbusier with his theories relating to objects and presentations. There are also links to Le Corbusier's approach in the choice of images, which included—as in his earlier installations—ancient masks, microscopic photographs from nature, scientific motifs, and a wide range of artistic works.

Independent Group, *Parallel of Life and Art*, Exhibition view, ICA, London, 1953

From the immediate postwar period onward, however, Le Corbusier's exhibitions exerted an influence not only on methods of exhibition presentation, but also as art itself. After all, Le Corbusier never viewed his exhibitions purely as propaganda tools, but as part of an overall artistic oeuvre which, in addition to his display techniques, also included basic media strategies such as the systematic breaking down of borders between living and museum spaces, the active involvement of visitors in the process of perception, and the systematic linking of presentation and publication techniques.

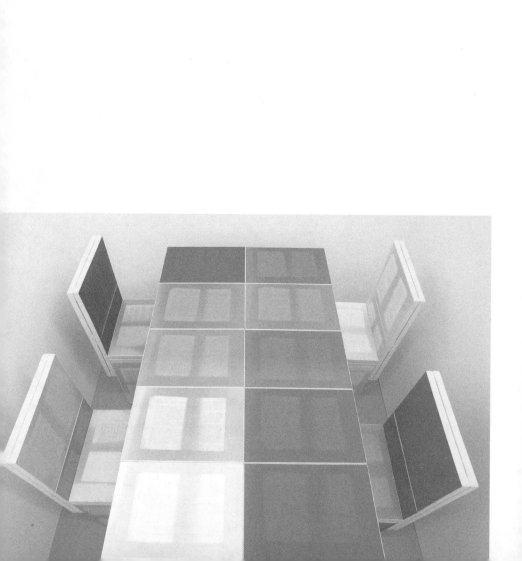

The influence of all this is evident, for example, in the work of Marcel Broodthaers, who launched his *Musée d'Art Moderne, Département des Aigles* in 1968 at his own house in Brussels.[23] He built the museum systematically and in line with scientific standards, examining the motif of the eagle in all of its many facets. In so doing, he called into question not only the borders between nature and art (as reflected in the contradictory two-part title), but also the legitimacy of museums and exhibitions in general, whose specialist tendencies he took to absurd lengths. Like Le Corbusier in the 1920s, Broodthaers used the connotations and semantic associations of the assembled objects (such as the various exhibits on the theme of the eagle), but also addressed the prerogative of the cultural scene to interpret its own products by publishing lavish catalogs on his museum's subject.[24]

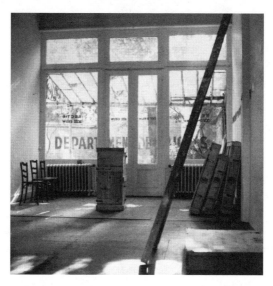

Distinction

Marcel Broodthaers, *Musée d'Art Moderne, Département des Aigles, Section XVIIe Siècle,* Installation view, Antwerp, 1969

Further evidence of the influence of Le Corbusier's exhibitions in recent decades can be found in the presentation strategies of many designers and architects. Designers often try to avoid the resemblance between "classic" design exhibitions and commercial trade fair and product presentations by deploying strategies

of collage and subversion similar to those used by Le Corbusier and Broodthaers. One example is provided by Achille Castiglioni, whose celebrated first interior *Colori e Forme Nella Casa d'Oggi* at Villa Olmo in Como in 1954 created a combination of found objects and his own designs whose rich contrast and subtlety is related to Le Corbusier's installations in many ways.

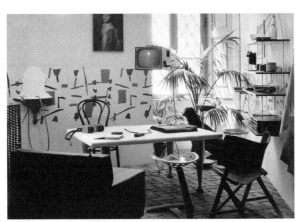

Achille Castiglioni, *Colori e Forme Nella Casa d'Oggi*, Villa Olmo, Como, 1957

A similar approach was taken in the period around 1990 by British designer Jasper Morrison with a series of spatial installations that established his reputation internationally. The first took place in 1989 under the succinct title *New Items for the Home* (a reference to Castiglioni) and consisted of a group of simple plywood furniture in a stage-like display case with other items merely drawn onto the inner surfaces. Compared with the eclectic design of the 1980s, these four rooms appeared refreshingly simple and almost modest, soon prompting talk of a "New Simplicity." At the same time, however, instead of advocating a return to *Gute Form* or any of the other isms of the 20th century, Morrison achieved—not least thanks to his formal reserve—a layering equal in complexity to the post-modern interiors of the preceding years. His *Reuters News Center*, for example, was not only a design proposal for an agency workplace, but also, in at least equal measure, a psychological profile of a human

inner world, ingeniously showing how our perceptions today are inundated by news.[25] In all four rooms, the mixture of real objects, pictorial references, and almost didactic austerity was more reminiscent of a museum display than of the forced relaxedness of the design of the 1980s. Morrison's interiors were ambiguous spatial collages, "built pictures" both implying the possibility of a real living space and offering an artistic depiction and commentary on domesticity.

Jasper Morrison, *Reuters News Center,* Sketch for documenta 8, 1987

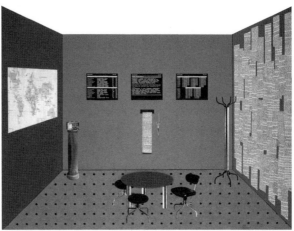

Jasper Morrison, *Some New Items for the Home, Part I,* Installation view, DAAD Galerie, Berlin, 1988

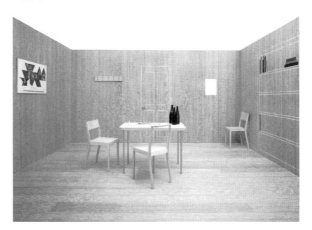

Beside the mixture of ordinary but surreal-looking objects and situations, however, Le Corbusier's influence is also felt here in Morrison's object theory of the *Super Normal.*[26] For this show, Morrison combined

the concepts of the "objets types" and the "objets à réaction poétique" in an interpretation of everyday objects which has been of decisive importance for design theory and consumer aesthetics ever since:

> "There's nothing wrong with normal of course, but normal was the product of an earlier, less self-conscious age, and designers working at replacing old with new and hopefully better, are doing it without the benefit of innocence, which normal demands. The wine glasses and other objects of the past reveal the existence of super normal, like spraying paint on a ghost. You may have a feeling it's there but it's difficult to see. The super-normal object is the result of a long tradition of evolutionary advancement in the shape of everyday things, not attempting to break with the history of form but rather trying to summarize it, knowing its place in the society of things. Super normal is the artificial replacement for normal, which, with time and understanding, may become grafted to everyday life."[27]

With his exhibitions and his theory of the Super Normal, Morrison, too, appealed for an exhibition aesthetic based on the inherent visual logic of the exhibits, their logos, taking this as the basis for complex semantic interconnections. In so doing, he formulated a counter-position to the analytical-decontextualizing exhibition strategies associated with the ideal of a museum cell for solitary confinement, also known as the white cube. The genealogy of Morrison's exhibition ideal, as we have shown, can be traced back via Le Corbusier to the cabinets of curiosities in which the potential for displays based on the visual links between objects was explored for the first time.

1 See Brian O'Doherty, *Inside the White Cube. The Ideology of the Gallery Space* (Santa Monica/San Francisco 1976/1986).
2 See Mateo Kries, *Total Design – Die Inflation moderner*

Gestaltung (Berlin 2010), pp. 170 ff. and Mateo Kries, "Funktion oder Fiktion – Zum Verhältnis von Kunst und Design seit Jasper Morrison," in Markus Brüderlin: *Interieur/Exterieur – Wohnen in der Kunst* (Ostfildern 2008), pp. 225-230.

3 Horst Bredekamp, *Antikensehnsucht und Maschinenglauben. Die Geschichte der Kunstkammer und die Zukunft der Kunstgeschichte* (Berlin 1993).

4 The art academy in La Chaux-de-Fonds had subscriptions to periodicals including the German magazine *Kunst und Dekoration* and the British title *The Studio*.

5 Le Corbusier, *L'Art décoratif d'aujourd'hui*, Paris 1925, pp. 141-163.

6 See H. Allen Brooks, *Le Corbusier's Formative Years* (Chicago 1997). These journeys played a crucial part in turning Le Corbusier "from a medievalist to a classicist" (Brooks), which he then remained for the rest of his life.

7 The concept of the "machine à habiter" first appears in Le Corbusier-Saugnier, "Des yeux qui ne voient pas...: Les Paquebots," in: *Esprit Nouveau* No. 8, May 1921, p. 848.

8 Stanislaus von Moos points to these links in his afterword to the new edition of his Le Corbusier monograph *Elements of a Synthesis* (Rotterdam 2010), pp. 180 ff. See also Walter Benjamin, "Exhibitions, Advertising, Grandville," in *The Arcades Project* (Cambridge MA 1999), pp. 171-202.

9 Mateo Kries (ed.), *Le Corbusier – A Study of the Decorative Art Movement in Germany* (Weil am Rhein 2008), p. 179.

10 On Le Corbusier's reading of Valéry, see Niklas Maak, *Objets à réaction poétique – Zum Verhältnis der entwurfstheoretischen Konzepte Le Corbusiers und Paul Valérys* (doctoral thesis, Hamburg University, 1998) and *Der Architekt am Strand* (Hamburg 2010). Maak focuses above all on the crucial role played by Valéry's philosophy in Le Corbusier's turn toward organic forms in the 1930s; Valéry's critique of institutions was less important.

11 Paul Valéry, "The Problem of Museums," in *The Collected Works of Paul Valéry, vol. 12* (New York 1972), p. 204.

12 See Le Corbusier: "Other Icons: The Museums," in: *Esprit Nouveau* No. 20, Jan./Feb. 1924, and in *The Decorative Art of Today* (1925) (MIT Press 1987), pp. 15-23.

13 Ibid., p. 17.

14 The *Immeubles Villas* were modules for two-story, freestanding villas that could be "stacked" to form a grid pattern creating large apartment blocks whose individual units nonetheless offered the qualities of freestanding houses, such as two storys, terraces, or balconies. After the war, this principle formed the basis for the *Unités d'habitation* that were built in Marseille, Nantes, Berlin, and Firminy.

15 To win Voisin over for his plan, Le Corbusier published advertisements for his company in *Esprit Nouveau*. See *Esprit Nouveau* No. 12/1923 and No. 24/1924. The first car Le Corbusier purchased for himself, in 1927, was also a Voisin.

16 On the interior of the *Pavillon de l'Esprit Nouveau*, see Arthur Rüegg, "Der Pavillon de L'Esprit Nouveau als musée imaginaire," in: Stanislaus von Moos (ed.), *L'Esprit Nouveau – Le Corbusier und die Industrie* (Zurich 1987), pp. 134 ff.

17 Christopher Green has documented that originally, instead of *Le Balustre*, another less striking, abstract picture by Léger from 1924 was hung. Only once the exhibition was underway

was it exchanged for *Le Balustre*, which had just been comple-
ted. Overall, however, Léger was not happy about the presence
of his work here, as he felt it was overly dominated by the
surrounding exhibition. See Christopher Green, "Painting for
the Corbusian Home," in: *Studio International*, Sept./Oct. 1975,
pp. 103-107.

18 Le Corbusier: *L'Art décoratif d'aujourd'hui*, (Paris 1925).
19 See Arthur Rüegg, op. cit., pp.135 ff., and André Malraux, *Psy-
chologie de l'Art I, Le Musée Imaginaire* (Geneva 1947).
Malraux and Le Corbusier had been close friends since the
1930s. Malraux supported him on various projects, including
the *Pavillon Suisse* (1930/31) and the *Unité d'Habitation* in
Marseille (1946–52).
20 Duchamp and Le Corbusier had known each other since the
early 1920s when Le Corbusier published works by Duchamp
in *Esprit Nouveau*.
21 See C. Lichtenstein, T. Schregenberger (eds.), *As Found – The
Discovery of the Ordinary* (Zurich 2001), pp. 30 ff. Le Corbusier
was in close contact with Alison and Peter Smithson through
CIAM.
22 Congrès Internationaux d'Architecture Moderne (International
Congresses of Modern Architecture).
23 See Anne Rorimer, *Redefining Reality – New Art in the 60s
and 70s* (London 2001).
24 See Marcel Broodthaers, *Der Adler vom Oligozän bis heute.
Marcel Broodthaers zeigt eine experimentelle Ausstellung
seines Musée d'Art Moderne, Département des Aigles, Section
des Figures* (catalogue for the exhibition of the same name at
Städtische Kunsthalle Düsseldorf, 1972).
25 documenta 8 was the second documenta where design was
shown, in a section curated by Michael Erlhoff. Design was
first presented at documenta 6, directed by Manfred
Schneckenburger.
26 See Mateo Kries 2008, op. cit., pp. 224-232.
27 Jasper Morrison, *Everything but the walls*, 2nd, extended
edition (Baden 2006), p. 233.

Sitting on Ghosts – Mamiko Otsubo

The interview was conducted
at Mamiko Otsubo's studio in New
York City on June 28, 2009.

Mamiko Otsubo The title, *Sitting on
Ghosts*,[—> p. XXVI] actually comes from
the Kartell tables used in the sculp-
ture. The tables themselves are de-
signed to be like ghosts of an actual
table, kind of barely there, because
they are made out of clear plastic.
The sculpture started with this piece
of walnut and I started to carve it.
I arrived at a form, which I thought
looked vaguely like a mountain.
I often use abstract, iconic images of
nature, not so much because I have
a specific interest in nature *per se*,
but mainly because I am interested
in form. The relationship between
form and image seems to be partic-
ularly fused there.
As I got further along in the piece,
I realized that I was looking for a
certain kind of precarious, uneasy
balance between all the parts. In
this piece, the arrangement of parts
that are on top of the tables really
came first. The material decisions
for this piece were based on the
fact that they were all materials a
product designer would often use to
design a piece of furniture or home
decor products. The idea here was
not to make a piece of furniture, but
to make an arrangement of parts
made with essentially the same tech-
nique and materials, but arrange
them in a way that designers would
never use. The viewer understands
the vernacular of the materials,
but the arrangement is meant to
create a kind of discomfort, a ques-
tion. A hand-blown glass globe,
that is slightly too big, sits precar-
iously on this piece of shaped
walnut connected only by a single
rubber plug. This whole arrange-
ment sits on two bent pieces

of stainless steel with sharp edges,
creating visible scratches against
the soft plastic table.
At the time, I was thinking quite a
lot about the agency of an individual
artist. I think the eyes of your aver-
age viewer, living amongst a world
of perfectly mass-produced objects,
are far more sophisticated about
surfaces, finishes, and production
than they consciously realize them-
selves. In the face of such uncon-
scious internalized expectations, what
are the options available to you as
one artist working in a studio, with
no real access to industrial techno-
logies and tools? You compete more
and more with product designers
for space in people's homes and even
in museums.

Burkhard Meltzer As an artist?

Mamiko Otsubo Yes, as a sculptor.
People buy $12,000 designer couches
that they don't sit on, and coffee
tables that they don't put their coffee
cups on. These pieces of furniture
are displayed in stores like sculpture,
and really behave like that in people's
homes when they are not used.
And at the same time, I always envy
designers for their access to tools
and the sheer industry that is at their
disposal to create these perfectly
made things. I thought about the
perfection of these injection molded
Kartell tables and how that can only
come from a factory. An individual
artist cannot afford to do anything
like this, but at the same time, we are
competing for attention with objects
that are so much more sophisti-
cated. Maybe not in homes, neces-
sarily, but in offices, in stores, and
so on. I think the level of finish that
is used is generally very high. And
so when you get into that area with
sculpture and finishing, you are
really competing with certain kinds
of expectations. These particular
tables, they're about $175 each.

They are actually not that expensive, and they are beautifully made, because they do them with these crazy machines. If I made them myself in Plexiglas, it would cost me literally twice the amount to make the same table and it would never look like this. I think the one true advantage that an artist has is to be able to claim things for their work.

Burkhard Meltzer Are you frequently looking at design?

Mamiko Otsubo I grew up around a lot of modern furniture. My parents also liked it. I see it fairly regularly now in New York. But I pay attention to and look at a lot of objects in general. All these objects in question really belong to a particular class of objects. I think design likes to think itself accessible and for consumption by a wider audience. Some are, I suppose. But in the middle and certainly higher end product design, the attitude doesn't seem that different from that of collecting art. I think as a class of objects, they all operate within the same social circle.
But much of my current interest in these furniture pieces is really because they have started to behave like actual sculpture and are treated more and more like it. In a funny way, my use of an Eames chair base could be considered as a reverse tactic to get a sculpture in the house. If it was just a "plain" sculpture, maybe there would be some built-in resistance to the idea of "living" with a sculpture and it taking up some room in a home. If they look and behave as if they are, in part, furniture, there is an additional dialogue for the artwork, but it also takes advantage of its familiar vernacular as furniture.

Burkhard Meltzer I would be interested to know if you would still call the Kartell table in your sculpture "furniture" or has it become something else for you?

Mamiko Otsubo I would call it "material." This is what I was referring to when I said earlier that the one true advantage an artist has is to be able to claim things for their artworks. I believe that an artist always has the right to claim things as material, whether that material be readymade, copyrighted, branded, new, old, historicized, etc.
My work is often talked about in terms of Formalism, but I really feel this is a misreading. In Formalism there is a resistance to content, a kind of an effort to divorce form from content. My usage of material really resists that kind of complete erasure, and maintains interest in the little bits of information that you cannot separate from form or materials.
I think more than Formalism, abstraction is a much bigger part of my work and the surroundings that have influenced me over the years. There's a lot of abstraction in Japanese environments (and in Japanese ways of thinking and communicating)—architecture, graphic design, textiles, symbols—it's really everywhere. And it's quite different from the way that it's treated here in the US. I think the Western conversation about abstraction is very limited to art, to painting and maybe certain types of sculpture. It often looks the same when people talk about it. There is not the same kind of investment in abstraction, like in the ways you might find in Japan. American ideas of space and abstraction are a totally different thing and really point to a different sensibility altogether.

Tido von Oppeln It's funny that when you talked about abstraction I immediately made the connection between modern design and abstrac-

tion, you could speak of abstract furniture. And historically, then, there are no roots in Western formal language for it, it comes from somewhere else. Leaving ornaments behind, but going on in formal development, but with no actual tradition for it.

Burkhard Meltzer So, if you use something as material in your work, it still remains the…

Mamiko Otsubo The "thing," right. I am very interested in the thing as it is, but also it serves me as material. In the artwork, the things display a kind of a double life. I pay quite a lot of attention to the surface of things, because there is something un-divorce-able there that maintains a connection with all the other things in the world. This is all part of the vernacular of materials, which is very important for me because that is one of the things that keeps an artwork from falling into an illusionary space. I am interested in an art that sits in the same space that you sit in, rather then somewhere else that's fictional.

Burkhard Meltzer So it seems a lot about balance between all those materials in your work rather than a competition.

Mamiko Otsubo I think the balance of the parts indicates to you the function. So the unusual balance of something indicates to you that it's not meant for the function that it looks like at first glance.

Burkhard Meltzer Were you ever approached by a person from the design field for a collaboration?

Mamiko Otsubo No, but I would totally love to do a collaboration. I always think that companies like Capellini or Vitra should have residencies

for artists. I would take that over any other art residency.

The interview was conducted by telephone on June 23, 2009.

Burkhard Meltzer First I'd like to talk about the *Dark Unit and Mask*[—> p. 1] that consists of two elements: the replica of an Eames storage unit, and the mask above it from an Arne Jacobsen chair. First of all, it seems a bit damaged, it's not evenly colored. It seems that modernity as shown in your piece is an uncomfortable place.

Martin Boyce Definitely. I studied at CalArts in Los Angeles as part of an exchange program in 1996. It was then that these things entered into my practice and it was the conversations with people like Sam Durant and Michael Asher, who of course was always talking about the question of critique in relation to the work, that really was a kind of flip point. This West Coast Modernism that I'd become familiar with in books could be seen there in its natural habitat, and of course elements of it were still highly revered but other elements, such as the Eames fiber glass chairs, could be found in everyday situations like laundromats and schools. It was also the year that Wallpaper magazine appeared, and that began the popularization and broader interest in modernist furniture and architecture. The reason I became interested in this stuff was not accidental. It had started with a friend's architect father who had bought a lot of this furniture at the time; then, as the pieces of furniture got old he would replace them and pass on the originals to his daughter and son, not as heirlooms, you understand, but simply as old useful furniture. Of course he understood its design significance but he couldn't be fetishistic about it. So I would find myself sitting around an Eames table on semi-derelict, three-legged Jacobsen chairs at my friend's house, while simultaneously coming across the same objects in books on design history. I started to make connections with time, and ideological and cultural shifts. So once I got back from Los Angeles, I started to make some work in relation to all the stuff I had been looking at, thinking about and discussing. The first pieces I made were the two Eames storage unit sculptures, although actually they weren't replicas because I made them at a different size to the originals. When I looked at images I always had an idea in my head of what size they were, and once I looked at the original measurements I couldn't believe that they were smaller than I imagined. Because I deal with sculpture, I just went ahead and made them as I felt they should be.

Burkhard Meltzer So you re-made them from memory?

Martin Boyce Sort of, although I'd never seen one in the flesh. I had only ever seen pictures of them. The very first storage unit sculptures were called *Now I've Got Worry (Storage unit I and Storage unit II)* which come out of all the research that I did about the city of Los Angeles and the kind of paranoia that is sort of engraved into the architecture. You know, these gated communities or armed response signs you would find in residential housing areas. I was reading *City of Quartz* by Mike Davis, which is this incredible dystopian critique of the topography of the city. I was also reading Reyner Banham, in particular *Architecture of the Four Ecologies*, which is like a love letter to Los Angeles; and also fiction like Bret Easton Ellis, you know, *Less Than Zero*, and so on. So

this noirish quality, which has always been embedded in Los Angeles, came through as well—the idea that this furniture was made with utopian yearnings and that the construction of an Eames chair or shelving system could be clearly figured out. And that the storage unit has these bright colored panels and very sunny, West Coast optimism built into it. Of course now, these objects were beginning to appear in museums and in magazines and in luxury apartments, and so on. So there was this gap between the time these objects appeared and the time I was there. I wanted to think about what these objects meant when they entered the world in 1949/1950, and what had happened to their ideological DNA as they passed through time up to now.

Burkhard Meltzer Do you see these designs as a part of a modernist idea of city building in Los Angeles?

Martin Boyce Yeah, there was an idea of collapsing the physical and mental landscape of LA and the shelving unit. The shelving unit, with its dividing walls and shelves as floors, becomes a model of a piece of architecture. In the original two *Storage unit* pieces, I boarded up parts of them with rough pieces of plywood. So in place of some of the primary colored panels there would be a rough piece of plywood that would say: GO HOME THERE IS NOTHING 2 SEE or RESIDENTS ONLY or KEEP OUT. So the objects themselves were becoming paranoid. The subsequent sculptures of the Eames units, I fabricated to the specific measurements of the original shelves.

Burkhard Meltzer I am very interested in one detail of the mask from the Arne Jacobsen chair that is shown together with the *Dark Unit*. As

far as I know, the mask is placed on a stand and it seems like it has been cut very roughly, the edges of the mask almost seem like they have been broken.

Martin Boyce The first mask pieces were made from a 1942 Eames leg splint that I bought while in LA. I found images of modernist interiors from that period, and if you look at the Eames house as an example, the collection and display of African or ethnic artifacts was quite popular at that time. It occurred to me that the Eames leg splint itself contained a kind of exoticism that was conjured up, not through its geographical and cultural remoteness but through its temporal and accumulated cultural significance. So I crudely cut up this artifact complete with eye holes, and suddenly I had this mesh of Californian reference points, from the Eames house to the mask in John Carpenter's *Halloween* to Joan Didion's writing on the Manson murders, to the display, rather than use, of collectible modernist furniture in the natural habitat of the Hollywood Hills. The Jacobsen mask you mention is an extension of this.

Burkhard Meltzer In the images from the Venice Bienniale this year, the motif of the mask re-appears in a different way in one of the spaces.

Martin Boyce The mask thing has continued, but now, in my more recent work, it's more of a free flow of possibilities. In the case of the Venice show, it takes the form of a bird box. With the Eames storage unit and the Jacobsen chairs, there is a very clear dialogue about the history and legacy of modernist furniture and architecture. I mean, I never think of the work as a critique as such, but certainly the earlier work is a con-

versation about very specific realities and histories, while the more recent work is less so.

Burkhard Meltzer One of the exhibition spaces is called *A River in the Trees* and you could obviously see references to the outside, like landscape or city spaces.[—> p. XIII] This space is full of concrete blocks and cement forms and leaves as well. Other spaces carry references to a potential interior.

Martin Boyce Take the table piece, for example. It's presented as an outdoor table, but it's been highly weathered, it's very rough. The legs have been rusted from the bottom up. It looks like a table you found in a garden or in a park, that's been left there for fifty years. Almost all of the works in the show have been artificially weathered. So as objects, there is a sense that they have been somewhere outside or that the elements have come inside. The idea was always that this was one place blown through another.

Burkhard Meltzer I would like to pose a more general question that could be linked to the *Dark Unit* work and also to a work like the two benches in Venice. Could one call these objects "furniture"?

Martin Boyce I just think of them as sculpture. Only in one situation did I allow that some of the works could be used as furniture. The exhibition, *Our Love is Like the Flowers the Rain the Sea and the Hours*, Glasgow 2002, takes the form of a really vast urban park. There were bench frame sculptures, just steel frames, and then there were three that had some wooden slats so they could be used. If someone sat on one of them, then that was fine. We didn't encourage them and we didn't discourage them, but

that was the only time. And in a way that was because I really wanted the installation to function like a park, I wanted people to use it like a park. And that's always been the case for me, that even if things do take the form of a piece of furniture, in terms of a straightforward understanding of use, it does not function as that. If you think of some installations--the idea of socializing the exhibition space and allowing people to do things that they don't normally do in exhibition spaces, like sleeping, make music, eating or so on—that has never been a priority of my interests. I like to think of the exhibition as a kind of a frozen image you can walk through, to be able to step inside a glimpse, so you have this intimacy and also a distance.

Burkhard Meltzer If there is apparently a special interest in working with furniture in your work, what keeps you occupied playing with that topic?

Martin Boyce For me it has to do both with interior and exterior landscapes. Because when I started to work with specific modernist images with very highly recognizable forms, like the Jacobsen chairs and the Eames unit, it allowed me to explore particular kinds of landscapes, particular kinds of interiors, and so on. You know, when you went into someone's house and they have an Eames unit, it kind of informs you of many aspects or interests of that person--culturally, politically, economically. There is something particularly interesting about that. And this went into a much more fictional or imaginary zone with these "noir" objects in my work. It was almost like painting or creating this new kind of landscape or a new genre of design, a kind of "noir moderne." With the [Eames storage unit] sculpture, *Dark Unit*, the shelves and the

steel were painted black, the panels were painted in their usual primary colors and then very lightly sprayed black. I had this idea to create an object that looked like it was in a dark room, as if it had been dusted in darkness. Of course you're in a bright room, but you're looking at an object that appears to be in a shadow. I think I made a conscious decision at some point around the time of the exhibition at Tramway (Glasgow, 2002) that I did not want to continue making high design reference points. There are still occasions when specific reference points seep into the work, but I became more interested in a kind of "unauthored" furniture, you know, the park bench, the chain link fence, the urban park. Parts of the city that seem to be forever caught in-between a process of construction and deterioration. What I describe as an entropic loop.

Burkhard Meltzer You mentioned the change in referencing authors of modern design after the Tramway show in 2002—as far as I know, there wasn't a change in your references to contemporary design?

Martin Boyce Yes, that's true. There is something about the weight that time gives an object, something that new objects just don't have. It seems to affect the way they occupy space. I like the idea of objects that have seen things, experienced things. But you know, one thing I'm not interested in is nostalgia. I'm not interested in looking back, in longing for a different time. All of the objects or references that find their way into the work are about how they are or may be now.

A productive interaction

The tendency within the disciplines of design and art to make productive use of each other's procedures, approaches, and objectives may have a range of motives. But it can certainly be taken as a sign of deep dissatisfaction with the conventional possibilities of the respective discipline—or even as a symptom of an actual crisis. Artists use design strategies to critique society, to reflect on everyday phenomena, to refine conceptual approaches. And designers, fed up with established market mechanisms and calls for properly and functionally designed products, intervene via their objects in social, political, ethical, ecological, and aesthetic discourse. Or they use these objects to make critical statements on their own discipline.

Using the examples of a historical phenomenon—the furniture of Czech Cubism—and a contemporary position—the works of Martino Gamper—this essay discusses cross-discipline strategies and their

productive impetus, revealing both common ground and substantial differences.

Prague: inspiration instead of function

For a long time, the phenomenon of Czech Cubism was forgotten in the West. Rarely did a picture by Bohumil Kubišta, Emil Filla, or Josef Čapek find its way into an exhibition or publication beyond the Iron Curtain; the existence of Cubist sculpture, architecture, and applied arts, even Cubist furniture and textile designs, was known only to a small circle of specialists. Since that time, however, several exhibitions and major publications have reestablished awareness of this interesting chapter of art, architecture and design history.[1]

What took place above all in Prague in the early 1910s was a far-reaching attempt by artists and architects—associated in the Group of Creative Artists (Skupina výtvarných umělců)—to apply to all branches of creative work the artistic innovation of analytical Cubism as developed by Picasso and Braque. In this spirit, Czech Cubism was more than just another new ism or fashion; instead, it was to become a new style and—as Czech cultural historian and essayist Josef Kroutvor has rightly pointed out—to display "universal traits." Nowhere did Cubism manifest itself in more diverse forms than in Prague, and with hindsight it even seems as if the designers of the time had a completely new vision for life and the world in general. There was not only Cubist painting, but Cubist furniture, ceramics, and other household items. Cubism also exerted an influence on typography, commercial graphics, and the theatre.

Its greatest impact, however, was on architecture, producing a number of unusual and highly original buildings. In the field of architecture, more or less all of the new movement's protagonists followed the teachings of Vienna's Otto Wagner. Their principal theorist was Pavel Janák (1882–1956). In his writings based on Wagner's theories, which were brought to Bohemia

and Moravia by his student Jan Kotěra, Janák arrived at a fundamental critique of rationalist architecture,[2] which he labeled "materialist, not poetic enough, and flat as earth," saying it was overly geared to utility, construction, and social issues. To date, he claimed, it had not been artistic enough, its forms subject to rigid schemes, its surfaces flat and cold. Now it was time to break through to the true architecture, of the kind most closely approximated in the work of Wagner's pupil Josip Plečnik. The architect's task, he claimed, was to penetrate lifeless matter with "creative energy" and draw dynamic forms from it. For Janák, architecture is the sculptural shaping of a geometric-dynamic mass, to which material and construction must be subjected. Finally, the most important buildings based on such theories were planned not by Janák himself, but by his colleagues Josef Gočár, Josef Chochol, and Vlastislav Hofman.

It was mainly architects—together with painter Antonín Procházka—who transferred the new artistic maxims to furniture design.[3] The results included chairs, cabinets, desks, vitrines, and chests of drawers whose surfaces, as in architecture, appeared as dramatic and sculptural landscapes. Right angles were taboo, and factors such as adapting to material properties were deliberately ignored, as the sole emphasis was on form "brought to life" by artistic genius. This "supra-material" or "spiritual form" (Pavel Janák) was viewed as matter's outer shell. The Cubists wanted to lend their furniture an "unusually compact feel, full of tensions" resulting from the coexistence of technology and design—a quality which "purely constructive products could never display."[4] And indeed, the ambitious designs posed almost impossible challenges to the Prague Artistic Workshops (Pražské umělecké dílny, or P.U.D., founded 1912) when it came to manufacturing. In many cases, workarounds were required, using hollow frames instead of solid parts, to prevent items planned as movable furnishings from becoming immovable.

Cubist furniture had nothing to do with the production mechanisms of advanced industrial society. With very few exceptions—such as interior designs for the café at Prague's House of the Black Madonna (U Černé Matky Boží, 1912)—they were elaborately produced one-off pieces. First and foremost, they were meant to reflect the Cubists' theoretical program; material, construction, and function seemed irrelevant. In place of the industrially mass-produced product, the Cubists deliberately focused on the individually produced unique item, which thus took on the character of the authentic and non-reproducible. Their products certainly drew attention in an international context, for instance, at the exhibition of the German Werkbund in Cologne in 1914, where the Prague Artistic Workshops were given a separate room within the Austrian section. According to Peter Jessen, writing at the time, these were valuable works whose "surfaces and volumes seek beauty via sharp-edged outlines and daring angles." Whether this approach had a future, he remarked, remained to be seen.[5] A more euphoric reaction came from Czech art historian and cultural theorist V. V. Štech in a text written for the Werkbund exhibition. He praised the Cubists for their "subordination of matter to thought," and recognized every single piece of furniture as an "independent organism" in which the designers had dared to go "to the very limits of structural engineering" to achieve the most overwhelming "impression of three-dimensional contrast."[6] For Štech, the pieces of Cubist furniture were quite clearly artworks, results of the "inner development of a creative idea"; factors such as use value or manufacturability were of no interest to him. Correspondingly, he also described these works as "theoretical furniture."[7]

Less enthusiasm for Cubism was to be found among representatives of the New Objectivity in architecture, especially Karel Teige as the Czech avantgarde's leading theorist. He classified the works of the Cubists as "unreal aestheticism" and pure "formalism";

their endeavors in the field of applied arts he described as a "chaotic play of forms, applied to some arbitrary lamp, an unpractical cabinet, an unusable desk, or a chair one cannot sit on without the risk of toppling over, or a vase or trophy that fell over at the faintest touch." Instead, he wistfully recalled the "heavenly comforts of American office furniture, Pullman coaches, English club chairs and Prague Thonet chairs, whose praises have already been sung by Adolf Loos." Teige's polemic culminated in comments that the individual pieces were "more gravestones than cabinets or sideboards" and that Cubism in architecture and applied arts had "betrayed modern international civilization."[8]

Josef Gočár, Vitrine, 1912/13

Josef Gočár, Sofa, 1913

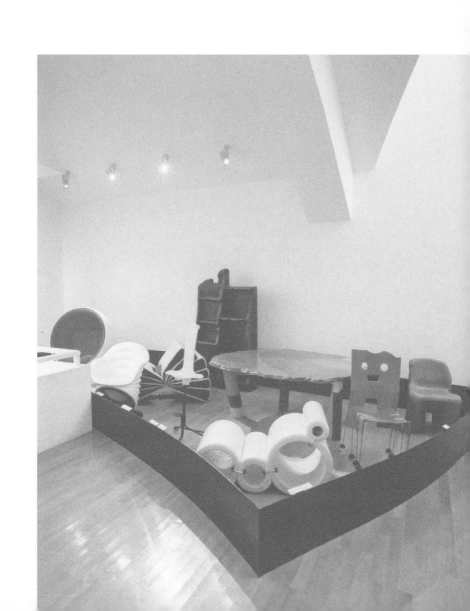

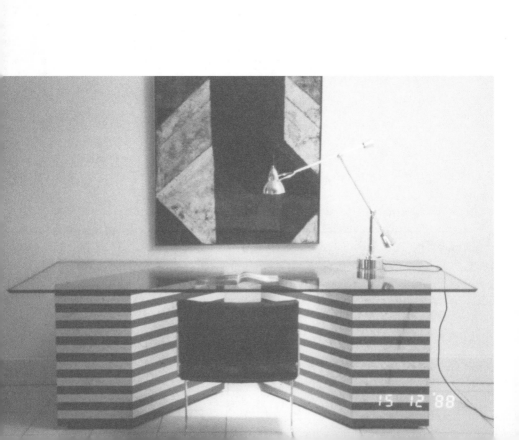

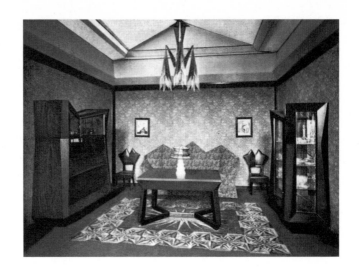

Josef Gočár and František Kysela,
Exhibition of German Werkbund,
Cologne, 1914

Distinction

London: tables, chairs, and fine food

A century after the Cubists' experiments in Central Europe, Merano-born and London-based Martino Gamper may not betray the achievements of modern civilization, but he does cultivate an unbiased and care-free approach to the products of (sometimes quite prominent) colleagues.[9] For example, in the project *100 Chairs in 100 Days* (2006–2007), for which Gamper—who visited both the University of Applied Arts and the Academy of Fine Arts in Vienna—collected old abandoned chairs, first on the street and then from friends' apartments, before dismantling them and using the components to make a new chair every day for one hundred days.[10] The results were first presented in an empty house in London—where they could of course be tested: "I think 'using' is quite important," says Gamper.[11] Which might seem surprising, as these are unique works created by the designer with his own hands. But they are defined by their creator himself as objects for practical use.

Which brings us to one of the central aspects of Gamper's work. His furniture is more than commercial design in the conventional sense. The aim of the *100 Chairs* project, for example, was to explore the character and mode of functioning of a chair and then to

transform it: "My intention is to investigate the potential for creating useful new designs by blending together stylistic or structural elements of existing chair types."[12] To an extent, then, these are three-dimensional collages of usage offering the viewer/user a broad spectrum of associations: thoughts on the original designers, on previous usage, on materials and manufacturing processes, but also on the cultural context in which they were created: "The stories behind the chairs are as important as their style or even their function."[13] They are objects which offer surplus value, which tell a story; not pushy and doctrinaire, but potentially evocable by those wishing to engage. Summing up, Gamper comments: "In essence, this exercise champions a certain elasticity of approach—both in terms of highlighting the importance of the sociological, personal, geographical, historical context of design, and in enabling the creative potential of elements of randomness and spontaneity to be brought to the fore."[14]

Martino Gamper, Arnold
Circus Stools, 2006

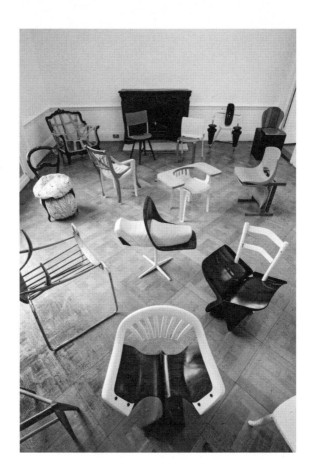

Martino Gamper, *100 Chairs in 100 Days,*
Installation view, Cromwell Palace,
London, 2007

The sociological context was also what prompted
the *Arnold Circus* project (2006). Here it was a matter
of regenerating and reclaiming public space. Over time,
Arnold Circus in London had become a kind of no-go
area, a square used by no one in the neighborhood.
Together with Gamper, dedicated local residents began
to organize picnics, concerts, gaming afternoons, and
other events. On these occasions, suitable furniture
was needed. The idea of using cheap, non-durable chairs
from large furniture companies was rejected and in-
stead, Gamper produced a mold for robust plastic stools,
which were subsequently produced in many different
colors and sold beyond the confines of the project. For
Gamper—who once worked as an industrial designer
in Milan—a crucial aspect of this project was the exis-

tence of an actual need: "It's quite important that there is a direct need, not some kind of market, where you have to create a need for it."[15] Moreover, the Arnold Circus stools have an additional value: turned upsidedown, they can be used as bins for rubbish.

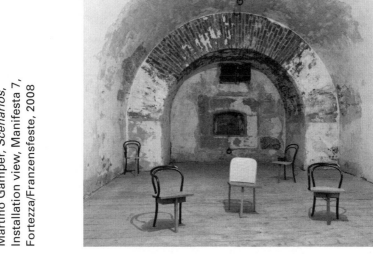

Seating was also the theme of Gamper's project for Manifesta 7 in Fortezza/Franzensfeste (2008). Gamper was supposed to supply chairs and benches for people watching video and sound installations. As most of the exhibition venues were in a fortress erected by the Habsburgs in the 1830s on the route of the Brenner Pass, he decided to use components of bentwood furniture and assemble them into new seating objects. In the first half of the nineteenth century, Michael Thonet began experimenting with bentwood techniques, going on in the second half of the century to became the first manufacturer to mass produce chairs and build up a worldwide distribution network. Austrian soldiers at the time could quite possibly have sat on just such chairs as they guarded the important Brenner road. Gamper was clearly interested in such a link between place and object, but rather than merely using historical models, he transformed them:

"So it was a bit of mixing the old Thonet chairs and some new elements."[16] Admittedly, the resulting chairs raised the question of whether they might in fact be art. Initially, their sculptural quality irritated viewers, but by appearing in such large numbers they soon turned viewers into users who sat on them and arranged them into groups. Incidentally, Gamper tracked down the components for these objects at the Mundus furniture factory in Varaždin (Croatia), which still produces bentwood items using traditional techniques.

No lesser figure than Gio Ponti was responsible for the raw materials out of which Gamper created new pieces of furniture as part of several performances in 2007—as at DesignMiami, Basel under the title *If Gio Only Knew.*[→ p. XXVIII] The materials in question had belonged to the interior of Hotel Parco dei Principi in Sorrento (1960/61) built by Ponti as an integrated creation: from the architecture to the selection of materials to the interior design. In these works, Gamper was interested in more or less reinventing the original pieces of furniture in the sense of second-hand objects; he gave them a new fate and a new task. The production process—shown by means of the performance—follows curiosity and spontaneity; in creative terms, the result is often shaped by chance: "The outcome is always unknown, the process is spontaneous and freewheeling and the result is a variety of objects, each with its own attitude, some functional, some pathetic, and some even beautiful."[17]

Gamper's projects *Trattoria* and *Total Trattoria*[18] are about more than just furniture objects. They are cooking events for friends and colleagues, held at a succession of venues including galleries, shops, studios, and museums, mostly serving menus that are unorthodox in composition but no less tasty for that. In many cases, the furniture used for these events is constructed spontaneously using whatever materials are to hand. For one Trattoria meal, he made the *Total Trattoria Off-Cut Table* (2008), a horseshoe-shaped ensemble of

thirteen individual tables of varying shape and size. The tabletops, each assembled differently, consist of three types of wood: teak from laboratory tables in English schools, oak from Scottish church pews, and poplar from the London Patent Office.

As Emily King has rightly observed, Martino Gamper makes "funny shaped furniture."[19] His work goes beyond what one usually thinks of as design. The pieces are three-dimensional objects, made for the most part using elements from existing items of furniture; recycling design, so to speak, but rather than taking on a new homogenous form, they are deliberately left with physical and semantically charged rough edges.

The way Gamper's furniture objects are crafted gives them a strong presence. They may be slightly disconcerting at first glance, but then—once their individual components have been identified—they reveal themselves as familiar items that invite usage. One soon begins to suspect that the creator of this furniture brings curiosity and imagination to his work, but also playfulness and humor, as well as a craftsman's skill. The work negotiates conventions and forms in order to produce something new that is design, but which by no means corresponds to our notions of a pioneering new creation. Here, other factors seem more important.

With his objects and actions, Gamper's primary concern is to highlight the relevance of sociological, historical, and personal context, using furniture that appears at first to be created spontaneously or even by chance as his vehicle for a critical questioning of established and authoritative notions of value, functionality, and form. In many cases, a specific context only comes into being as a result of the artist's own curiosity, through spontaneity, or due to strong need for social interaction. This is where design can then emerge—design which, unlike the usual mainstream productions, raises questions, acts as a motivating force, wants to move something, to bring change.

Martino Gamper, *Total Trattoria,*
Off-Cut Table, 2008

More than design

What links Czech Cubists like Gočár, Janák,
and Hofman with contemporary designers like Martino
Gamper is the will to create more than just commer-
cially viable objects for practical use. The positions of
these avant-garde designers reflect their inability to
identify with the established discipline, their discomfort
and discontent, and even their opposition to existing
conventions.

In their objects, clear legibility of function and
identifiability of production methods has been replaced
by other factors: out of what initially looks like a banal
piece of furniture they make an object with many and
varied messages, allusions, references. These may reach
back into the past, but also into the future; they may
operate within the discipline or allude to a specific as-
pect of life; they can critique their own discipline or
deliberately avoid being judged by existing criteria. Here,
design becomes *critical praxis* and can acquire the
character of a *work*.[20] A work of design, of course, and
not an artwork; although—or precisely because—it
has productively appropriated qualities, procedures,
and objectives from the neighboring discipline.

The production of anonymous and industrially manufactured mass commodities, for example, is strongly questioned and contrasted through individual creations that follow other mechanisms and laws. An obvious choice for the Czech Cubists would have been to fit out their buildings with the standard craft products of the time—designs in line with the dictates of construction, material, and utility, or the Thonet furniture then very widespread in Bohemia and Moravia. Instead, they favored a return to the ideal of applied art; the creation of items for practical use as unique, handcrafted pieces. Moreover, they revived something thought to have been banished for good by Art Déco— the tendency towards the *Gesamtkunstwerk*, as expressed in room-filling pieces by artists like Josef Hoffmann or Henry van de Velde. What initially manifested itself on a theoretical level was then presented to the interested public at the first exhibition by the Group of Creative Artists in January 1912 at the Municipal House in Prague: the aim was to exert a comprehensive shaping influence on all fields of both art and life. Paintings, sculptures, architecture models, pieces of furniture, objects of applied art, all embedded in a suitably Cubist exhibition architecture, were synthesized into an all-embracing visual experience. The design followed a concept all of its own, with references pointing not outwards but only to other objects and artworks in the show.

Unsurprisingly, these endeavors led to a dead end—at the very latest when, after World War I, the Cubists tried to expand their formal idiom to include motifs from Czech folk art and arrived at a new kind of "monumental decorative architecture" (Karel Teige). How much subsequent movements—at least implicitly and in spite of vehement denials—also indulged the idea of the *Gesamtkunstwerk* is a moot point.

In any case, such endeavors do not seem relevant to Martino Gamper. When he does exhibit his furniture creations, he does so in the form of installations,

spatially and temporally open environments with considerable semantic and symbolic potential. Looking at his always harmonious arrangements, one is almost reminded of Adolf Loos waxing lyrical about bourgeois homes circa 1800: "Back then, people furnished their houses as we clothe ourselves today. We buy our shoes from the shoemaker, coat, pants, and waistcoat from the tailor, collars and cuffs from the shirtmaker, hats from the hatter, and walking stick from the turner. None of them knows any of the others, and yet everything matches quite nicely."[21] In spite of their symbolic capital, Gamper's chairs and tables do not mutate into modern artworks which (usually) rule out ascribed purpose and intended use. They may resist a little at first ("At the same time, I wanted to play a bit with the question: Can you sit or can't you sit."[22]), but finally, they are made to be used. In decision-making processes of this kind (to sit or not to sit?), there is often a situational component: the specific setting on a given occasion can influence the direction taken. If we pursue this notion further, we arrive in general terms at a polyvalent, dynamic, ultimately situation-driven definition of design, which is crucial to many of Gamper's works. And often it is a specific constellation of social space or a deliberate disturbance of everyday routine that shapes the design. Producing for a merely potential audience, focused by a marketing or trendsetting department, is something Gamper avoids on the basis of his own experience: "I wanted to work on a level that I could control much more—I mean, control the situation, control the experience, control the outcome process."[23]

Furthermore, both the Cubists and Gamper seem to pass over all the elements by which the quality and value of *Gute Form* are usually measured. Functionality—in the sense of optimal fulfillment of purpose—was the exact opposite of what the Cubists were aiming for; instead, they created objects whose practical function was just one function among many.

Gamper's work aims in a similar direction, offering a wide range of functions that go beyond object-based functionality and are only rendered concrete by the subject viewing or using them. As a result, his furniture achieves a concentrated force of expression with referential potential on various levels that can be activated in individual ways.

Finally, his works can also be read as constructive comments on his own discipline—on the issue of comfort, for example, which usually ranks top of the canonical list of functions required of design. Comfort may actually be the yardstick of good design; the usefulness of a chair, for example, depends on it. What good is an armchair, however functional, elegant, and timely its design and use of material, if it is uncomfortable, if settling down in it with an interesting book becomes physical torture after just a few minutes? Bruno Munari has alluded to this in humorous form. And Martino Gamper takes a similar approach. With his collaged, multi-referential chairs, he raises questions that are often neglected in everyday life. What constitutes "comfortableness"? Which materials does it call for? Is a chair I find comfortable automatically comfort-

able for you? Which have been or are the most comfortable pieces of furniture to sit on? Does a chair even have to be comfortable? Is "comfortableness" not often sacrificed to design factors? This last question is especially relevant to the Cubists in Prague. But one might also recall Le Corbusier's love of bentwood chairs, which appear again and again in his interiors. This seems to be a case of programmatic considerations taking preference over *commodité*, as no lesser figure than Adolf Loos, dedicated to bentwood furniture at least since his interior for the Café Museum (1899), appreciated his colleague's preference, but also pointed out that he had unfortunately chosen precisely the most uncomfortable models.[24] This shows that although the anonymous process of optimizing industrially manufactured objects for practical use can lead to a high degree of standardization and formal perfection in the sense of the *objet-type* favored by Le Corbusier at the time, it by no means guarantees comfort and "comfortableness." Whether or not Martino Gamper is familiar with this anecdote, he certainly calls it to mind for those who once knew it but have forgotten. The more likely reason for Gamper to bring bentwood furniture into play is its status as the epitome of an anonymous, mass-produced industrial product. And with his mix-and-match bentwood quotations, the designer also seems to be humorously caricaturing the fact that a transport crate with less than a cubic meter capacity can hold 36 Thonet chairs, in pieces, for reassembly on delivery.

Although later criticisms of Cubism may be partly accurate, it was able, before the triumphant rise of the Bauhaus and *Gute Form*, to articulate major shortcomings of functional design. Specifically the fact that a designed object—be it a house, a piece of furniture, or a tea service—must offer more than pure utility, correct use of material, and commercial viability. Optimization based on these criteria alone leads to the feeling of alienation from the design process registered

by today's designers. Assuming, of course, that they reflect on what they are doing and share the view of Jasper Morrison that their task "as designers is to concern themselves with the manmade environment and make it better."[25] The work of designers like Martino Gamper precisely reflects such an attitude, based on an understanding of design as critical praxis.

1 A good overview is offered by: Jiří Švestka, Tomáš Vlček (eds.), *1909–1925 Kubismus in Prag. Malerei, Skulptur, Kunstgewerbe, Architektur*, exhibition catalog, Kunstverein für die Rheinlande und Westfalen, Düsseldorf, Stuttgart 1991; Alexander von Vegesack (ed.), *Tschechischer Kubismus, Architektur und Design, 1910–1925*, exhibition catalog, Uměleckoprůmyslové muzeum v Praze, Vitra Design Museum (Weil am Rhein 1991).

2 See for example: Pavel Janák, "Hranol a pyramida" (Prism and Pyramid), in: *Umělecký měsíčník*, Vol. 1, 1911–1912, pp. 162-170.

3 See Olga Herbenová, "Das tschechische kubistische Möbel," in: Švestka, Vlček, *1909–1925 Kubismus in Prag*, op. cit., pp. 260-283.

4 Pavel Janák, "O nábytku a jiném" (On Furniture and Other Things), in: Umělecký měsíčník, Vol. 2, 1912–1913, pp. 21-29.

5 Peter Jessen, "Die Deutsche Werkbund-Ausstellung Köln 1914," in: *Jahrbuch des Deutschen Werkbundes*, Vol. 4, 1915 (*Die Deutsche Form im Kriegsjahr. Die Ausstellung Köln 1914*), p. 10.

6 V.V. Štech, "Čechische Bestrebungen um ein modernes Interieur," 1914, quoted from: Švestka, Vlček, *1909–1925 Kubismus in Prag*, op. cit., pp. 447-449.

7 Ibid.

8 Karel Teige, *Moderní architektura v Československu* (Modern Architecture in Czechoslovakia) (Prague 1930), pp. 100-105.

9 Much information is available on Gamper's homepage: http://www.gampermartino.com/; see also the publications: Martino Gamper, *What Martino Gamper did between two-thousand and two-thousand&four* (London 2004); and *Piccolo Volume II* (London 2009).

10 See Martino Gamper, *100 Chairs in 100 Days in 100 Ways* (London 2007).

11 Interview by Tido von Oppeln and Burkhard Meltzer with Martino Gamper on May 21, 2009, in London, see pp. 39-41 in the present volume.

12 Interview by Christian Brändle with Martino Gamper ("Martino Gamper," in: Katya García-Antón, Emily King, Christian Brändle (eds.), *Wouldn't it be nice... wishful thinking in art and design*, exhibition catalog, Centre d'Art Contemporain Genève, Geneva – Museum für Gestaltung, Zurich 2007, pp. 210-212).

13 Ibid.

14 Ibid.

15 Interview with von Oppeln, Meltzer, op. cit.

16 Ibid.

17 Interview with Brändle, op. cit.

18 See Trattoria Team (eds.), *Total Trattoria* (London 2008).

19 http://www.gampermartino.com/about/, visited March 12, 2011.

20 On this subject, see the essay by Tido von Oppeln, pp. 16-31 in this volume.
21 Adolf Loos, "Intérieurs," in: *Neue Freie Presse*, June 5, 1898. Printed in: Adolf Loos, *Ins Leere gesprochen. 1897–1900* (Paris 1921). Reprint, ed. by Adolf Opel (Vienna 1981), pp. 68-74; 68.
22 Interview von Oppeln, Meltzer, op. cit.
23 Ibid.
24 Adolf Loos, "Josef Veillich," in: *Frankfurter Zeitung*, 21.3.1929. Printed in: Adolf Loos, *Trotzdem. 1900–1930* (Innsbruck 1931), reprint, ed. by Adolf Opel (Vienna 1982), pp. 213-218.
25 Quoted from Markus Brüderlin (ed.), *Interieur/Exterieur. Wohnen in der Kunst* (Ostfildern 2008), p. 224.

Good Design vs. Minimal Art

Ever since industrial design emerged as a discipline in the nineteenth century, artistic engagement with its aesthetic has provoked heated debate over dividing lines and common ground. In the art of the twentieth century, far from playing a minor role, industrially manufactured and designed objects repeatedly raised fundamental questions on the place of art and its re-presentations within society and the economy. In the name of art criticism, institutional critique, and a critique of the avant-garde, the second half of the twentieth century witnessed many ideological battles over the territory of design—a domain where ties between the spaces where people live, the industrial economy, and creativity are particularly close.

To show what art is not, references were made to design, and vice versa. The Minimal Art of the 1960s was criticized by Clement Greenberg in the following terms, referring back to the notorious "Good Design" exhibition series organized by the Museum of Modern

Art between 1950 and 1955: "Behind the expected, self-canceling emblems of the furthest-out, almost every work of Minimal Art I have seen reveals in experience a more or less conventional sensibility. [...] I find myself back in the realm of Good Design, where Pop, Op, and Assemblage, and the rest of Novelty Art live."[1]

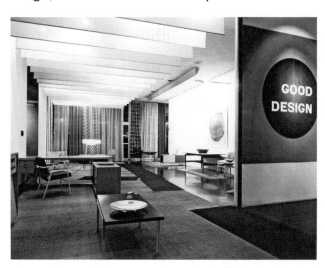

Exhibition view, Good Design, Museum of Modern Art, New York, 1951

The response from the artists' camp came immediately, hitting back harder still at the critic. From 1968, Donald Judd regularly organized presentations in his own private space that featured both sculptures and furniture, and in a laconically titled article in *Studio International* magazine,[2] he accused Greenberg of no longer being able to perceive individual artistic qualities beyond media-compatible group labels like "Minimal Art." Moreover, in the 1970s Judd actually began producing and selling tables, chairs, and shelves. The atmosphere of his converted loft combined the distancing qualities of a modern white cube with the personal dimension of the furniture he made himself. He took the accusation of producing Good Design and turned it into a spatial situation straddling the border between his work in the fields of art and design, referring to the conventions of presenting industrial design as a commodity, to its function as representative dis-

play in the bourgeois household, and to the white cube standard of modern art—using design to further develop a definition of the artwork that was already "fraying" on all sides. The result was an installation that must have come fairly close to the atmosphere of today's "Concept Stores." Judd by no means resolved the potential conflicts between furniture and art object, the roles of host and guest, or the conventions of using and beholding, nor did he reconcile all this with his position as an artist. On the contrary, while maintaining the distinction between the design and art contexts within his production, Judd exacerbated the associated problems by staging exhibitions in the domestic environment of his loft.

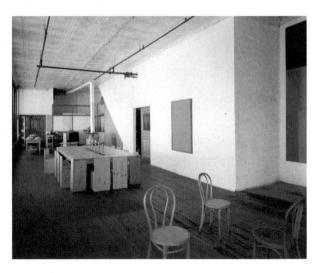

Donald Judd, Loft, 101 Spring Street, New York, 1970s–1990s

In this critical judgment that banishes Minimal Art to the realm of Good Design, the role of industrial design with regard to art is assessed in two ways:

1. Good Design is clearly acknowledged by Greenberg as a cultural discipline in its own right, as distinct from the usual anonymous mass production of commodities.
2. Good Design acts as a critical anti-image to the art favored by Greenberg.

As a result, in the face of a crisis surrounding definitions, over subsequent decades, of what constitutes art, Good Design has become a category frequently used as an example in critical diagnoses of what is not art. At first glance, this may appear simply as a disparaging polemic against the dominant commodity culture increasingly found in the artworks of the Minimal and Pop Art of the 1960s. But when Greenberg spoke of Good Design, he was referring to a museum category that was acknowledged at the time, at least in the United States. In spite of its negative role in the critic's judgment, the term also resounds with the appreciation already attained by non-anonymous design as a cultural field in the first half of the twentieth century. As early as the 1950s, well-designed living served as a consumer model in which artistic and industrial progress were to be united as Good Design.

Signs of dissolution

However little this paragon of postwar modernism is the subject of serious debate today, the concept of Good Design has established itself as aesthetic surplus value in contrast to mere utility value. In the 1950s, before the major crisis in the 1960s of traditional definitions of the artwork, the United States saw the emergence of a discipline of design that was adopted as a self-critical instance—although initially as a polemic defensive reaction. In recent decades, thanks to exhibitions, media coverage, and self-referential discourse, non-anonymous design went from being an anti-image to a counterpart sharing common ground—a terrain associated with many artworks as a topic of discussion, source of material, or point of reference. The fact that Greenberg's defensive stance has now given way to a curious and often even optimistic outlook with regard to design is due primarily to a much expanded definition of design and to ongoing negotiations concerning the borders between disciplines.

Design, a concept used from the end of the nineteenth century mainly for industrially produced items, no longer refers primarily to a specific category of objects, but also to media user interfaces, aesthetic experiences, and spatial environments. While a recent manifesto of *Critical Design*[3] attempts to establish "inbuilt" self-critical moments in design, the concept of *DesignArt* situates works in a sphere between design and art. First coined by artists Joe Scanlan and Neal Jackson,[4] the term was later used by British art critic Alex Coles in his 2005 book of the same name to describe phenomena in the art context featuring explicit references to design.[5] At the same time, limited editions or one-off pieces produced for exhibitions at design galleries and museums are also referred to colloquially by many design critics as *DesignArt*. There is no doubt that the contexts of art and design have come very close, especially with the installation having become the dominant exhibition format. In both design and art, experiencing the exhibition format in aesthetic terms is not only possible, but actually common practice. Even if I encounter similar formats, however, the contexts are by no means interchangeable.

The processes of rapprochement between design and art concern specific themes and presentation formats addressed within each field, but not necessarily these fields themselves. Nonetheless, whether or not these two fields will continue to exist within their current boundaries, in spite of or precisely due to all the self-reflexive efforts of those involved, is a question each critique must answer afresh. For Zurich-based art and architecture historian Philip Ursprung, the discipline of design will soon become a higher-order category for all creative disciplines, as design moves from a culture of shaping products towards a comprehensive economic and social model for society: "In this light, the question is less whether art, architecture, and design will merge, and more whether [...] art and architecture will be absorbed into design."[6]

Does this mean we are about to witness the dissolution of these former antagonists, and thus of the critical role of each field for the other? Although such a development is possible, it seems rather unlikely in the light of statements made by artists and designers themselves (see interviews in this book), all of which point to a stronger self-reflexive separation between the two disciplines. Manifestos like the *Critical Design FAQ* provide further evidence of this. It is true, however, that any kind of self-reflexive questioning and criticism may ultimately jeopardize the right to exist of who- or whatever is being questioned.

Let us turn our attention back to the period of Greenberg's critique: At the beginning of *Aesthetic Theory*, Adorno reminds those in the culture industry what has been jeopardized by permanently expanding the definition of art: "It is self-evident that nothing concerning art is self-evident any more [...], not even its right to exist."[7] Of course, the expansion of the definition of art in the 1960s cannot be directly compared with the current situation of design, which appears far more comprehensive and touches, as Ursprung points out, on almost all areas of life. So far, however, the "threats" to and expansions of what is considered art (for example, in the 1960s with Pop and Minimal Art) have not caused the field of art to dissolve into Good Design or pop culture. On the contrary: thanks to permanent dialog with industrial design, new spaces, themes, and formats for art have been opened up.

Design as artistic (self-)critique of the present: Martin Boyce

It would seem, in the context of a study of the role of design in art's self-criticism, to make little sense to invent further portmanteau concepts à la Art+Design= DesignArt, nor to speculate on the unlikely absorption of one discipline by the other. In spite of everything, Greenberg's verdict from the 1960s is still alive and well in today's discussions, as indicated, for example, by

the approving description of a particular set of artworks as "design in reverse."[8]

As his contribution to a group exhibition in 2004, Scottish artist Martin Boyce showed an installation with fragmentary icons of Good Design, interpreted by the show's curator Will Bradley as its exact opposite. The installation included an *Eames Storage Unit* recreated by Boyce and a wooden mask.[—> p. I] But this was not a perfect replica of the well-known piece of furniture included by the Museum of Modern Art in its "Good Design" exhibition series. Instead, Boyce built a version of the shelving unit whose dimensions correspond to the original, but which does not shine in the original's cheerful primary colors. On the contrary, from a distance the object looks like a clearly structured but overly cool architectural model. In this work, Boyce alludes to the hidden paranoia of Good Design and modern architecture, to their "dark quality," as discussed by writers like Mike Davis (*City of Quartz*) or in the novels of Bret Easton Ellis. With his different versions of the *Storage Unit* (1997–2004), initially constructed from memory on a slightly altered scale, Boyce transfers the design of postwar modernism, now enshrined in the museum, into a different design genre, which he dubs "noir moderne."[9] Although the foreground appears more playful than the cold shelving unit, the scene creates a somewhat damaged impression: roughly dismantled parts of Arne Jacobsen chairs hang from the ceiling, attached to a mobile.

Of course, one can follow Bradley in reading this as a simple reversal of the functional-optimistic furniture design of postwar modernism: things here are not functioning (any more) in accordance with the program of Good Design on which they are based. But Boyce's work knowingly refers to the symbolic value of these items of furniture, which in cultural terms are already established as works in their own right. The artist uses elements of modernist sculpture and architecture to comment on the attribution of new value to design by

the museum. This may result in their functionality being interrupted, but their programmatic content is not turned into its exact opposite. So does this interruption of the functional promise simply mean a critique of design? Or does this critical procedure also address the program of art, in whose context the work in question takes place? On one level, the work is an updated critical "status report" on America's cheerful postwar modernism which in cities like Los Angeles also produced unwelcoming facades and gated communities. But Boyce's design fragments are also a critical take on the organization of space, as well as asserting the possibility of appropriating objects by other artists that have already been inducted into the museum.

Martin Boyce, *Now I've Got Worry (Storage Unit)*, 1997

From criticism to self-criticism

In contrast to the binary model of Greenberg's über-critique—which, from an essentially outside position, identified good and bad, true and false, what I see today is a situation in which every institution already possesses a built-in criticism option. At this moment, another newsletter from an art institution explaining its critical position is probably waiting in my email inbox. Following on from the investigative journalism of 1970s Institutional Critique, which made visible the hidden mechanisms of the art business,

artists today use these mechanisms not only in opposition to the institutions, but also in complicity with them.[10] According to Helmut Draxler, design actually played a constitutive role in the artistic praxis of Institutional Critique.[11]

Martin Boyce, *Undead Dreams*, Installation view, Roma Roma Roma, Rome, 2003

Where I credit certain works with critical potential, I am referring to visible criteria that enable a differentiation within aesthetic experience between various contexts (art/design) and artistic strategies (appropriation/reconstruction/damage). In Boyce's work, the Greenbergian anti-image of Good Design is still on show—if in a damaged state. For this kind of self-reflexive critique I would like to use the no longer fashionable concept of self-criticism, as defined by Peter Bürger in his *Theory of the Avant-Garde*.[12] In his view, the historical avant-garde movements of the early twentieth century were a self-criticism of art in bourgeois society in Marxist terms. He interprets their "avant-garde protest" as an attempt to transfer a praxis of life into art that reveals the link between the nineteenth-century concept of art's autonomy within bourgeois society and its lack of impact on that society.[13] Rather than integra-

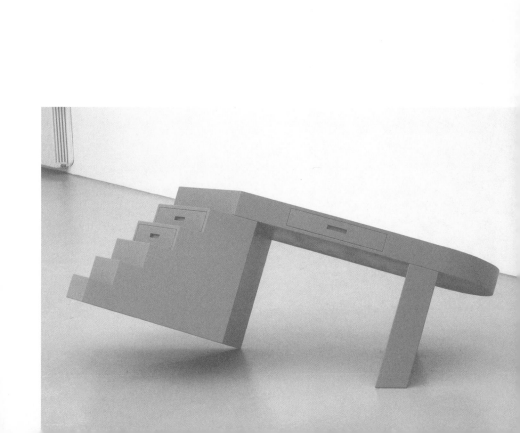

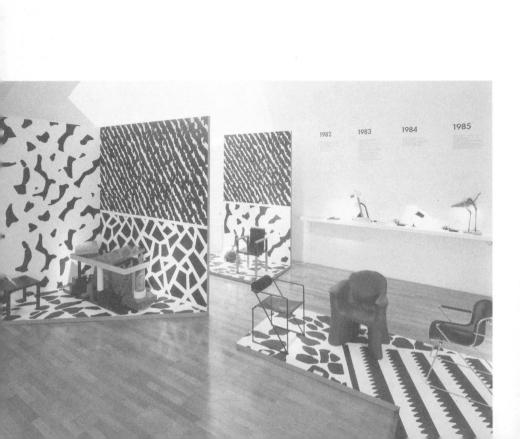

ting art into bourgeois everyday life, however, the artistic avant-gardes wished to bring forth a new praxis of life. For Bürger, however, Pop Art, Happenings, and other art forms in the expanded field of the 1960s represent a failure to integrate life praxis into art, which continues to be "divorced from reality." A self-critical analysis, focusing less on changing life praxis by means of art and more, in the true sense of the word, on changes in the field of art itself, would doubtless have come to an entirely different conclusion. And from today's point of view, it seems questionable to present an objective formulated by proxy for the members of historical avant-gardes as a binding goal for the artistic currents of the 1960s.

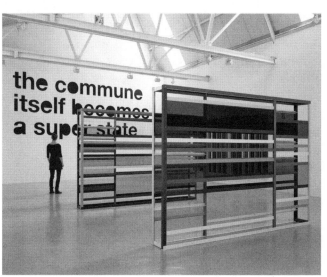

Distinction

Liam Gillick, *The Commune Itself Becomes a Super State*, Exhibition view, Corvi Mora, London, 2007

Looking at the relationship between avant-garde movements in art and the historical development of design—as an exemplary site of exchange between art and life praxis—one can describe the impact on the field of art, even as early as the 1960s, as very far-reaching. For all the resentment and ignorance with which they were expressed, historical assessments of the influence of design do point (especially if one recalls Judd's "reply") to the importance already

accorded at the time to this terrain from whose influ-
ence Greenberg and Bürger wished to protect art
and the avant-garde.

What I mean by self-criticism here is neither
an inbuilt stance in the sense of self-censorship, nor a
binary opposition of the kind Bürger uses with regard
to the historical avant-gardes and Pop Art (art versus
life praxis). Instead, the concept recognizes the self's
position as being limited by and involved in life praxis,
at the same time as articulating the goal of critically
rendering differences visible. Compared with the
currently very popular concept of "criticality," pro-
posed by Irit Rogoff instead of the historical terms
"criticism" and "critique" to denote the involved state
of the critical,[14] "self-criticism" refers more clearly
to the critic's point of view and to the embeddedness
of the object of criticism within a system of self-
reflexive meanings and conventions.

Structures of difference: Liam Gillick

Critical distinctions are far more difficult to make
in the case of works that no longer show individual
objects, references, or production methods, offering
instead a structure that permeates all possible areas
of an art audience. In 2000, Liam Gillick—discussed by
Alex Coles as a prime example of the *DesignArt*
merger—greeted visitors to Stockholm's Moderna
Museet with a large-scale architectural installation made
of materials that recalled trade fairs and shopping
malls. The other works in the group show *What If: Art
on the Verge of Architecture and Design* were struc-
tured by his grid of multicolored Plexiglas. In Gillick's
work, individual points of reference or traces of the
manufacturing process can no longer be identified. But
in his many writings, interviews, and other statements
carried by the media, the artist does reveal numerous
sources to which his work is anchored. At first glance,
his exhibition architecture generates the kind of con-
sumerist "ambience" so critically analyzed by Stefan

Römer as a parallel to the privatized shopping furniture in public spaces in the 1990s.[15] Does this mean we are encountering art that has become an integral part of a design atmosphere, as predicted by Philip Ursprung? And does this artistic praxis thus mean the end of design's role as a channel of self-criticism for art? Although this may initially appear to be the case, Gillick is actually more the opposite. Although the artist borrows his material idiom entirely from today's trade fair design, he does not make the art exhibition space or the conventions of that space totally disappear.

Liam Gillick, *Suspended Discussion*, 2007

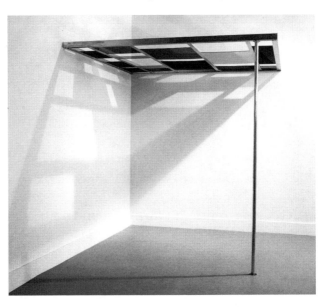

This is especially clear if one compares his work to the total design installations of the 1990s that transformed art spaces into functional everyday settings. In Douglas Gordon's reading room, Jorge Pardo's café, or Rirkrit Tiravanija's canteen, the design of items of furniture often explicitly appealed to viewers to participate in the exhibitions. In contrast to Pardo or Tiravanija, Gillick's installations do not stage experiences of audience participation in the art space, even if the titles of his works sometimes point to the possibility of doing something. In recent years, he has made

several pieces of "discussion furniture": one table was billed as a *Multiplied Discussion Structure* (2007), and a year later he made a shelf-like construction, which he placed in the audience's way as *Suspended Discussion*.

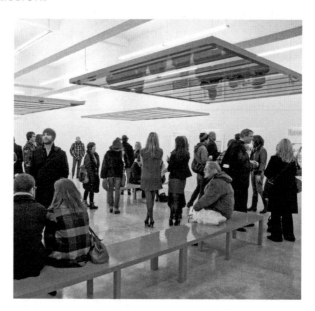

Liam Gillick, *Discussion Bench Platforms*, Exhibition view, Casey Kaplan, New York, 2010

Although furniture and architecture form a total exhibition design, it only makes a vague allusion to potential usage: who actually participates in the discussion mentioned in the title? And do Gillick's structures actually facilitate anything? It could be that no one participates, and that nothing takes place. Whereas in works by Gordon, Pardo, and Tiravanija, the audience members actually consume publications, food, or drinks, Gillick's exhibitions remain a kind of shell, a package with elaborately materialized announcements made of semi-transparent plastic panels, coated aluminum, and large-format wall texts. Precisely because Gillick's works exhaust themselves, neither providing a service to the audience, nor in the design of the inviting object, they insist on a critical distinction between the two disciplines: one might speak here of structures of difference. "In common with many people of my genera-

tion I embraced certain aspects of design as part of a critique of established terms of judgement within the art context,"[16] Gillick wrote in 2002. According to this statement, aspects of design play a critical role on the stage of art by becoming part of an artistic critique of specific conventions of exhibiting and judging art.

Self-critical conflicts

Although Gillick and Boyce approach design in very different ways, they do refer to certain common themes: the atmospheres of (semi-)public spaces, the material aesthetic of "user interfaces," the modernist design enshrined in museums. And with their parallel further development of the installation, the two disciplines have pursued a presentation format that reflects an expanded concept of what constitutes a work in art and the emergence of such a concept in design.[17] Entirely in the spirit of Judd's loft presentation, contemporary art, too, often creates exhibition situations that aggravate conflicts between the conventions of the disciplines, but without causing them to dissolve one way or the other. That contemporary artists whose work draws strongly on design do not cross the borders of their discipline, in spite of predictions by theorists and curators that the two will merge, is certainly no coincidence—as this would result in a sudden dissolution of the object of criticism. The fragmentary inclusion of materials and references from design creates conflicts in art which, within the model character of an exhibition, enable a critical discourse on economic and social factors.

Over the past decade, writers have been searching for the right term to reflect the altered relationship between the disciplines and their potential (*DesignArt, Critical Design* etc.). Finally, however, such attempts to work on a merging of art and design, at least on a linguistic level, lacks any basis in the self-image and praxis of artists and designers. Moreover, I have the impression that for all their positive rhetoric,

these neologisms perpetuate the logic of the Greenberg era, implying that art that engages with design really belongs to a different discipline. Creating a "new discipline" is a way of casually dispensing with all the problems that might arise from a self-critical examination of the disciplines of art and design. But such an approach based on threats and incentives, of inclusion or exclusion from the discipline, is unlikely to be fruitful. If, on the other hand, the past and present differences between the two disciplines are dealt with in the mode of a "self-criticism," then theory and criticism might finally be able to work on the problems already rendered productive by the reception of design in art since the nineteenth century.

1 Clement Greenberg, "Recentness of Sculpture," (1967), in Gregory Battcock (ed.), *Minimal Art, A Critical Anthology* (Berkeley/London 1995), p.184.

2 Donald Judd, "Complaints: Part I," in: *Studio International, an illustrated magazine of fine and applied arts*, London, April 1969, quoted from: Donald Judd, *Complete writings 1959–1975* (Halifax 2005), pp.197-199.

3 Anthony Dunne and Fiona Raby, "Critical Design FAQ," (2007), developed for the exhibition *Designing Critical Design* at Z33 house for contemporary art, Belgium. http://www.dunneandraby.co.uk/content/bydandr/13/0, visited January 13, 2011.

4 Joe Scanlan and Neal Jackson, "Please, Eat the Daisies," in *Art Issues 66*, Los Angeles, January 26, 2001.

5 Alex Coles, *DesignArt* (London 2005).

6 Philip Ursprung, "Disziplinierung: Absorbiert das Design die Kunst?", in: Gerald Bast; Krüger & Pardeller; Pessler, Monika (eds.), *Das Phänomen Raum in Kunst, Architektur und Design* (Vienna 2009), pp. 144-148.

7 Theodor W. Adorno: *Aesthetic Theory* (1970) (London 2004), p. 1.

8 Will Bradley: "Design in Reverse – Martin Boyce," in: Ingvild Goetz; Rainald Schumacher (eds.), *Sculptural Sphere* (Ostfildern 2004), pp. 59-64.

9 See Burkhard Meltzer interview with Martin Boyce, p. 68 in this volume.

10 Barbara Steiner: "Corruption, Corruptibility and Complicity," in: Monika Szewczyk (ed.), *Meaning Liam Gillick* (Cambridge MA 2009), p. 78.

11 Helmut Draxler, "Loos Lassen! Institutional Critique und Design," in: *Texte zur Kunst*, issue 59, Berlin 2005, p. 66.

12 Peter Bürger, *Theory of the Avant-Garde* (1974) (Manchester 1984).

13 Ibid., p. 22.

14 Irit Rogoff, "What is a Theorist?" http://www.kein.org/node/62 (2006), visited January 13, 2011.

15 Stefan Römer: "Eine Kartographie – vom Whitecube zum Ambient," in: Christian Kravagna, *Das Museum als Arena - institutionskritische Texte von KünstlerInnen* (Cologne 2001), pp. 155-162, (originally delivered as a lecture in 1997).

16 Liam Gillick: "The Semiotics of the Built World," in: Monika Szewczyk (ed.), *Liam Gillick, The Woodway* (London 2002), p. 81.

17 See Tido von Oppeln's essay "For a concept of the autonomous work in design," pp. 16-31 in this volume.

In the past two decades, design has come to serve as the master discipline of contemporary culture, of the culturalized economy. Buildings, phones, apps for phones, lifestyles, identity: everything is seen as being subject to design. In art, the 1990s saw the emergence of a "relational" art that recast composition as design, or meta-design, the furniture installations of Jorge Pardo and Tobias Rehberger, and Liam Gillick's slick quasi-minimalist structures being relevant examples. This is the context in which Barbara Visser made her photographic series *Detitled* (2000), which consists of more or less classic designer chairs and couches in some form of disarray—missing one or more legs, melted, or with ripped upholstery. One of the photographs shows the Eames lounge chair in a neutral, white environment, pathetically broken. There is a separate image of the matching ottoman in a similar state.

There is something pathetically comical about seeing the epitome of a certain kind of functional,

managerial luxuriousness in this state. Obviously, the sign value and exchange value of the lounge chair are not substantially altered by one artistic intervention, but Visser's—literally—broken allegory suggests that we should go beyond the normalized consumption of stylish signs for functionality. Visser's apparent destruction of use value points beyond much of the aforementioned DesignArt, which often milked stylistic signifiers for their obvious retro associations. Visser's broken chair suggests that the meaning of design does not lie in such retro chic, but in the exploration of alternative uses, of possible or impossible functions. These functions may themselves be seen as interventions in the life of the object, an object that can be seen as a graph, as a trajectory in a network.

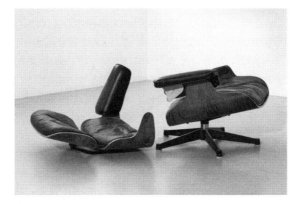

Barbara Visser, From the *Detitled* Series, 2000

David Joselit has contrasted the commodity, an "objectified figure of desire" that forms the "paradigm of the consumer society," with the network as the

"paradigm of the information society." Joselit characterizes this network as "an ever-expanding web of data resurfacing the globe," and analyzes the TV set as the "point of contact between networks and commodities" where "things expand into information as information contracts into things."[1] This account needs two qualifications. Firstly, the "objectified figure of desire" is itself part of a semiotic system, a system of objects-as-signs. Secondly, if we contrast this *system* —this codified world of sign design—with networks that are not necessarily transparent to the gaze, these networks should not be imaged as being exclusively composed of dematerialized data.

There are informational and social networks, but also those of goods, of tangible commodities circling the globe. All these networks not only condition design, but are also potentially subject to design. If one is interested in redefining design, in going beyond *design as sign design*, a number of artworks that seemingly have nothing to do with design can be more productive than the stylish ensembles of Pardo or Rehberger. In such works the object is treated as a factor and potential intervention in economic and social networks, not merely as an objectified figure in a system of signs.

From Designed Objecthood to an Art of Thingness

With its canny combinations of elements from modern design and abstract art, the art of the 1990s excavated a fundamental ambiguity of Modernism, which glorified the purity and autonomy of art while at the same time collapsing the boundaries between streamlined art and slick design. Against this erosion of difference, Barnett Newman, for one, maintained that "[the] God image, not pottery, was the first manual act."[2] His claims for a lofty art of sublime symbols was threatened by a variety of interwoven practices, all centering around the status of the object, and all calling into question the distinction between art objects and

other—particularly industrial—objects. Newman argued that Duchamp's readymades had helped to create a situation in which museums "show screwdrivers and automobiles and paintings" without making a fundamental distinction between them. Duchamp's readymades and the designs of "Bauhaus screwdriver designers" both claimed to be art, and they were thus two manifestations of the same fundamental problem.[3]

In the 1940s, Clement Greenberg described a loose group of American artists that included Newman and Mark Rothko as a "new indigenous school of symbolism."[4] Newman is at the end of a romantic tradition that attempts to counter the confusion of modernity by seeking salvation in the sensuous revelation of truth in visual symbols—symbols that are themselves confused, but in the positive sense of being mysterious and thus distinct from the profane banality of modern media.[5] However, in spite of efforts by various symbolist and abstract artists, the twentieth century saw the definitive demise of the dream of the symbol as an anti-idol, an instantaneous form of sensuous knowledge. As Adorno put it, "Art absorbs symbols by no longer having them symbolize anything [...]. Modernity's ciphers and characters are signs that have forgotten themselves and become absolute."[6] This development can already be seen in Newman's work, in which the relation between titles such as *Vir Heroicus Sublimis* and Newman's idiom of color planes and "zips" is so opaque that the forms are often experienced as meaningless.[7]

In the 1960s younger artists such as Frank Stella would distance themselves from all symbolic pretentions. Stella permutated forms in a more systematic manner than Newman ever did, systematically working through formal options in one series after another. Leo Steinberg noted the collusion of such art with the rigidity of corporate innovation when he observed "how often recent American painting is defined and described almost exclusively in terms of internal

problem-solving. [...] The dominant formalist critics today tend to treat modern painting as an evolving technology wherein at any moment specific tasks require solution—tasks set for the artists as tasks are set for researchers in the big corporations."[8] The results also looked corporate—serially executed in industrial paint, with compositions that recalled nothing so much as post-war logotypes, which are equally centralized and geometric. The logo suggests that it is the apparition of a transcendental logos or idea, but in contrast to the romantic/modernist symbol it is patently arbitrary and differential. Rather than emanating from transcendental ideas, it is generated through the interplay of signifiers. We are thus dealing with a code of *desymbolized signs*; we are moving from romantic symbol theory into semiotics, and into the applied semiotics that is design.

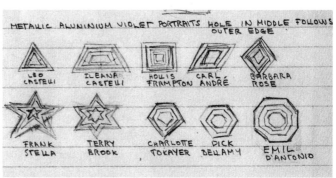

Frank Stella, Sketch for *Purple Paintings*, Detail, 1961

Caroline A. Jones, who compared Stella's *Sidney Guberman* (1963) to the 1960 logo for the Chase Manhattan Bank, noted that in the post-war years corporate logotypes were increasingly simplified, moving "away from narrative and toward iconicity," so as to "form a visual imprint, as if branded on the retina."[9] But Stella's paintings are bulky logotypes, hanging on the wall like quasi-reliefs. This made Stella a crucial pawn in the 1960s battles over objecthood, in which the work of art was either contrasted with or assimilated to "regular" objects. While Donald Judd saw a logical progression

from Stella's works to the "specific objects" of Minimalism, Michael Fried sought to inscribe Stella in a history of modernist painting that refused to allow paintings to slide into objecthood, into mundane presence.[10] Clement Greenberg, who contrary to Fried was not convinced that Stella's work pulled off the feat of repelling objecthood by absorbing some of its characteristics, once described the threat posed to modernist painting in these terms: the painting, reduced to its bare essentials, to bare canvas, risked becoming an arbitrary object just like a table, a chair, or a sheet of paper.[11] But in the age of hyper-designed Bauhaus screwdrivers, which object can still be termed arbitrary?

In the late 1940s, Greenberg had written about the period style constituted by modernist art, design, and architecture. Taking his cues from the Museum of Modern Art's emphasis on the aesthetic aspects of "International Style" design, Greenberg effectively acknowledged the sign value of design by privileging stylistic over functionalist concerns.[12] The developments that led Fried and Greenberg to perceive "objecthood" and "arbitrary objects" as a threat can be placed in several overlapping genealogies; the Cagean aesthetic was an important factor for many practitioners of neo-Dada art, while phenomenological approaches came to dominate US discourse on Minimalism. What was rarely articulated at the time was that the new objecthood in art occurred *under the sign of design*—specifically, of design as sign design. In the late 1960s and early 1970s, in France, Jean Baudrillard wrote what is probably his best work, on the system of object, conceived as a system of signs.[13] It can be productive to read these writings in the context of 1960s art; in addition to Pop Art, a major point of reference for Baudrillard was functionalist modernist design: it stood at the beginning of the triumph of fashion and thus to a play of retro styles, since the reduction of the object to a sign of functionality opens up an endless play of signifiers.[14]

Certain works by John Armleder from the 1980s and 1990s interpret the new objecthood explicitly in terms of sign design. A crucial work in particular is the installation (comprising two rooms) *Ne dites pas non!* (1996/97), which combines furniture and objects on pedestals with a variety of abstract painting-objects on the walls, including works by Imi Knoebel and Günther Förg. If the promise of sociability or at least of use is an important part of the younger artists' aesthetic, Armleder bluntly puts chairs, beds, as well as guitars and artworks, on pedestals. The result is a theater of design fetishes that brutally seems to exclude any possibility for human inhabitation. In Armleder's work we have, as it were, a postmodern version of Greenberg's "Period Style," a recycling of neo-modernist signs ruled by the eternal returns and permutations of fashion.

John M. Armleder, *Ne Dites Pas Non!*, Installation view, Deichtorhallen Hamburg, 1997

Exhibited in 1997 in an exhibition that also included works by Jorge Pardo and Tobias Rehberger, Armleder's piece—a variation of which from 2006 has different components—can be seen as a desubli-

mation of such relational works, which revive the "theatricality" that Michael Fried decried in much 1960s art with hints at the 1990s club/lounge/networking context. If pieces by Tobias Rehberger such as *Lying around lazy. Not even moving for TV, sweets, Coke, and Vaseline* seem to evoke a private duration that breaks with the time of fashion, they are indeed—in Ina Blom's words—"less design solutions than ephemeral style suggestions imbued with the restless knowledge of being precisely dated, fashion-wise, and so also soon outdated," leading Rehberger to make new versions that "update" the works.[15] What remained dominant in many "relational" practices was the play of signs and thus sign value.

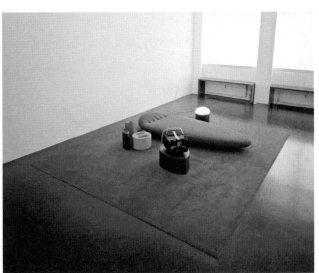

Tobias Rehberger, *Lying Around Lazy. Not Even Moving for TV, Sweets, Coke, and Vaseline*, Installation view, 1996

Liam Gillick's work in a sense provides the mythic narrative for this art, with its reduction of theories of post-Fordism to a cartoon-like narrative about closed factories becoming sites for immaterial labor working as the founding myth justifying an endless series of quasi-modernist forms that seem to be almost accidental manifestations of the kind of clean, disembodied work that we see in Gillick's video *Everything Good Goes* (2008), in which an architectural structure (the factory

from Godard and Gorin's *Tout va bien*) appears on a trendy flatscreen in a stylishly minimalist office, the Mac mouse being manipulated by an operator who remains unseen—in spite of the mirror behind the monitor. On the soundtrack, there are some semi-audible phone messages on contemporary labor. What is carefully left out of this video is anything that could complicate the image of disembodied sign production: the production of the machinery being used, the hidden world of server centers and their ecological implications, the potential execution of the design seen on the screen, its implications outside a rarified environment where everything is perceived in terms of fashion, of the right signifier at the right time.

To be sure, there are impulses in the art of the late twentieth and early twenty-first century that point beyond the limitations of "standard" relational discourse and practice. These impulses point beyond the system of object-signs to unruly things and their tangled material and symbolical relations: in W. J. T. Mitchell's words: "'Things' are no longer passively waiting for a concept, theory, or sovereign subject to arrange them in ordered ranks of objecthood. 'The Thing' rears its head—a rough beast or sci-fi monster, a repressed returnee, an obdurate materiality, a stumbling block, and an object lesson."[16] If objects are named and categorized, part of a system of objects,

"thingness" is resistant to such ordered objecthood. If we grant that a work of art is both more and less than other types of things, this should not be regarded as an incentive to exacerbate and fetishize those differences, but rather as a point of departure for analyzing the complex interrelationships of artworks with these other things—and for examining certain works of art as problematizing and transforming this very relationship.

There is a potential here for reconceptualizing the relationship between art and design. In recent years, design itself has been increasingly redefined as a social rather than semiotic practice; this does not mean that the visual side of design is neglected, but that the design object as image is no longer designed in terms of a hypercoded sign, in terms of a *legibility* that is in fact a reduction of the visual.[17] What is seen as crucial is the circulation of design not just as a sign, but also as a material thing. We are thus dealing with intersecting semiotic and material networks, and if the design object is to be an unruly thing, it has to articulate and challenge its questionable status as a fetish sign whose histories and entanglements are left out of the picture. This is clearly no small challenge, and some contemporary art practices can be seen as critiquing as well as completing more conventional designed commodities, turning them into mutant things.

The Use of Value

Some of Hans Haacke's installations confront the logos of Corporate Art sponsors such as Mobil with the corporation's exploitation of labor or involvement in authoritarian or racist regimes. A relatively small work from 1976, *The Chase Advantage*, is a quasi "shaped canvas" from acrylic plastic. Prefiguring Caroline A. Jones's analysis by twenty years, this piece plays on the Stella-like qualities of the striped Chase Manhattan Bank logo, from which it gets its octagonal form; this idiom in turn seems to be mirrored by the modernist

painting seen on a photo behind Chase chairman and MoMA vice chairman David Rockefeller, which Haacke has placed in the logo's center. The photo is captioned with quotations by David Rockefeller and PR consultant Ivy L. Lee on art sponsoring, publicity and goodwill, accompanied by a few short notes by Haacke (both on and in addition to the piece) that reveal some of the bank's and the Rockefellers' involvement in practices that PR seeks to gloss over.

Such a work goes a certain way to meeting the challenge of intervening in the empire of signs, laying bare their complexity and contradictions, and questioning the conditions under which their programmed surfaces came into being. Taking cues from Baudrillard's exploration of sign value, 1980s theories of postmodernism often diagnosed and criticized an "aestheticization" of capitalism, the economy becoming culturalized as the commodification of art reached new heights. However, it might be more productive to argue the reverse: that what appears as hyper-aestheticization is in fact an *impoverishment* of the aesthetic. There is a chance in proper aestheticization if one refuses to limit the notion of the aesthetic to the play of commodified signs, instead taking the aesthetic to a wide set of questions pertaining to the sensible—including the (in)visibility of labor conditions and ecological costs.

A prominent proponent of the *thing* in recent theory is Bruno Latour, who has taken it upon himself to reveal "the terrible flaws of dualism," which marked modernity.[18] The hubristic project of modernity was based on the dichotomy of society and nature, of subject and object; this enables the modern "work of purification," the triumph of the subject and the relegation of nature and of non-moderns to the abyss of thought. Underneath this purifying dichotomy, however, there is a disavowed continuity of networks, of hybrids; modern binary, "critical" thinking exists by virtue of the denial of this continuity, this world of "quasi-objects" and "quasi-subjects"—that which is "between and below the two poles" of object and subject.[19] "Moderns do differ from premoderns by this single trait: they refuse to conceptualize quasi-objects as such. In their eyes, hybrids present the horror that must be avoided at all costs by a ceaseless, even maniacal purification."[20] Like all good caricatures, Latour's portrayal of modernity presents some traits in sharp, even exaggerated clarity. And like many good and bad caricatures, it is one-sided and self-serving. If we look carefully at modern theory and (art) practice, it should be obvious that there have been a number of significant attempts to go beyond a static dichotomy of subject and object. Reexamining such moments can be of extreme interest—not in order to create some kind of oneiric ancestral line leading up to present concerns, but in order to sound out the limitations as well as the unfulfilled potential of various practices. The reappraisal of Soviet Constructivism/Productivism in both the late 1960s and early 1970s is a case in point.

Benjamin H.D. Buchloh once linked the "lack of surface aesthetics" in Dan Graham's works of the 1970s and in the designs of Russian Constructivism/Productivism to the promise of a use value, a potential use value inherent in such works.[21] The concept of use value is of course notoriously contested. In anchoring exchange value in sign value, Baudrillard broke with what

he regarded as a Marxist fetishization of use value, which is just a case of nostalgia for a lost referent, a "real" that was swiped away by capitalism—even while Baudrillard himself nostalgically gloried pre-modern societies of "symbolic exchange."[22] There are passages in Marx that seem to justify such an argument. If exchange value is pure quantity, an abstraction, use value is equated by Marx with the sensuous qualities of the commodity's physical side, which is "realized" in actual use. On the other hand, that every commodity with an exchange value must perforce also have a use value throws another light on the issue: if this is the case, then even "pure" design fetishes and all commodified works of art must have one.[23] This means that use value can be more intangible than Marx's examples suggest. Often, the primary use may be the accruing of social capital from the sign value of, for instance, a vintage Eames chair, or a Bauhaus screwdriver. But perhaps the real use is systemic, economic: do not economists constantly remind us that we need to consume in order to keep the economy going?

In the 1930s and 1940s, Georges Bataille opposed the "productivism" and fetishization of use value by modern industrial capitalism with his concept of excessive expenditure, with the potlatch as its ultimate example. This was one of the ingredients for Baudrillard's later notion of "symbolic exchange," which resuscitated the romantic cult of the symbol by redefining it in social and performative terms as the logic of traditional societies, in opposition to the system of sign-objects of modern capitalism.[24] What Bataille by and large failed to perceive was that the distinction he made between *sociétés de consumation* (societies in which value is completely consumed or "consummated" by uneconomic excessive rituals and gifts) and modern *sociétés de consommation* (in which "consumption" is at the service of production and economic growth) was eroding. Does capitalist consumption not finally result in a global potlatch that consumes the

planet itself?[25] Thus, while it would be a mistake to equate use value with some simple, everyday, "productive" use of objects, there is an obvious need to go beyond the culture of conspicuous consumption and waste that dominated the last decades. If use value is far more flexible than minimalist definitions suggest, this means that the determination of what is actually useful and socially desirable under current circumstances is subject to political debate. Use value is not an ontological given. It also suggests that we should not merely look at the individual usefulness of a commodity, but also at its wider ramifications beyond the individual.

The renewed reappraisal of Constructivism/ Productivism should be seen in this context. Now that everyday life is increasingly marked by convoluted attempts to gain some insight into the tangled "thingness" in which we are embedded, to trace the origins of the food we buy, to try and quantify the production of pollution resulting from our energy consumption, to do more than merely survive under ever more precarious working conditions, Productivism chimes with current concerns. It is reactivated in contemporary practices such as that of Chto delat, even if the formal means employed in their videos and installations sometimes court the risk of appearing to be exercises in nostalgic retro chic.[26] In a less literal way, a similar impulse can be detected in the activities of Temporary Services, for example in the recent *Art Work*, an exhibition in the shape of a newspaper discussing the consequences of the collapse of the economy for artists, and pushing for "new ways of doing things, developing better models."[27] Here one may also think of Natascha Sadr Haghighian's *Solo Show* project (2008), which foregrounded the semi-hidden world of companies that produce work for today's big artists by giving a man used to interpreting artists' designs a much more active role in determining the show's content, as well as that of her earlier installation, titled *...deeply_to the notion*

that the__world is__to the observer...(committed)
(real) (external).[28]

...deeply__to the notion that the__world is__to
the observer...(committed) (real) (external) contains
a video in which two women set up a do-it-yourself bill-
board in the middle of a highway. The billboard itself,
which shares the space with the video projection,
consists of a series of photo/text montages that address,
in a less than linear way, the consequences of multiple
events of the early 1970s: the collapse of the gold
standard, the rise of Conceptual Art and immaterial labor,
and the transformation of the dollar into a "virtual
currency" whose fate is, however, linked to the price of
oil. All of its graphic components can be downloaded
from the Internet and then printed and pasted onto
a self-assembled wooden structure. Rather than a
didactic exposition molding these elements into a clear-
cut narrative, the board's montage creates juxtaposi-
tions that are, quite literally, questionable. How exactly
does the rejection of the object in Conceptual Art relate
to the collapse of the gold standard, and immaterial
labor to the continuing importance of oil—the oneiric
master-commodity? Having been emphatically told
that various wars were definitely not about oil, should
we believe such statements any more than the rhetoric
of dematerialization employed in the context of Con-
ceptual Art?

In spite of the increasing importance of certifi-
cates for determining the rights to a work of art, the
concepts faxed or mailed by managerial artists are still
destined for production by specialized companies—
a division of labor that Sadr Haghighian's project *Solo
Show* undermines by instigating a different working
relationship, one that leads to the production of mutant
things. For *Solo Show*, Sadr Haghighian investigated
the productions of artworks by artists who mostly
belong to the generation that came to prominence in
the 1990s; in a kind of reverse Productivism (an investi-
gation into production rather than its glorification),

Solo Show focuses on the shadowy world of companies that specialize in producing works for the Pardos, Höllers and other art-world bigshots. In Sadr Haghighian's reversal of values, the process is more interesting than the end result, and what usually remains invisible is brought to light: the works by the fictitious artist Robbie Williams, which were made by one of those specialized forms that execute artists' designs, are aesthetically void compared to the interviews with which Sadr charts the circumstances under which such contemporary art is produced.[29]

Natascha Sadr Haghighian, ...deeply— to the notion that the___world is___to the observer... (commited) (real) (externall), 2004, Installation views, Kunstverein München, 2004

In this sense, her work participates in the diagrammatic tendency in contemporary art practice, which can be traced back to the generation of Hans Haacke and Allan Sekula. Sekula's *Fish Story* and related projects chart the largely unseen trajectories of commodities and workers on and near the oceans. In the film *The Forgotten Space* (2010) by Sekula and Noël Burch, the montage of sites and struggles in Sekula's photo/text essay becomes a linear filmic montage, taking the viewer from the Dutch delta via California to China, and repeatedly to the crew of a container ship at sea. The shipping container, that black box filled with unseen commodities, is effectively the protagonist—a protagonist of abstraction. Allowing for increased volume and lower shipping costs, the container is effectively one of the least recognized and most successful pieces of design, allowing for the increasing migration of industrial production to the Far East.

One might also think here of pieces by Sean Snyder, especially those that show commodities ranging from Mars bars to Toyotas and video cameras circulating in Iraq and Afghanistan, and Hito Steyerl's writings and films on the travails of "thingness"; *In Free Fall* (2010) is a video essay on an airplane junkyard in the Californian desert, which provides both a setting for Hollywood movies and raw materials for CD production in China, becoming an allegory of economic bubbles and busts, and of the travels and travails of objects and materials in the storm of economic history. It may seem abstruse to discuss such works in the context of design, but I would argue that this in fact becomes a necessity. Such works suggest that design does not end with the object; if design is to have any meaning, it has to engage both with object and system, with thing and network. Design not only has to engage with shaping the actual products, but also with their production processes, distribution, and "afterlife." Here, design is being redefined in terms of formal interventions in "System," a buzzword of the 1960s, and used in

many contexts. Hans Haacke was one artist who referenced systems theory and investigated natural as well as (and increasingly) social systems in his work. But regarding the latter pieces in particular, the term "system" seems too grand; they constitute interventions in structures that one could characterize as *networks* inside and in-between systems. The Actor-Network Theory developed by Bruno Latour and others, according to which humans as well as things are equipped with some degree of agency, is relevant in this regard. Latour emphasizes that the network is not "out there," existing objectively, but that it is constituted by the act of tracing it.[30] The artworks that are under discussion here intervene in networks that they trace and constitute. The works create images of invisibility; they are coagulations in the system of signs that allow a rethinking of economical networks. This is the unrecognizable rebirth of design from its own ashes: design after sign design.

Allan Sekula & Noël Burch, *Forgotten Space*, Film still, Netherlands/Austria, 2010

Certainly, the aforementioned practices operate at a considerable distance from actual product design. Closer to actual design practices is a project such as Superflex's *Free Beer*, an "open source" recipe which anyone can brew, even if it is still *branded* in a way that is reminiscent of capitalist brands; the actual design of the brand, with its blithely pop-modernist logo, has no imaginative force and thus contributes to the project's inability to progress much beyond the "nice idea" stage. By contrast, Dan Peterman's modular

constructions out of recycled materials are a more successful model for alternative structures and a different *habitus* precisely because of their formal elegance and playful rigor. For some, Peterman's modular and predominantly grey and brown structures may suggest a return to a certain puritan valorization of simple and elementary uses and a suspicion of anything smacking of excess and waste. However, one can also see such a practice as being devoted precisely to *excessive and perverse use value*.

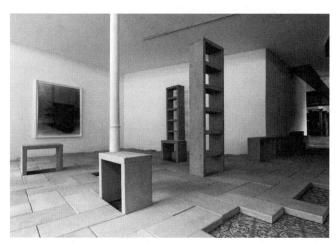

Dan Peterman, *Plastic Archive (Version for 57 People)*, 1998, Installation view, CEAAC Strasbourg, 2010

If the capitalist system is predicated on unlimited growth and expansion, then the introduction of social and ecological considerations into design, to an extent that goes beyond a new form of eco-branding, must appear as an excess, as a dangerous indulgence by deviants. Sign design, as applied semiotics, was always about the production of subjectivities, of consumers participating in the production of surplus value. In producing things that are as social as they are visual, the design that is in the process of emerging also has to rethink the object's old other, formerly known as the subject.

This text incorporates elements from "Under the Sign of Design," (*Texte zur Kunst* no. 72, December 2008) and from my three-part essay "Art and Thingness," from *e-flux journal* (nos. 12, 14, 15, 2010).

1 David Joselit, *Feedback: Television Against Democracy*, (Cambridge MA/London 2007), p. 3.

2 Barnett Newman, "The First Man Was an Artist," (1947), in: *Selected Writings and Interviews*, ed. John P. O'Neill (Berkeley/ Los Angeles 1992), p. 159.

3 Barnett Newman, "Open Letter to William A.M. Burden, President of the Museum of Modern Art," (1953) and "Remarks at the Fourth Annual Woodstock Arts Conference," (1952), in: Ibid., pp. 38, 245. Intriguingly, Duchamp's 1918 painting *Tu m'* contains the shadows of a number of known readymades as well as that of a corkscrew.

4 Clement Greenberg, "Review of Exhibitions of Hedda Sterne and Adolph Gottlieb," (1947), in: *The Collected Essays and Criticism 2: Arrogant Purpose, 1945–1949*, ed. John O'Brian, (Chicago/London 1986), pp. 188 f.

5 On Romantic symbol theory see Sven Lütticken, "After the Gods," in: *New Left Review 30* (November/December 2004), pp. 90-94.

6 In German: "Kunst absorbiert die Symbole dadurch, dass sie nichts mehr symbolisieren [...]. Die Chiffren und Charaktere der Moderne sind durchweg absolut gewordene, ihrer selbst vergessene Zeichen." Theodor W. Adorno, "Ästhetische Theorie," in: *Gesammelte Schriften*, vol. 7, eds. Gretel Adorno/ Rolf Tiedemann (Frankfurt am Main 1972), p. 47.

7 This was obviously the case for Erwin Panofsky, whose reactions to the misprinted title "Vir Heroicus Sublimus" (instead of Sublimis) betrays his anger at the, in his view, misplaced pretensions of Newman, who after all only painted abstract planes devoid of iconological meaning. See Barnett Newman, "Letters to the Editor (Replies to Erwin Panofsky), ARTnews," in: *Selected Writings and Interviews*, pp. 216-220.

8 Leo Steinberg, *Other Criteria: Confrontations with Twentieth-Century Art*, (London 1972), pp. 77 f.

9 Caroline A. Jones, *Machine in the Studio: Constructing the Postwar American Artist*, (Chicago/London 1996), p. 162. In speaking of forms being "branded on the retina," Jones is paraphrasing Stella himself.

10 Fried's relevant texts here are of course "Three American Painters: Kenneth Noland, Jules Olitski, Frank Stella," (1965) and "Art and Objecthood," (1967), in: *Art and Objecthood: Essays and Reviews*, (Chicago/London 1998), pp. 148-172, 213-265.

11 In the 1960s, Greenberg still argued that the "limiting conditions with which a picture must comply in order to be experienced as a picture" could be "pushed back indefinitely before a picture stops being a picture and turns into an arbitrary object"; a few years later, the work of Stella, Judd and others suggested to Greenberg that this leap into the arbitrary was now a real threat. Clement Greenberg, "Modernist Painting," (1960), in: *The Collected Essays and Criticism 4: Modernism with a Vengeance, 1957–1969*, ed. John O'Brian, (Chicago/London 1993), pp. 89 f. See also Thierry De Duve, *Kant After Duchamp*, (Cambridge MA, /London 1996), pp. 199-279.

12 Clement Greenberg, "Our Period Style," (1949), in: *The Collected Essays and Criticism Volume 2*, pp. 322-326.

13 Jean Baudrillard, *Le système des objets*, (Paris 1968).

14 Baudrillard developed his critique of functionalism in *Pour une critique de l'économie politique du signe*, (Paris 1972), pp. 229-248.

15 Ina Blom, *On The Style Site: Art, Sociality, and Media Culture,* (Berlin/New York 2007), p. 101.

16 W. J. T. Mitchell, *What Do Pictures Want? The Lives and Loves of Images* (Chicago and London 2005), p. 112.

17 See Georges Didi-Huberman, *Devant l'image. Question posée aux finds d'une histoire de l'art,* (Paris 1990).

18 Bruno Latour, *We have never been modern,* trans. Catherine Porter, Cambridge MA 1991), p. 54.

19 Ibid., pp. 51-55.

20 Ibid., p. 112.

21 Benjamin H.D. Buchloh, "Moments of History in the Work of Dan Graham," [1978], in: *Neo-Avantgarde and Culture Industry: Essays on European and American Art from 1955 to 1975,* (Cambridge, MA/London 2000), p. 191.

22 As he distanced himself from Marxism, it became increasingly obvious that Baudrillard's work was underpinned by a hysterical mourning for a lost reality. In a fine example of the pot calling the kettle black, Baudrillard accused Marxism of a nostalgia for pre-capitalist economies, a nostalgia for an oneiric reality before the universal rule of exchange, before alienation, while his own narrative of an increasing loss of reality certainly went hand in hand with such a nostalgia. Baudrillard's own utopias were premodern economies of "symbolical exchange," in which objects were not exchanged as abstract commodities but as part of a network of symbolic obligations, anchored in a hierarchy that is sustained by the gods (or, in certain tribal societies, the ancestors, who are seen as ever-present). Here the symbolic is not a platonic archetype, but part of enacted social obligations. On the capitalist market, such symbolical obligations are replaced by equivalence; this means that, as this market penetrates societies more and more, reality is lost and simulation takes over.

23 Karl Marx, *Capital Volume I,* trans. Ben Fowkes, (Harmondsworth 1990), p. 131.

24 The usual French term for the "consumer society" is *société de consommation.* In "Theory of Religion" and "The Accursed Share," Bataille consistently uses the alternative term *consumation* when sacrifice, waste or excessive consumption are concerned. The counterpart of the *société de consommation* is a *société d'entreprise,* in which consumption is mere *consommation,* not all-consuming *consumation.* See Georges Bataille, "La Part maudite," (1949), in: *Œuvres Complètes,* vol. VII, Paris 1976), pp. 51-54. (When my article "Under the Sign of Design" was published in *Texte zur Kunst, consumation* was changed into *consommation* during the editing process, thus obliterating what to Bataille was a crucial distinction, and creating a highly confusing account.)
Baudrillard's early take on "consumer society" and waste in *La société de consommation* (Paris 1970) reads in part like Bataille plagiarism or pastiche; see for instance pp. 48-56.

25 There are, however, moments in Bataille's postwar writings in which he reveals an early insight into this development; see "Théorie de la religion," (1948), in: *Œuvres Complètes,* vol VII, p. 339, where he states that the real purpose of the modern development of the means of production is the unproductive consumption of its products.

26 See, however, the cogent discussions on Productivism in issue 01-25 of the Chto delat magazine (March 2009),

http://www.chtodelat.org/index.php?view=article&id=606, visited March 3, 2011.

27 *Art Work: A National Conversation on Art, Labor, and Economics* exists as a printed newspaper as well as in various online versions that can be downloaded from http://www.artandwork.us/download/, visited March 3, 2011.

28 See "not about oil" at http://www.possest.de/notaboutoil.html, which contains the billboard schematics and graphics, as well as an essay, visited March 3, 2011.

29 See the exh. cat. *Solo Show*, MAMbo – Museo d'Arte Moderna di Bologna, London 2008.

30 Bruno Latour, *Reassembling the Social: An Introduction to Actor-Network-Theory*, (Oxford 2005). Joana Ozorio Almeida Meroz points out the relevance of Actor-Network Theory in her paper "Constellations of the Visual: Towards a Politics of the Networks of Product Design" (VU University Amsterdam), in the context of an analysis of what she terms the "symbolic" and "material" approaches to design scholarship.

Reflecting Furniture
Sofia Lagerkvist

The interview was conducted by telephone on July 1, 2009.

Sofia Lagerkvist Each and every project that we do is looking at what the designer does. We look at the design process as such and then we divide the process into the small parts that we are interested in. So we work a lot like a fine artist, in a way. Fine artists look at what an artist is or what an artist does. We're looking at design in the same kind of way but from the designer's point of view. We look at what kind of qualities and things the designer adds to the process or projects, and what kind of tools we're working with as designers. Lately, we have been looking at the importance of pictures in design. For a very, very long time the product will only exist as an image in the design process. And we have to communicate through all these images. First, it could be like a sketch, and then it becomes a 3D sketch, and then a photomontage and then a model, a photo of the model and then the model turns into a drawing—different forms of two-dimensional images. So when we were doing the *Moment Collection* for Moroso, we wanted to make furniture that existed in between that three-dimensional image and its transformation into the three-dimensional object. And then it's also interesting to look at when people take photos of it at exhibitions, when it's going to be in a catalogue, and so it sort of transforms into an image —an image instead of a product.

Tido von Oppeln Images become more part of the product itself?

Sofia Lagerkvist Sometimes the product can only be an image. There are pro-ducts that people recognize because they've seen them so many times in magazines and books. You have seen it, but perhaps you have never seen it for real. Or you might have seen it, but you've not been able to touch it or to sit on it. The product that we are trying to do is not trying to be an image. But it is trying to talk about that kind of in between, that moment when it sort of comes from an object and into an image.

Burkhard Meltzer Do you mean in all situations where design is exhibited more or less in museum situations or at fairs, it is generally perceived as an image?

Sofia Lagerkvist Not when you stand in front of it. It's often perceived that a chair is there to sit on. But in many situations a chair is not about that. There are so many other differ-ent qualities within an object that are a lot stronger than the practical function. But I think it is very diffi-cult to just line them up. A lot of our work is about trying to bring out some of these functions and to look at those in different ways. It's really a general part of the designer's profession. It's part of our tools to understand objects in a more complex way. And I think some people do it more obviously or more openly, or emphasize that part of design. But we also tried once to design objects that were never in-tended to become a product or a material object in a computer game or as products within a computer game. And we were exploring ways to create products that are designed to be images. That's a slightly dif-ferent angle to the same kind of idea. Those products were put in the pa-rameters of a videogame and there-fore they could be other kinds of material and the rooms could have other qualities that they could never have in real life. Somehow we would

explore, if you only design images, what kind of products could they be? So that was a project we called the *Representation of Things*.

Tido von Oppeln We are talking a lot about different aspects of furniture. But take the *Walking Table*, for example. Would you really call it a table? I mean, it walks away and has this random principle. It's probably a piece of furniture because it looks like one. But is there something really shifting the meaning of a common table?

Sofia Lagerkvist Perhaps the absence of being a table is why the object is communicating something about a table in general.

Burkhard Meltzer But in the case of the reading chair project for IKEA that you did, did you consider it in terms of ergonomics or is it more like the image of an object that you did the research for?

Sofia Lagerkvist I think that our aim was never to make a chair that was like a new way of sitting. It was never a functional study, so we used the knowledge that they already had at IKEA.

Burkhard Meltzer You did some projects in the art context as well, like for Tensta Konsthall.

Sofia Lagerkvist Yes, that was one of the first things we did in the context of art. It happened at the same time with other design projects—I think it's also that we believe the idea of design is such a broad field. We did two projects in the Tensta Konsthall: One is the permanent interior design, and then a year later we also made a self-initiated project in the public space of Tensta, which is a suburb of Stockholm. It's connected to the art gallery, but has

more the character of a city-planning project. It was initiated by an art group called International Festival, and together we decided that we wanted to create a square in Tensta. The city has divided floor levels—a part of the city where people walk is situated above the ground where people are driving. And the gallery is where people are walking, with people driving underneath. So we wanted to construct a new square where we could combine both levels. We came up with an idea of a really big staircase—like for an audience. And we initiated a series of events around that square. It was also about how you could work with people's decisions to create something. I think it's a lot about other people's decisions. As a designer you can come up with an idea, but it can often only happen if other people agree on it happening.

Burkhard Meltzer Is that something that you feel is working differently in art and design contexts?

Sofia Lagerkvist I think it is very clear that there is much less interference in a fine artist's work, while in design it feels like everyone can have an opinion.

Burkhard Meltzer They can choose the colors and things like that...

Sofia Lagerkvist Yeah! It's like: "My wife thinks that!" But when we were working in art we were so surprised because we came with an idea and they said, "Yes! Go ahead." That is very rare to happen in design.

Burkhard Meltzer I saw on the website that your installations at Tensta were partly permanent and partly temporary...

Sofia Lagerkvist Yes. The idea of the interior design is that it changes all

the time. The objects don't change. They have a built-in changeability. They change with time. For example, the floor has been painted golden and then repainted with the color that was there before. It was first gray, then gold, and then gray again. If people walked on it, it became gold. We wanted it to be like every time you go there you would see something new. Constant change. Where people hang their coats we put up these small plastic things, but people could put them up themselves. After a while, there were more and more hooks, there were hooks everywhere. The space looked like the things that grow underneath boats.[—> p. 30]

Burkhard Meltzer I also see that you can buy these things as a product as well. Could I buy a chair?

Sofia Lagerkvist The only thing you can buy is the chair. It's in production, but not for Tensta. It's produced by a company in Belgium.

Burkhard Meltzer Are they prefabricated Monoblocs? Or are they replicas?

Sofia Lagerkvist You can buy it for two Euros, and then we made a leather piece that goes on it.[—> p. XXII] But you buy it as one piece. So it's like a new chair. We think it's an interesting idea to sell something that is really cheap and you can redo it in another context. The interest came about when we read this article about how they were going to ban this chair in Sweden, in some areas. I wonder what other things can they ban? It's a weird way of looking at taste. These white plastic chairs were considered to be too ugly. We bought hundreds of these simple chairs. The idea was that people could move them around in the city. So it would be like a café area that would spread out. And they still constantly buy new chairs.

Burkhard Meltzer It's also a link to a special social background with the Monobloc chair.

Sofia Lagerkvist If you look at the pictures, you see that they become really beautiful, when there are a lot of them. We filmed how people were moving these chairs around, since they are portable and also easy to move around. For us it was a question about talking about the public space in general, not specifically about class. And how to blur the border between inside and outside. It's an interesting thing how design can change the way we walk in the city or how we act in a place.

[... p. 169]

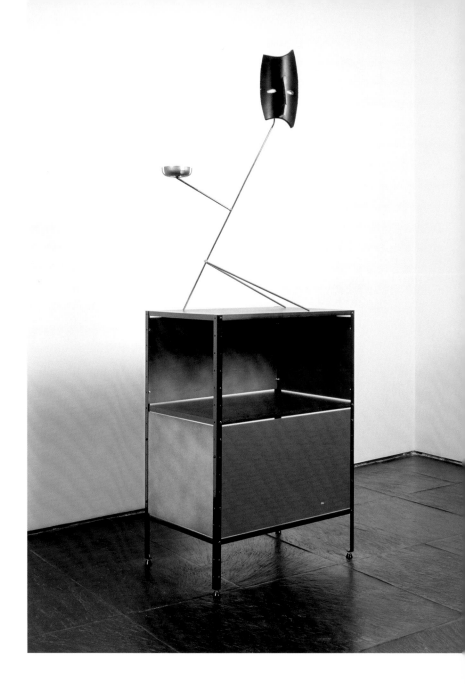

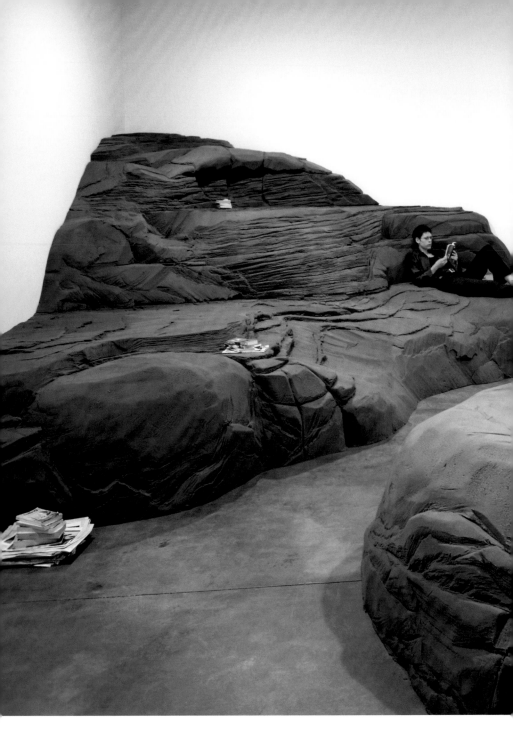

III

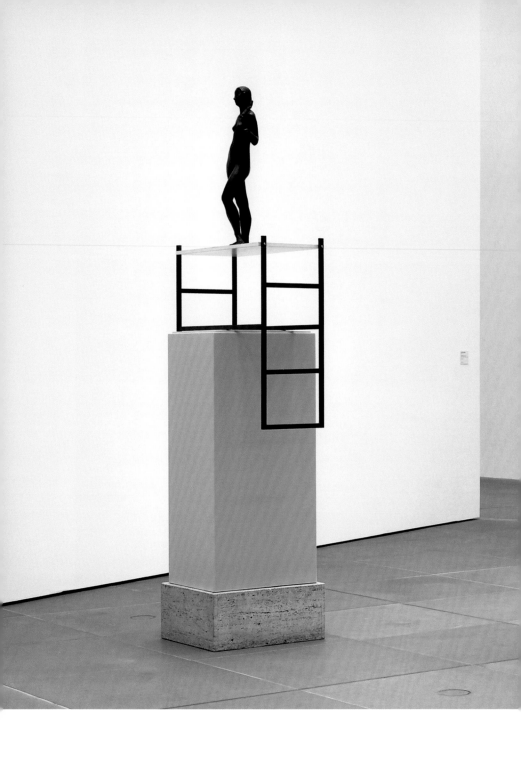

IV

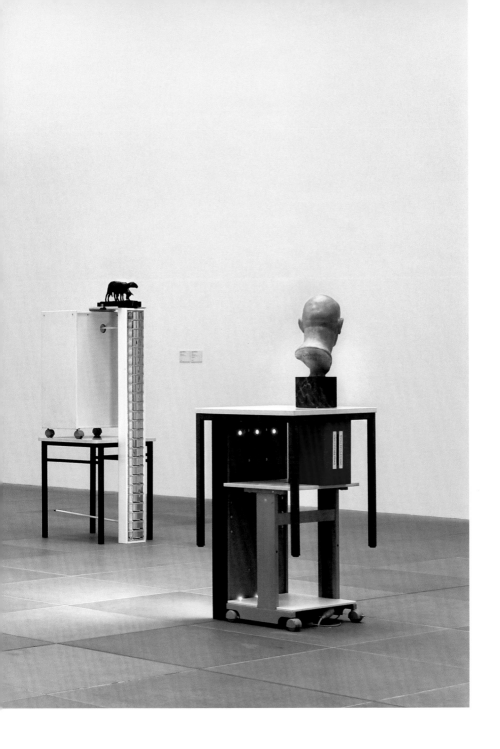

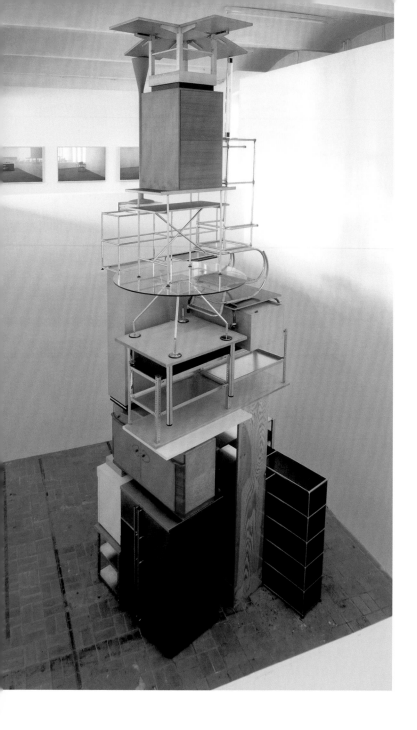

VI

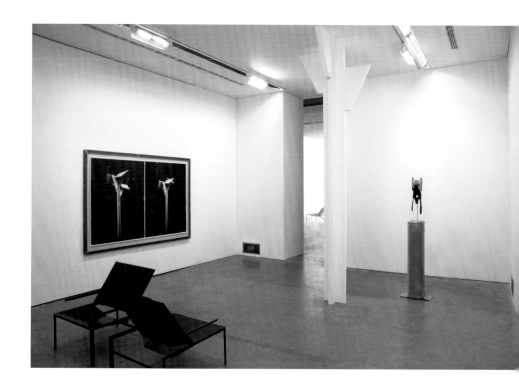

VII

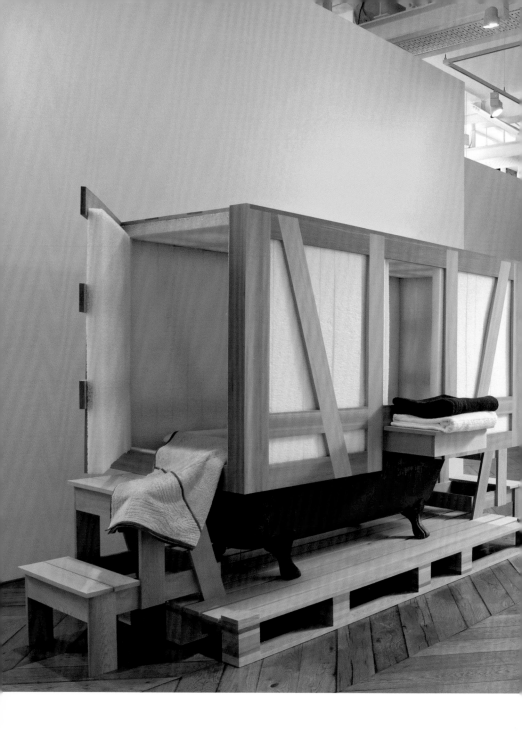

VIII

X

XII

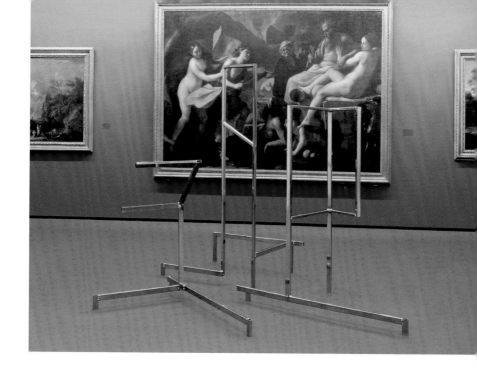

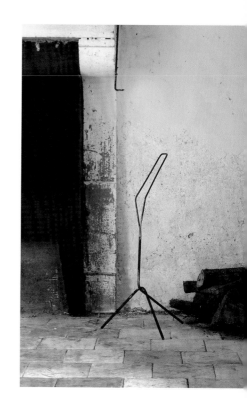

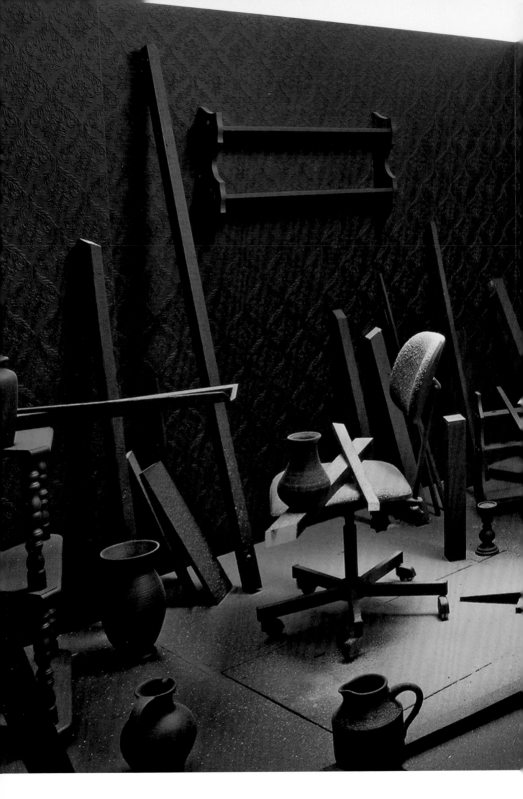

XIV

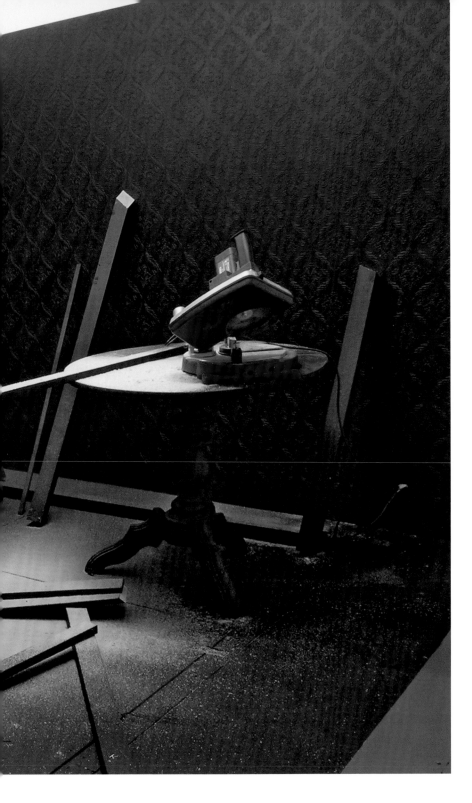

XV

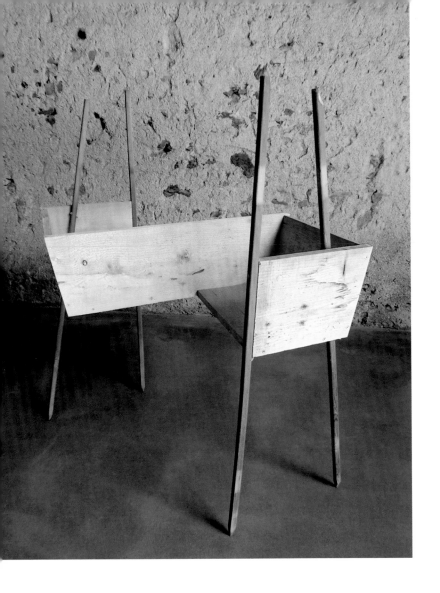

XVI

XVII

XVIII

XIX

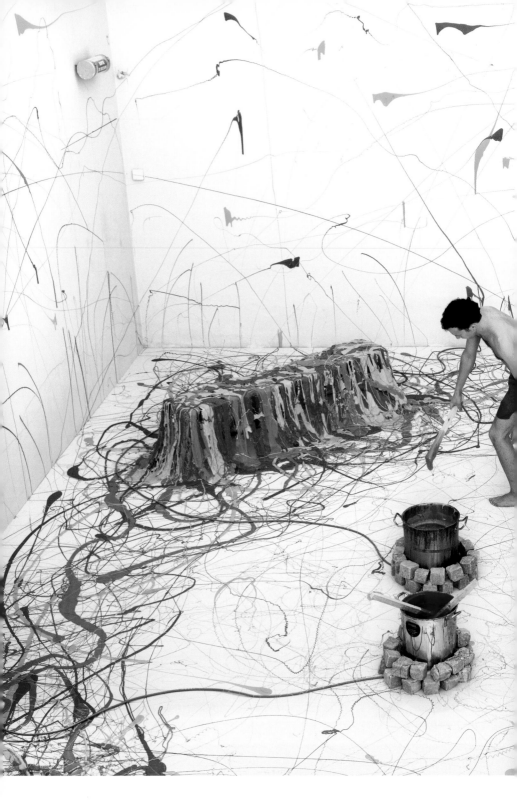

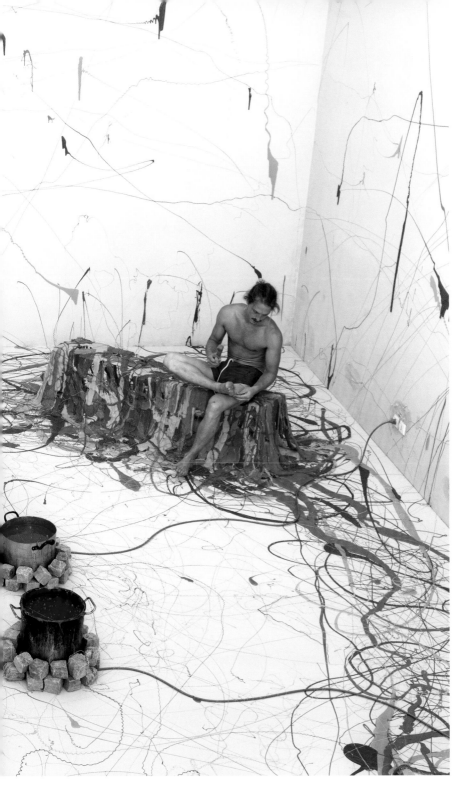

XXI

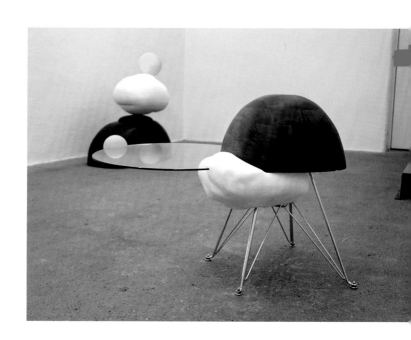

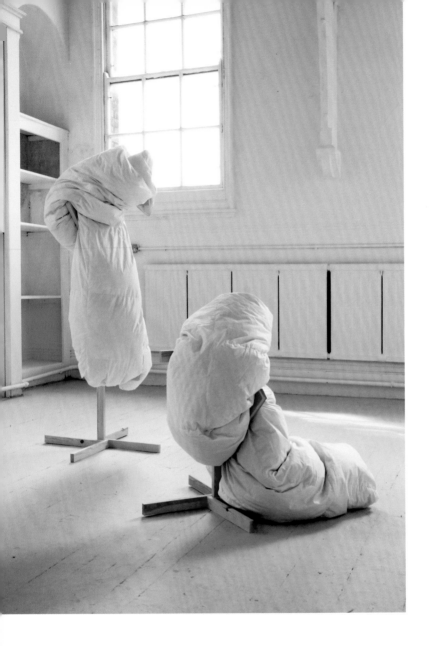

XXIV

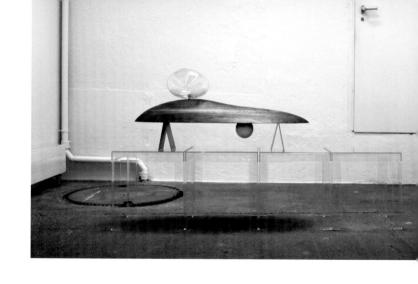

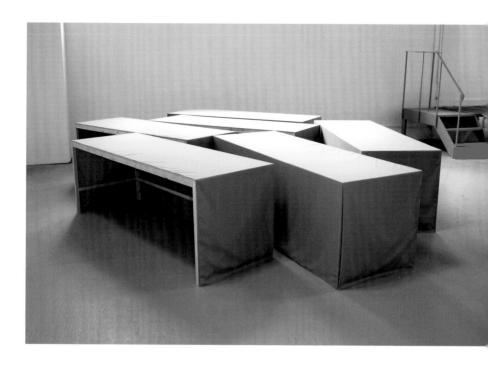

XXV

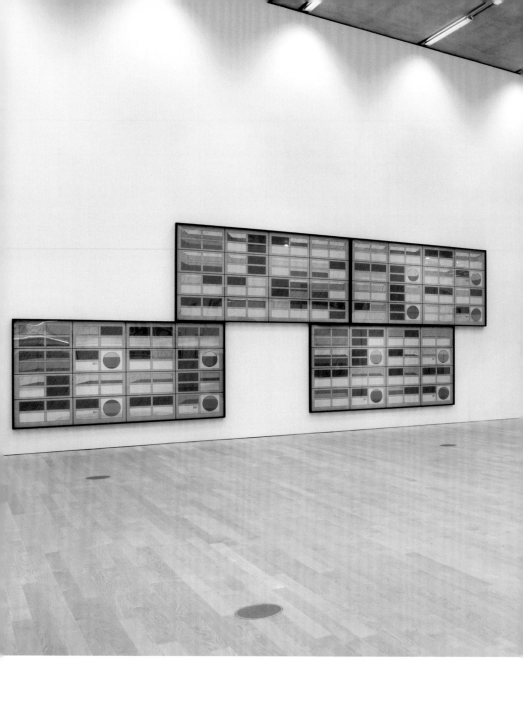

XXVI

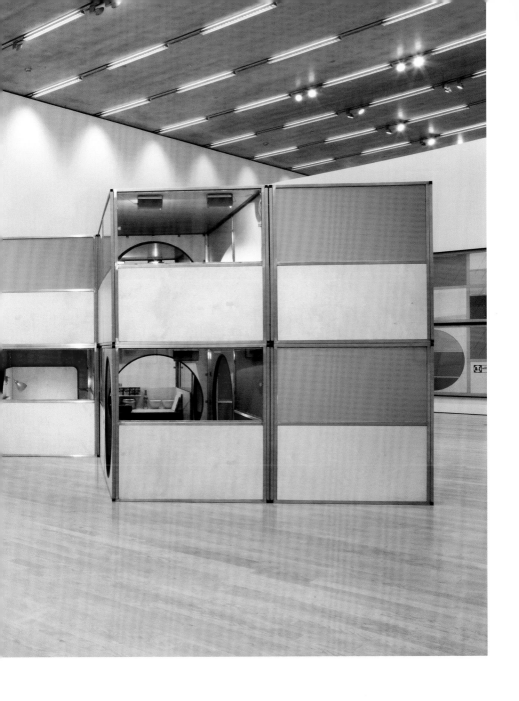

XXVII

XXVIII

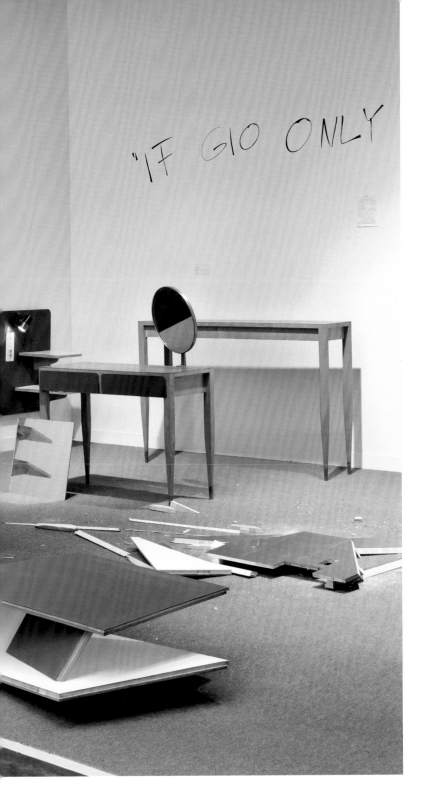

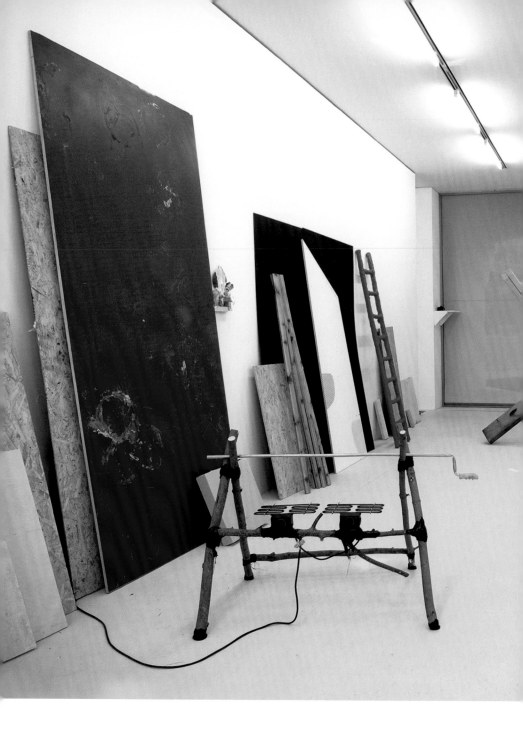

XXX

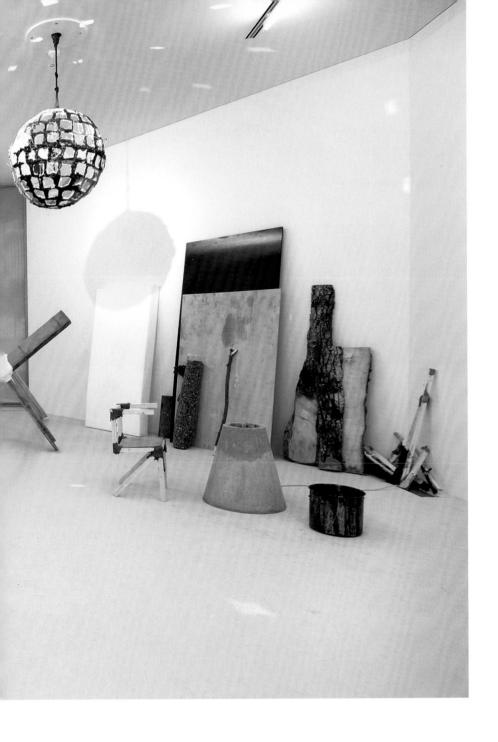

XXXI

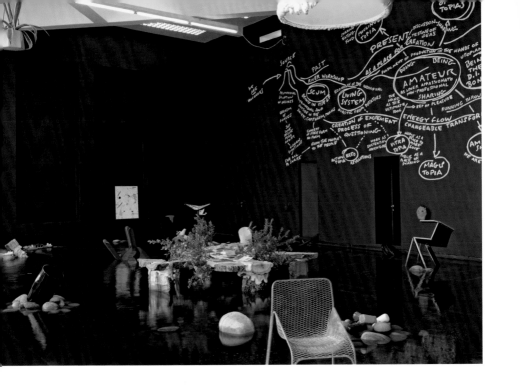

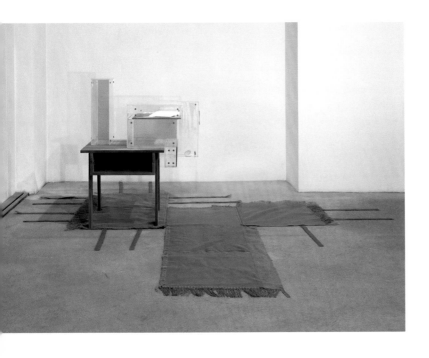

XXXII

XXIII ↓
Mamiko Otsubo, *Untitled
(with Eames chair base)*, 2007

XXIV
Matthew Smith, *Duvet
with Stand No. 5*, Installation
view, Limoncello Gallery,
London, 2007

XXV ↑
Mamiko Otsubo, *Sitting
on Ghosts*, 2006

XXV ↓
Matthew Smith, *Semi-
Comfortable*, Installation view,
Limoncello Gallery, London,
2008

XXVI–XXVII
Andrea Zittel, Monika
Sosnowska, *1:1*, Exhibition view,
Schaulager, Basel, 2008

XXVIII–XXIX
Martino Gamper, *If Gio
Only Knew*, Installation view,
DesignMiami, Basel, 2007

XXX–XXXI
Jerszy Seymour Design
Workshop, *Coalition of Ama-
teurs*, Installation view, Mudam,
Luxembourg, 2009

XXXII ↑
Jerszy Seymour Design
Workshop, *Being There. River
Workshop*, Installation view,
Villa Noailles, Hyères, 2009

XXXII ↓
Studio Makkink & Bey,
Reading Table, Installation view,
Mitterrand + Cramer / Design,
Geneva, 2009

Participation

Deeply Superficial
Alexander García Düttmann

Whereas a work of art can be defined in terms of its scope for exhibition—the value attributed to it as an exhibit that indicates its independence from specific time and place—this does not seem to be the case for objects of design.

Design objects are also exhibited, of course—and the grounds for this are not merely abstract. Moreover, the fact that design objects can be exhibited is certainly not due solely to the fact that they are objects, which by their very nature can be put on show. But design objects are not defined by their scope for exhibition the way artworks are, for the exhibition of an artwork goes hand in hand with a ban on touching it, as if, to use an expression from Walter Benjamin, the work of art still possessed some residual cult value. If one alters the order of the words in a poem, it becomes a different poem, or something other than a poem; if one paints over part of a painting, it becomes a different painting, or something other than a painting; if one adds an element to a sculpture, it becomes a different

sculpture, or something other than a sculpture; if one interrupts a performance, it becomes a different performance, or something other than a performance; and if the parameters governing a piece of aleatory music are amended, or if the musicians are suddenly asked to play from a score, then the result is a different piece of music, or something other than a piece of music. Even a work that is explicitly meant to be touched becomes a different work, or something other than a work, if the viewer doesn't touch it, since in the case of such a work, the fact that it should be touched proves an integral part of its untouchable status.

The difference between art and design, then, should be sought first and foremost in this characteristic combination of "exhibitability" and "untouchability" that has been called the autonomy of art, something no avant-garde that seeks to be seen as an art movement can break with or forgo. Of course, if the appearance of a designer-produced chair is altered, although it may still be usable as a chair, it does become a different design object, or even an object that might no longer be recognized as belonging to the category of design. Use value, the functional aspect, the intention to create a chair rather than a refrigerator, all went into producing the object. They are intrinsic to design, as important as exhibitability and untouchability are to the work of art. Perhaps this is the reason why it is possible for a viewer or listener to become involved in art, to actively participate in it, whereas the idea of "participation" in design sounds strange.

What makes participation in art possible, what provokes it and even makes it necessary, is precisely the untouchability of the exhibitable and the exhibited. Involvement in art exists, must exist, because in art exhibitability and untouchability coincide and can no longer be separated.

In the case of the design object, its touchability as an exhibit, its use value, produces a characteristic ambiguity that the artwork lacks, and which is not tied

to participation but to usage only. Having purchased a designer chair, one never knows whether or not one should actually sit on it, or even, if one does sit down, whether what one is doing is really sitting. Exhibitions of clothes, or, as jargon has it, of the "creations" of great fashion designers, are intended to remind us of the time when these clothes were worn, while at the same time encouraging us to forget the fact that the couturier had them made in order to be worn, regardless of whether or not they were ever actually worn.

The more design objects seem to resemble artworks, then, whether in fashion, in the domain of items of practical use, or in the realm of ornaments, the more they are exhibited and hence appear untouchable, the more they distance themselves from art, as their use value catches up with them, however minimal that value may be. Is the word "design" employed as a euphemism for arts and crafts?

Use value is inherent in design, whereas art serving as an object of practical use, or art that is consumed for reasons best left to sociology, is manipulated art. Is it not precisely the relevance that use value has for the design object that leads us to hesitate before attributing the added value we perceive in it to an alleged "embeddedness" in art? Is it not because of this relevance that we tend to locate it in the intermediate zone of the ornament, a zone where objects still have functions while something is added to them, something that takes on a life of its own, as if the functional object had begun to detach itself from purpose?

When examining participation in art, one finds that such participation is always double. The challenge of the work, which is what makes it an artwork while not depending on its being a work in the strict sense of the word, consists in this doubling, since one type of behavior towards art is always irreconcilable with the other.

On the one hand, participating in art means being open to and responding to its illusion, or being open to its semblance. What does such semblance

amount to, exactly? It can amount to the artwork trig-gering a "reality effect": for a moment at least, the viewer or reader forgets that the artwork is an artwork. Seen in isolation, one might consider this response a regression into a behavior that does not belong to the sphere of art. But the illusion of art can also consist in the fact that an artwork touches its beholder, so that the beholder has the impression that something about the artwork is significant and keeps calling for atten-tion. It is as if the work of art addressed itself to the be-holder, as if, when standing in front of the work, the beholder felt moved to exclaim: "Yes! That's the way it is! It can't be any other way!"—all of this without knowing what it is, precisely, that is one way or another, and why it cannot be any other way.

On the other hand, participating in art means responding not to its semblance but to it as art. One must be aware that the artwork is an artwork, something that has been created intentionally in a given framework, even if occasionally the artist may turn against the in-tention of making art. As something that has come into being and is therefore determined in a certain manner, an artwork lacks the peculiar necessity, the uncondi-tional quality attributed to it by the exclamation: "This is how it is, how it must be!"

Consequently, participating in art means that one is aware of art as art, yet one also allows art to im-pose limitations on this awareness. The difficulty of participation in art lies in this simultaneity, in the tension generated by art's demands, since openness to its semblance and critical alertness, the alertness any under-standing requires, must ultimately prove mutually exclusive. The goal cannot be to resolve this tension or unite the two types of behavior into one, thus over-coming the difficulty of participation. Such an approach would probably do away with the art itself. If, as with some conceptual works, the art itself gives little food for thought, precisely because it offers too much food for thought, it runs the risk of giving no food for thought at

all, exhausting itself in a gesture, a gag, an "idea," as if the boundless "sea of the formerly inconceivable"[1] mentioned by Adorno at the opening of his *Aesthetic Theory*, had shrunk to a puddle. But art gives much food for thought for the same reason one must also cite if one wishes to explain why participation in art splits into two types of behavior: it is because the mediation between existence and essence, between *thatness* and *whatness* breaks down.

This idea was developed by Adorno. It can also be expressed as follows: the more one penetrates the artwork, apprehending or comprehending it, gaining access to it and becoming familiar with what it is all about, the more abruptly it suddenly snaps shut and retreats from the beholder's participation. Or, to put it differently again, the more the beholder appreciates and understands art, the more baffling and confusing his realization of the otherness of art, of the impossibility of subordinating the artwork to a specific purpose and thereby rendering its creation meaningful. As a result, participation in art springs from art's enigmatic character, which is also what accounts for the splitting of participation.

The site of participation in art is the irresolvable tension between thatness, the fact that art exists and touches the viewer without the viewer knowing what art actually is, and whatness, the fact that art is made and that a work can be consciously apprehended or comprehended. Hence, if it makes no sense to speak of participation in design, this is because the design object is not inhabited by such a tension. The design object, unlike the work of art, does not have an enigmatic character.

But would it not be equally possible to claim the exact opposite? Does the design object not also generate a tension between thatness and whatness, between something that goes beyond pure use value and the usefulness of the object in a functional context? Does the unquestioning way we make use of an object

devised by a designer not correspond to the unquestioning way we take artworks as a simple given? Does the surprisingly altered view of the object used not correspond to the unexpected realization of the otherness of art, the inexplicability of its factuality, regardless of any attempts to ascribe a function to it, the function of playfulness or of creating illusions? Could not the designer strive to devise an absolute chair, the chair of chairs, just like the architect in Thomas Bernhard's novel *Correction* conceives of an absolute house? Would he not demonstrate his artistic vocation by fulfilling the object's functional purpose so precisely as to elevate the resulting object above that purpose?

Conversely, a supporter of relational art and aesthetics might ask whether use value cannot be integrated into art, and whether such an integration might not also render obsolete the traditional distinction between art and design. If one calls to mind, for example, the open lounge and living spaces created early in the millennium by Rirkit Tiravanija at the Vienna Secession and inspired by the memory of Rudolf Schindler's house in Los Angeles, then one cannot avoid viewing this installation, in which interior and exterior were so inseparably entwined that there no longer was a house or a finished building, as a spatial distribution designed for practical use. The aim, according to the organizers of the exhibition, was to create an "ideal living situation," a "place for social gatherings and hospitality." Visitors could get involved, participate in the art, by "occupying the space," by "using it as a meeting place and stage," or in order "to relax and even sleep."

As so often with relational art and aesthetics, the actual "work" offers extremely meager fare, at least if one sticks to its description. Tiravanija's installation boils down to a mix of formalism, positivism, and infantilism. There is talk, as in cold, cutthroat competition, of what is "on offer," but there is also high-flown, reassuring talk of participation amounting to a "shaping of a cultural space"—though it is not said what this

shaping might actually look like: future participants should not be over-challenged or even scared off!
In the playground set up by the artist, who means well, participants must not be prevented from feeling like good, cultured individuals who belong and who get involved. But "occupying" a space, using it as a "meeting place and stage," even as a place to rest and sleep, is hardly enough to merit talk of "shaping" "culture." Between the positivism of a utopia realized here and now at the Secession, the formalism of overly general conditions that constitute only the framework for the event of participation, and the infantilism of all-too-familiar patterns of behavior, the real question here is obscured: the question of the relationship between art and usage, and of what participation in art might mean. In truth, this question has always been answered, and the answer is a sedative.

Participation in art splits and doubles, takes on an enigmatic character, because when we apprehend and comprehend artworks, when we try to understand them, we tend to forget that an artwork is a thing and that we do not know what that thing is. The effect of this splitting and doubling is to starkly remind us of this not-knowing. Our interaction with a design object is never split in this way because regardless of any initial or even lasting uncertainty, we always end up knowing precisely what kind of a thing we are dealing with: it is a chair, for example, and the designer had it manufactured because he wanted to sell an object that allows the user to adopt a sitting position, to work at a desk, or eat at a table. One may contemplate the chair for a long time, baffled or captivated, but as a chair it is an object on which one sits and which should not collapse as one sits down. Design objects are witticisms in the realm of practical usage, they give pleasure; artworks provide food for thought, but it is impossible to identify and determine the resulting thoughts conceptually. When Swiss designer Frédéric Dedelley speaks of his fear of chaos and describes

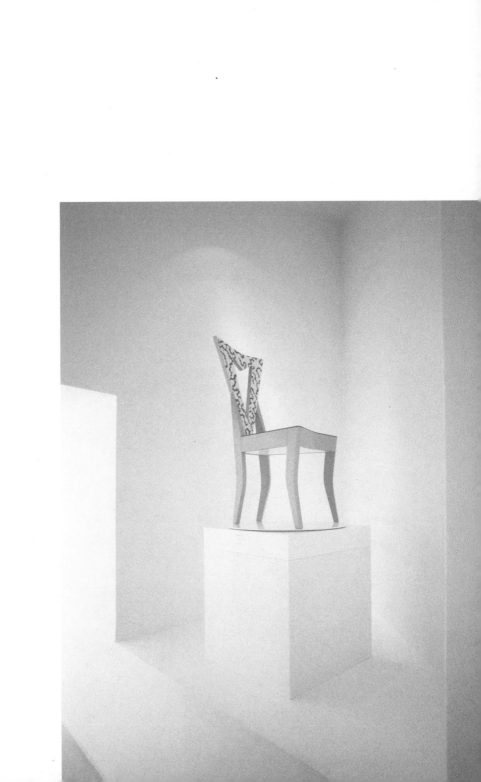

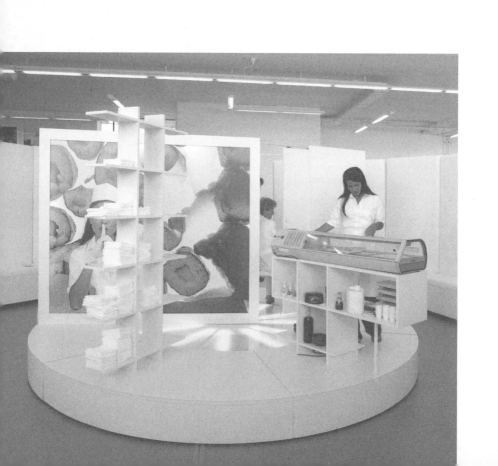

his task as a search for ordering principles, rather than confessing to conservatism, he is highlighting an essential aspect of design. The chair that collapses might turn its creator into an artist, but it might also brand him a dilettante.

In 2007, Dedelley created a series of objects which he called "deeply superficial," as if referring ironically to the relationship between design and art, or playing off the supposed superficiality of design against the supposed profundity of art, or proposing, as a counterpart to Nietzsche's "superficiality out of profundity," the concept of "profundity out of superficiality." The works consist of Styrofoam cubes. Inspired by his studies of "crystalline geometries," the designer has rounded off their corners. They resemble huge, many-colored gemstones. One could use them as stools or side tables, or perhaps even, stacked up, as plinths.

Dedelley is an observer. For him, creating does not mean generating an object out of nothing. Instead, it consists of adding, of taking away, of rendering independent, of shifting. What inspires Dedelley is a coincidence in the world of objects, something that sticks out in a subtle way, imposes itself on the eye, as if it embodied some secret, invisible order. Making this order visible in the form of an object allows Dedelley to outsmart chaos. It is as if the designer, finding his way through the world, were to exclaim: "There are gags out there and no one notices! I want to use such a gag by trying to make a halfway decent object out of it and draw order from chaos." Whether the gag would exist without the designer's eye is doubtful. In this sense, too, the objects created by Dedelley are superficial in a profound way. Sometimes he takes his cue for an order not from coincidence, but from a puzzling architecture, a puzzle that can only be solved on closer inspection: "I love it when situations have a logic that only becomes apparent at second glance."[2]

The precise use value of the *Deeply Superficial Objects* appears hard to define. Those visiting the

Zurich gallery for "decorative design" where they were exhibited were probably not expecting to be able to attribute any such value to them. Dedelley's objects were probably perceived as ornaments, as decorative objects. They may have pleased the viewer because of their shape and color. Their title, or name, may have been deemed amusing. Would it have been possible to ignore their decorative, ornamental function and view them as purposeless but nonetheless meaningful things, for example by associating them with sculptural works from Minimalist artists? It is by no means certain that one does greater justice to design ornaments, that one views Dedelley's *Deeply Superficial Objects* with greater attention, when refusing to distinguish between design and art.

On one occasion, the artist Katharina Grosse took a "seating element" upholstered in green leather— an object entitled *Island* and designed by Dedelley for an exhibition at an art gallery, sprayed it with paint and integrated it into an installation of her own.[—> p. XVIII] If Dedelley had given this "element" its particular form by removing all the parts of the leather that showed imperfections, then, measured against this ideal of perfection, the artist had clearly disfigured the object. No wonder the designer said he was speechless. Was this a clash of two different and irreconcilable conceptions of art? Did the artist re-dig a ditch between art and design that Dedelley had wanted to fill in? Or had Dedelley always drawn a line between art and design, a line that the artist then crossed?

Such an example raises the question of the relation between the skilled craft dictated by usage and by the application of ordering principles, and the technical skill traditionally demanded of the artist, the sense of how to and how not to make a work of art. The professional artist serves a purpose, is occupied with producing an artwork. And yet, however little one would wish to define in advance what a chair has to look like for it to be considered a chair, this openness

cannot be compared with the radical openness of art, for one never knows what the things referred to as artworks are. They can never be adequately described in terms of a given purpose because the purpose of artistic activity must always remain undetermined.

Perhaps, however, the question one should ask is not so much that of the difference between art and design, but that of the relevance of a praxis which, regardless of whether it is viewed as that of a designer or that of an artist, pushes the creation of a functional object so far that it touches the line beyond which art lies. Here, it is no longer an easy task to decide whether one is dealing with an object of design or an object of art. It may well be that such borderline cases must then be judged according to whether or not they possess a polemic force. Where they present themselves as positive facts, they risk sinking below art and turning into mere ornaments.

Why shouldn't it be enough that there are objects of design on the one hand, and, on the other, objects or works of art? What drives the designer or the artist to create a different kind of object—if one ignores the pathetic answer that other kinds of object can be made and that this very possibility justifies doing so? Are ornaments the only borderline cases between design and art, inhabiting the only space where design and art can meet? If borderline cases of design and art are to be more than mere borderline cases, if they are to allow for an insight into the "conventional" normal case by moving beyond it, beyond the design object and the artwork, they must provide an answer to this question. One possible answer is given by Adorno in his essay on functionalism when he observes that there is no such thing as "an aesthetic object in itself," and that there is merely a "field of tension" brought about by the "sublimation of purpose."[3] Displaying this field of tension as such would be less a matter for something that already proclaims itself a work of art than for something that goes beyond the

distinction between art and design, but without assuming an ornamental function.

I am grateful to Burkhard Meltzer for the stimulating questions from which this text grew. AGD

1 Theodor W. Adorno, *Aesthetic Theory* (1970), (London 2004), p. 1.
2 Frédéric Dedelley, *Design Detective* (Baden 2008), p. 112.
3 Theodor W. Adorno, "Functionalism Today," (1965), quoted from: Neil Leach (ed.) *Rethinking Architecture: A Reader in Cultural Theory* (London/New York 1997), p. 8.

Surfaces that are easy to clean also show dirt more – Andrea Zittel

The interview was conducted at Andrea Rosen Gallery in New York City on June 29, 2009.

Andrea Zittel For several years, everybody thought that what I do is make living units, but that was back in 1991. I spent a lot of time exploring the territory where design and fine art cross over. At that time I'm not sure that everyone considered what I was doing was art; however, I was interested primarily in objects that could be used, and then felt that what connected these objects to art was the underlying system of logic, or mental constructs that surrounded these objects.

Burkhard Meltzer Logic in terms of rules or restrictions?

Andrea Zittel Yes, I suppose that these could be considered systems of restrictions. You know, the mental structures through which we perceive the world consequently affect how everything around us functions. I believe that humans are inherently seeking some sort of logic in the world, and so we invent mental systems that ultimately determine how the world manifests itself around us. When I did the work *Single Strand Forward Motion* I was really interested in how the visual outcome of an object could be determined by the rules inherent in its making. I would start with a set of rules but no master plan, so the final shape could take on a huge number of different forms, although there was always a consistent visual language manifested by the "rules" inherent in the work. One comparison for this type of influence is the software that architects use to design buildings—and

how that software often results in a particular and identifiable visual language. I should add that, to some extent, these *Single Strand* works of the last few years are a series of conceptual exercises. Lately, I have been thinking more about the actual experience of the world rather than the formal arrangement of it, and I am interested in a more sociological aspect of design and architecture in how they generate an illusion of "lifestyle," or an illusion of lived experiences that very, very seldom really become experiences.

Burkhard Meltzer It was interesting to see all those billboards in your Basel show 2008 now giving rules and creating systems that formerly were furniture and clothing. I felt there was another form of knowing things.

Andrea Zittel One form of this logic, which is highly psychological, is the creation of rules. And the language of graphic design and advertising has always been really interesting to me in the ways that it directly reflects and then distorts our culture's value systems and mental interpretation of things. The texts on the billboards are generated from a series of "principles" that I've been collecting over the years. There is sort of a silly one about objects: "Surfaces that are easy to clean also show dirt more. In reality a surface that camouflages dirt is much more practical than one that is easy to clean."

Burkhard Meltzer It sounds like in your new work you are trying to focus less on producing objects or making experiments with objects more than once.

Andrea Zittel This is the ongoing split in my work. I am inherently an object-maker, I'm technically good at making things and I love the

challenge of making a good object. But I often wonder if it even makes sense to make "things" in a world that is already overflowing with commodities. But whether I make physical objects or just conceptual exercises, I keep coming back to the "thing"–both as a point of stimulation and as a limitation.

Burkhard Meltzer Like a rule itself?

Andrea Zittel Yes. Perhaps one reason that I probably have always leaned toward object making is in order to avoid representation. When I came of age, there was a strong movement against representation amongst my peer group, though now I find that I'm starting to question this bias. Recently I have found that representation can often be one of the most succinct ways to communicate an experience. For instance, with the ongoing project at A-Z West in Joshua Tree, it has always been really important to me that people see my work in its original context. I was living my life and putting it on view, but at a certain point I realized that instead of making my work more "real," the public component of the undertaking actually made my life less real. I realized there can be a real experience and a representation of that experience, and they don't have to be the same thing in order to communicate the message. And sometimes the "real" empties the "real real" out of the thing...

Burkhard Meltzer I asked myself, after I first saw Living Unit or Raugh furniture,[→ pp. II, X] if the idea of comfort would play any role in these works? With the A-Z Living Unit you could almost reach everything from your bed.

Andrea Zittel I thought that bed was very comfortable, my boyfriend disagreed at the time. It's hard when you are making furniture to make it comfortable. I am definitely interested in both physical and psychological comfort and how sometimes one can override the other. For instance, sometimes it is more important that something is psychologically comfortable than physically comfortable.

Burkhard Meltzer If I read the title Critical Space [exhibition catalogue and monograph, New York, 2006]—

Andrea Zittel I've never been totally comfortable with that title as I'm not sure how I feel about the word "critical."

Burkhard Meltzer Is there a kind of criticism in your work that questions itself at the same time as it is perceived as comfortable?

Andrea Zittel Well, if my work is critical, it is more in the sense that it is an undertaking to explore the underlying functions of human nature and the psychological makeup of the man-made world. I am sometimes uncomfortable about value judgments, so I don't know if I ever actually criticize anything overtly from the outside. And sometimes I am criticizing myself rather than anyone else. When I make highly experimental structures for living, I am trying to provoke thought, but not necessarily by trying to make anyone's life uncomfortable, and I actually am sort of irritated by design that overrides the function of the work and becomes an attention-grabbing gimmick. Well, I shouldn't say that, though. If you think of someone like Martin Margiela, his work is critical and completely functional at the same time. But I really like furniture that is both conceptual and completely functional.

Burkhard Meltzer You've mentioned you're working at the crossover of design and art.

Andrea Zittel I am interested in both fields. Sometimes, my work is positioned as design by others—but I'm not really sure if it is. Ultimately I guess that my chosen position as an artist is more that of a consumer—approaching all of these objects and trying to navigate and understand them and how they work, physically and psychologically. One of the reasons I'm initially interested in the crossover between art and design is that in my research it became very clear to me that design came out of art in the very early 20th century. I have always felt that it was impossible to talk about art and culture without talking about design. I really think that they are two parts of the same thing. But one thing I like about design is that it is actually a very strong reflection of the state of the culture that we live in.

Burkhard Meltzer Looking at design?

Andrea Zittel Yes, you can understand so much about our culture by looking at design—such as the underlying economy, social structures and value systems, while art is often so caught up with its own self-referential vocabulary, it neglects to address the world at large.

Burkhard Meltzer When your pieces enter a museum, are they no longer used as they may have been used before? And if some collector would sell a piece of yours to a museum or donate it, would it then be allowed to be used in a show, or not?

Andrea Zittel This is an ongoing and actively debated decision. Recently, the Guggenheim purchased a *Wagon Station* that was customized by an individual—so in that case we decided that it needed to be maintained with all of his customizations intact. But they also purchased an "un-customized" work, which they can change and modify. Then, the bigger question is: if someone were to customize a *Wagon Station* in a museum collection, what would the actual function be? Why would anyone want to live (or camp out) in a museum anyway? Moderna Museet in Stockholm has a work that they allowed someone to live in, within the museum, when the work wasn't on view—which was a sort of interesting way of dealing with issues of both function and security, and privacy for the occupant.

Burkhard Meltzer So that's a kind of lived experience becoming visible in an object?

Andrea Zittel I think that ultimately the experience embedded in the work is the most interesting aspect of it. You know, my work does not always function that well in institutions, which is why I am always trying to find other contexts for it. The museum is a great place to preserve work or to educate people about art, but to really experience a work, they need to experience it in the world, not in a museum. Sometimes gallery shows are actually a bit easier because a gallery is so much like a store. The shop-like quality creates a more accessible relationship for the viewers, since they can at the very least fantasize about buying something—or maybe they really can afford it and then they can take it home.

In Good Company:
Constructing Identity Through Objects
Monika Kritzmöller

"Something that can be inhabited, that offers shelter, but that's made with whatever happens to be at hand."[1] This description could be said to sum up Florian Slotawa's artistic engagement with human environments and the things used to build them. In his work, these environments represent social themes within a larger context, a central issue being the constitution of individual identities—a theme currently found, not coincidentally, both in sociological studies and in design and art. Using works by Florian Slotawa, Mamiko Otsubo, David Renggli, and Jerszy Seymour as examples, this essay analyzes the ways artists and designers address and perform identity work.

In their work with furniture, the objects used by individuals to shape their everyday personal living spaces leave their usual context and challenge viewers, confronting them with contrary worlds: familiar domestic objects can no longer be deciphered in the usual manner, added to which the viewer is confronted with a treatment of themes central to life today. But what

is the motivation for this discussion in design and art? Are visions behind it, or utopias? Calls to action or food for thought? Critiques or possible solutions? And what is the "task" of those confronted with these works in their role as recipients or even participants?

Scope for design, scope for interpretation

The following analysis is based on the concept of the "life-world" developed by Alfred Schütz. Taking his lead from the ideas of Edmund Husserl, Schütz describes the everyday life-world as the self-evident, unquestioned reality "in which the individual participates with inevitable, recurrent regularity. The everyday life-world is the region of reality in which the human individual can intervene, and which he can change by acting on it by means of his body. At the same time, the objects and events found in this region, including the actions of others and the results of these actions, limit his own scope for action."[2] Schütz's notion of the life-world thus includes everything encountered in everyday life—from nature through the cultural and social context. It is the shared frame of reference in which life takes place and where individuals enter into mutual relations.

The material facts of the life-world are supplemented by "all sensory strata that transform natural things into cultural objects, human bodies into fellow humans, and the movements of these fellow humans into actions, gestures, and messages."[3] The life-world is divided, then, into its material content on the one hand and, on the other, the (shared) background of experience used to interpret it, as the result of many and varied acts of acquisition and appropriation. These in turn are embedded in (sometimes conflicting) biological, subjective, and social timescales.[4]

Mamiko Otsubo: So much for "and so forth"

Whereas many private interiors are routinely assembled on the basis of the individual's unquestioned assumptions or modeled on reference groups, mostly

using components manufactured elsewhere, works of art and design constitute professional engagements with aspects of life-worlds and lifestyles, produced by the artist/designer him/herself or manufactured according to his/her guidelines. Artist Mamiko Otsubo[5] uses fragments of design classics, integrating them into her own work, reflecting on encounters between these "bastards," as she calls them, and the prestigious originals in the domestic setting of bourgeois collectors. In so doing, she refers on the one hand to a history of life-worlds, a process of learning taste and culture of the kind described by Pierre Bourdieu as the basis and motor of social distinction.[6] At the same time, she encourages advances in how classic designs are perceived, firstly by integrating well-known components into her work as "points of entry," and secondly, via this decontextualization and appropriation, by disrupting and destroying existing assumptions concerning their appearance and usability.

In this way, Otsubo intervenes in a functional principle used by actors within society to orient themselves in their life-world. The everyday praxis of interpreting the life-world draws on an existing store of knowledge on the basis of which current situations are classified by type. The sight of an Eames frame evokes the whole piece of furniture before the mind's eye of the viewer (assuming the viewer possesses a basic knowledge of modern design classics), plus everything that person associates with this model—intellectual aspects such as the design's historical context, but also places or situations where it was previously encountered, as well as recollections of actual use, personal body memories in which sitting position and degree of comfort resonate. Confidence that such a store of knowledge will continue to be valid, at least in certain contexts, can be described in Husserl's terms as the ideality of "and so forth": one assumes that what was valid today will also be applicable at some later point in time. Without such routines, any given

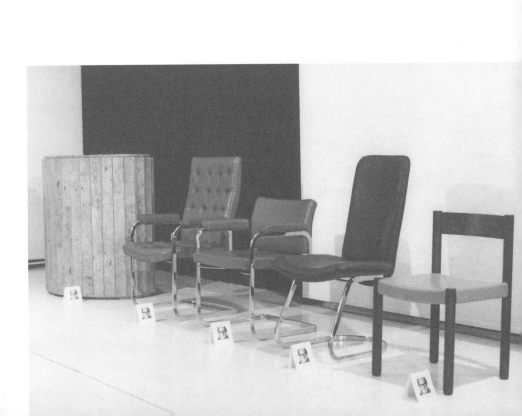

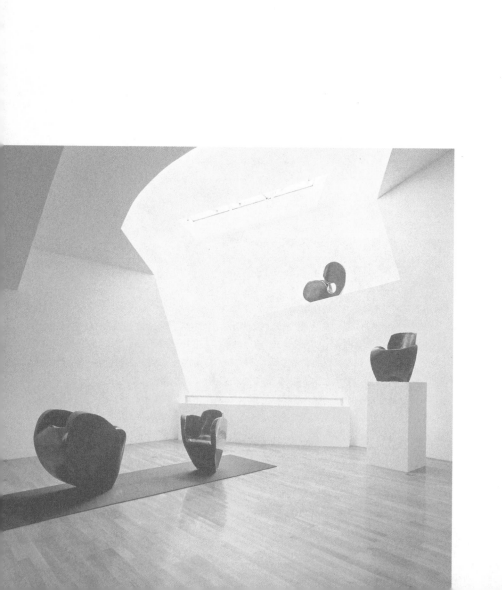

situation, however banal, would have to be questioned, classified, and the correct response learned afresh each time it was encountered.

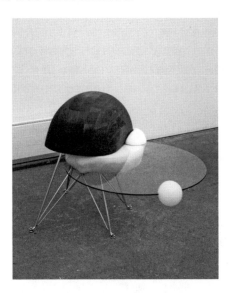

Mamiko Otsubo, *Untitled (with Eames chair base)*, 2007

Quite clearly, however, approaches that aim to fracture, disrupt, and break down such assumptions have been a central component in the work of designers and artists since modernism. At this moment, the situation shifts away from the unquestionably given towards the problematic, and calls for a solution (to be found): "We might say," Schütz writes, "that the un-questioning quality of my experience 'explodes' [...]. The reality of my life-world challenges me to reinterpret my experience, so to speak, breaking the chain of things I take for granted."[7]

Florian Slotawa: Crossing borders of space – identity – privacy – mobility

Experimenting on himself, so to speak, Florian Slotawa crosses the line between private interior and exhibition context by transforming his own furniture (or that of the museum director) into an installation, or by dismantling the furnishings of hotel rooms as the raw material for cave-like dwellings all of his own.

The result is an interweaving and transcending of learned life-world meanings via the functional displacement of objects which in Slotawa's works no longer provide their usual utility, instead finding themselves "reset" as raw material for his large-scale sculptures where they are given an entirely new task: "From being objects of everyday use, things temporarily become material for art, before returning to use."[8]

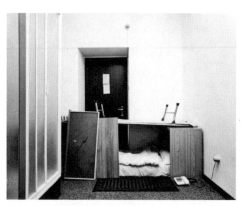

Florian Slotawa, *Hotel Città di Parenzo, Triest, Zimmer 307, Nacht zum 2. Januar 1999,* Photography, 20.5×26cm, 1999

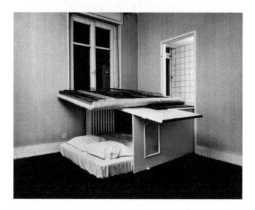

Florian Slotawa, *Hotel des Vosges, Strasbourg, Zimmer 66, Nacht zum 13. März 1999,* Photography, 20.5×26cm, 1999

One point of departure for Slotawa's work is his engagement with the contents of his own apartment. In *Besitzarbeit I* (Property Piece #I), the artist translates seminal life events such as moving house or the end of a relationship into the form of an art project. First, a photographic inventory divides the objects according to their subjective importance into A-, B-, and C-grade possessions, with the last category then banished

from the artist's personal sphere. This approach involves dealing not only with objects, but with materialized aspects of the artist's own biography. When things that were formerly filled with meaning lose their function, the same then applies equally to the setting in which these things were used. In this way, work on possessions becomes identity work.

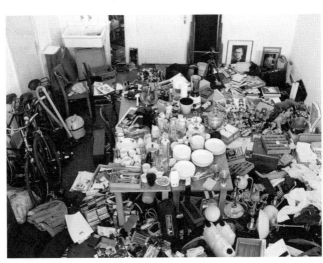

Florian Slotawa, *Besitzarbeit I: Gesamtbesitz*, Installation view, Hochschule für Bildende Künste Hamburg, 1996

The construction of identity is a central issue for the individual in post-modern societies.[9] Closely entwined with the private and creative shaping of external life-worlds (and spheres of experience), the question of identity is a call to "make oneself at home" in one's own biography. In the 1950s, Erik Erikson described a linear concept of identity according to which identity work is limited to the phase of adolescence, ending when adolescence ends, as this phase results in the formation of a personality that henceforth remains stable. What for Erikson was an exceptional state early in life becomes, in individualized societies, a permanent state. The work of carving out and piecing together one's own "persona" (Latin for "actor," "mask," but also "character") is a lifelong task. Worn-out parts are cut out and new facets inserted. The degree to which individuals struggle to "position" themselves

in a volatile environment is matched by the importance of the material surroundings in and by which this process and its intermediate stages can be said to be recorded, materialized, visualized. This is how Peter Gross describes the struggle for identity in his book *Ich-Jagd* (Hunt for the self): "And if objects and relationships emerge from these qualities, […] then they are not (as may have been the case in pre-modern cultures) selves of memory, and not (as perhaps in the great monotheisms) angel selves, but possible selves that are sent forth and hurled into the future."[10]

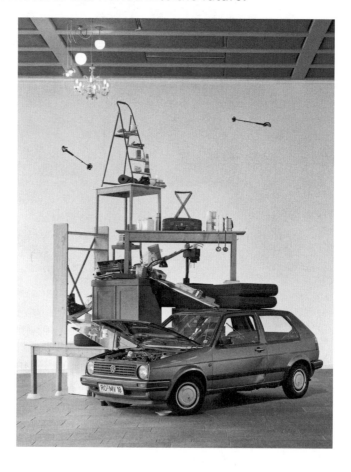

Florian Slotawa, *Besitzarbeit VIII: Jüngstes Gericht,* Installation view, Kunsthalle Mannheim, 2000

In Slotawa's other property pieces, the personal dimension of the objects (which, as he points out, no longer show any traces of his life and are not expected

to convey his personal stories or history) "takes on a life of its own" as soon as the objects leave the personal sphere to enter the art context. Materializations of personal life give way to materializations of habitats, as in *Besitzarbeit IV*, where Slotawa builds a model of the landscape of his home region—the pre-alpine country-side between Munich and Rosenheim—on a scale of 1:35,000. Such reconstructions of one's space of origin become relevant when this place has been left behind, no longer to be taken for granted as the view from a window, in the worst case as something inescapable, but as something seen from a distance, perhaps even idealized. Like identities, the places we call home are no longer a given, but must be worked on. "It was also about the tension between being at home and being on the move, I was building my home region at the same time as dismantling my home there."[11] To the un-fixed quality of the individual is added that of place: biographies have long since become mobile, in many cases placeless. But defining a sense of home does not necessarily mean having a home; where one feels at home and where one lives may also drift apart. This "placelessness" is intensified when Slotawa not only moves away from his regional roots, but also inte-grates his furniture into a number of exhibitions taking place as far away as New York, thus stripping them of their domesticity, while he makes do with temporary solutions in an almost empty apartment.

As well as forming the core of Slotawa's work, the tense relationship between separation and attach-ment is also present more generally as a recurring phenomenon in everyday life at moments of transition from one phase of life to the next. Mobility always also means leaving old things behind and letting go—although the impact is rarely as "radical" as that resul-ting from *Property Piece #4*, which Slotawa also refers to as the "Last Judgment." Over a period of weeks, in a photographic activity resembling a ritual, the artist took leave of the entire contents of his apartment—

which had been purchased as an artwork—so that the pictures now tell a story whose subject is no longer physically present for the artist.

The narrative component of identity construction and the conflict between detachment and retention are also addressed by Slotawa in *Property Piece #6*, in which his mother's height determines the scale of the towers he builds. In this way, he makes use of a fixed variable which, alongside the impossibility of deciding to be born, is one of the few things that cannot be chosen in today's world—the identity of one's mother as a lifelong constant. This maternal link inevitably stands at the beginning of one's individual "history," providing an anchor of personal orientation throughout one's existence.

Building bricks of identity: narration and bricolage

In this process of narration, as well as bricolage, we see the second principle governing identity work: it unfolds in constant interaction with others. Individuals devise and tell their own "story," whose persuasiveness is measured by several things, including audience response. This raises the issue not only of the historical content of such a narrative, but also that of its perspective, the vanishing point towards which it is directed. Such (initially imaginary) identity options are visualized and bodied out in the built, designed life-world; possible selves are symbolically materialized and thus brought within reach, while the individual gauges his/her everyday decisions by such perspectives, using them to assess the available options.

Admittedly, such a vision of the future is not at the center of Slotawa's works, whose focus lies primarily on coming to terms with the past and the present, on "ordering" what went before and what now exists (*Bonn Ordnen*, Bonner Kunstverein, 2004), or checking its ability to support new designs. Often, this checking concerns dealing with the available

resources and their scarcity, with the need to make do with what there is, whether this involves making an exhibition with *No Money* or creating a shelter in the alien settings of hotel rooms.

Processes of appropriation, territorial rights

Not only the components of the work, but also the way they are acquired shaped Slotawa's exhibition at the Kieler Kunsthalle, in which he responded symbolically on a different material level to the organizers' "transgression" of having "no budget"—and thus wishing to use the services of the invited artists free of charge.[—> p. IV] Slotawa's intervention extended to the museum's administrative structures (only indirectly involved in matters of art) where he negotiated with staff members about using their work furniture, desks included. As a result, the institution hosting the show became the object of Slotawa's work, as the artist negotiated its internal boundaries of access, responsibility, and authority. The sourcing of objects he used played a central part in Slotawa's work: whereas initially he carried his own possessions (and thus his own choices) into the public context, the way he sourced his working materials at the Kieler Kunsthalle was a social experiment in negotiating territories and (transgressing) frontiers, making it a form of power-play based on advancing into foreign spaces and disposing of insignia that symbolize the role of others.

The segregation between front and back areas of the stage cited by Erving Goffman in his dramaturgical model of the maintenance of social identity[12] is lifted when the male artist explores his claim to the mirror in the women's toilets (a space from which he is barred as a private individual). If the project as a whole signified *No Money*, then established roles are called into question, the "price" of abandoning them formulated. As a result, the personally troubling intervention in one secretary's working environment was compensated for by the status-enhancing publicity she subsequently

received as the "owner" of the desk: the object of her mundane work became an essential part of an art object about which the owner was later interviewed for television. In this way, Slotawa's narrative had a knock-on effect for the "project partners," enhancing their status as employees of an art museum. The former backstage area of the Kunsthalle offices shifted into the limelight of artistic dramatization, becoming the object of media documentation.

Between stage and backstage

The artist's work enters deeper still into the life of Madeleine Schuppli, the director of the Thun art museum. Lacking material of his own, Slotawa shipped the furniture from her apartment into the exhibition space (*Museumsshop Thun*, 2003). Schuppli's private life (and that of her partner) was thus played off against her professional role as curator and art-lover. Her furniture left the shelter of her private living quarters to be put on display in reinterpreted form in her own workplace. Thus both the director and her possessions switched roles, being subjected to the scrutiny of reinterpretation and public viewing.

Slotawa's works can be read as social constructions of objects consisting of different materials and elements which, like the actors in human societies, make their impact in relation to each other and to the audience. What also becomes clear is the creation of spaces and the definition of borders and possibilities for access as a social construct, as emphasized by Georg Simmel: "Social interaction among human beings is—apart from everything else it is—experienced as a fulfillment of space," he notes in his essay on "Space and the Spatial Ordering of Society."[13] Social relations, also in terms of proximity, belonging, or distance, become sensual and spatial. Space and living spaces, even supposedly "natural" ones, are not givens.[14]

In his works, then, Slotawa offers a sensitive mirror image of processes of space-making and territo-

rialization as they shape day-by-day dealings with living spaces and the negotiation of positions and hierarchies among social actors.

David Renggli:
Materializing processes of negotiation

David Renggli also deals with life-world themes: in his works, he arranges everyday objects, using them to reorder the existing surroundings. In the unfamiliar combinations of all the things that can be found in similar form in many ordinary homes—Monobloc chair and conservative pumps in *Behind Stuhl* (Behind Chair), teenage bed and exercise machine in *Arm Holds Hand*—common practices are called into question; apparent breaks in the work shed light on no less absurd but seemingly self-evident everyday behavior. In *Arm Holds Hand*, Renggli develops imaginary biographies and identities and tells the conflict-ridden stories of bodies in the process of negotiating the world of objects.

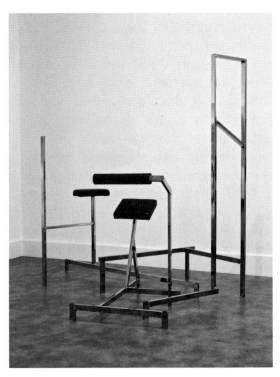

David Renggli, *The Train from A to B*, 2008,
Installation view, Nicoletta Rusconi, Milan, 2010

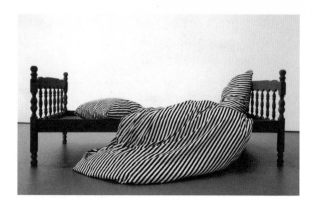

With his pseudo-exercisers entitled *The Train
from A to B*, Renggli addresses the desired transforma-
tion from the actual to the ideal, highlighting the un-
attainability of collective utopias. In real life, such meta-
morphoses "from shapeless to muscle-bound" often
remain a pious hope when social norms collide with
personal practice. Not only in Renggli's artwork does
the shiny tubular steel of fitness equipment mutate into
a frame for cobwebs, which cut a far more striking
figure than the struggling, sweating owner. Similarly,
the stories emerging from a hypothetic use of his objects
move between stage and backstage in Goffman's
sense, between publicity and intimacy. Ideally, the pri-
vate context of a teenage bedroom (as in *Arm Holds
Hand*) or the exclusive setting of the gym are supposed
to present all the figures that are then shown to the
world at large as a seemingly self-evident state. The fact
that the gym equipment cannot actually be used is
linked to the inadequacy (measured against the ideal)
of the physical form achieved. Rather than a potential
solution, what is revealed is the unattainability of a
collective utopia. The spotlight here is on the individu-
alistic notion of being able to make and shape one's
own body which refers those concerned back to them-
selves, attributing successes and failures not to the
formerly (God-)given quality of physical appearance
but to the individuals themselves and their (wrong)
decisions.[15]

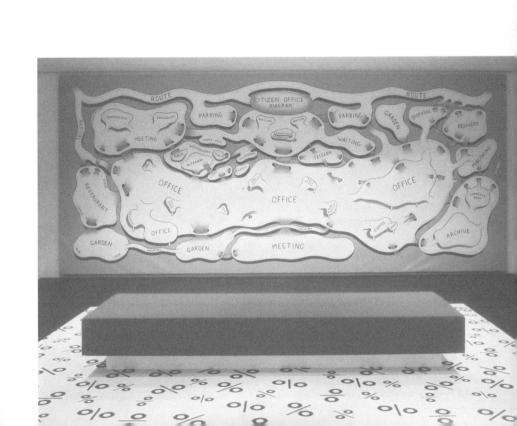

The arrangement as a whole moves beyond the frame of a snapshot of an individual body, referring to processes of contestation within society between past and present, family lifestyles, and personal biographies. Inscribed into the combination and processing of furniture objects, there are parallels here to a set of furniture assembled over the years—a private process of curating, so to speak, aimed at "making oneself at home" in a sequence of different biographical situations. The green-painted teenage bed, its color chosen by Renggli in reference to the folk art of Swiss decorative painting, is also the expression of a national identity and its history. The anticipatory gesture—when the parents select a bed in which they hope their little boy will sleep well in the years to come—coexists with the already obsolete object when the boy will have grown out of it, both physically and stylistically.[16]

The sociological concept of a patchwork identity,[17] which in spite of lifelong work will never be complete, is artistically distilled into objects as heterogeneous as the mass-produced wooden bed, its traditional green paint, and the once fashionable but long since outmoded Op Art blanket which is now reinterpreted as a quotation from the 1960s.

Showdown between object and subject

Renggli's work makes clear the interrelation between influence and resistance: Individuals intervene via their actions in the life-world, changing it, while at the same time being restricted in their freedom to develop. Forms of these modes of action as well as the limitations they face offer information about the prevailing cultural understanding: which movements should and must be permitted by a piece of furniture designed for sitting? And how does the user choose to treat it? In conversation, Renggli speaks of the lack of comfort sometimes experienced on public transport. In such areas of the life-world not shaped by him/herself, the individual faces the challenge of coming to terms

with forms which were not designed in accordance with his/her own needs but to which he/she is exposed more or less voluntarily for a certain time. The artist goes one step further with the character imagined in the teenage bedroom, who has grown out of his bed once and for all, taking care of this "being" rather than *it* granting *him* refuge: "The bed is titled *While I work, my bed sleeps.* As if I always had such a guilty conscience, the bed is so old and needs lots of sleep, which is why I work so much, so the bed can sleep."[18]

A tension is revealed here between the individualism demanded by society and the standardization of large parts of the life-world. Which options are open to those affected by this? What is the outcome of the showdown between self-will and resistance? In Renggli's work, the object "triumphs" over the subject, so to speak, the latter apparently left with no choice but to adapt its own behavior to what is given (and imposed). This foregrounds a diagnosis of the current state of affairs, rather than any vision of its overcoming: the ever-flexible individual, failing in its noble (fitness) objectives, maneuvering between different worlds of experience within which it seeks its identity.

Jerszy Seymour:
Amateur and capability

Jerszy Seymour, on the other hand, is concerned as a designer precisely with writing new user-generated narratives pointing to an imaginary, visionary "vanishing point." He calls on his audience to participate, making it an essential part of his work. At the same time, however, he operates in the "sheltered," artificial, and thus controllable context of the museum. His work, too, focuses not on the still "inanimate" objects, but on the events they trigger: "Design is the creation of life situations."[19] The main protagonist here is the "amateur," who takes center stage (this text featured as a projection in the *First Supper* exhibition at MAK, Vienna, in 2008): "First Supper is a nowhere place, an amateur

soup and an open ended utopian question mark. it is cooked on a non-commodity flame, and made with ingredients of doing, sharing and being. should it exist? could it exist? what will we eat? what will we talk about? you are invited to dinner by Jerszy Seymour and the coalition with love. please enjoy and vive la utopia!"[20]

The means available for the realization of Seymour's *First Supper* at MAK do not go much beyond simple wooden laths, synthetic resin granules, stoves and cooking pots, and some pumpkins. The social event here, then, is not preceded by a flourishing trade in finished products from furniture via tableware through kitchen equipment, which would recall a hi-tech operating theater, used to heat up ready-to-serve meals. Instead, the emphasis is on shared experiences and the "management" of one's own capabilities in the sense of *manus agere*: taking things in hand. In contrast to the "outsourcing" used in the professional world, Seymour offers the creative self-confidence and passion of the amateur who enters into a project out of love.

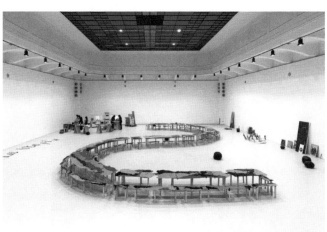

Jerszy Seymour Design Workshop, *First Supper*, Installation view, MAK, Vienna, 2008

In this work, the designer addresses a central and all-encompassing development of recent decades: the commercialization of private everyday life, combined with an erosion of individual capabilities. Whereas

children once built their toys out of what they could find in the woods and meadows, their gaming consoles must now be updated with the latest tools. Homemade jam has been replaced by industrial products from the supermarket. Knitted styles are back in fashion—knitted not by hand, but mass-produced and distributed on an international scale. Even the business of having fun on vacations is delegated to a host, parties at home organized by an events agency. "The supposedly myriad possibilities for action are reduced to the social actor's function of spending money on services whose quality can only be guessed at in advance. Ironically, individuals use a considerable portion of their household budgets to 'reward' themselves—for working so hard. In exaggerated form, this situation can be described by comparison with someone in a nursing home who depends on others to manage his/her life."[21] And finally, in a state of acquired helplessness, things which not so long ago were cultural skills taken for granted across society are now experienced as being beyond one's own capabilities.

While in everyday life the capabilities of "amateurs" are often ignored, denied, and shifted to the professional level, Seymour's aim is to challenge them

in an active life. Creating life-worlds with one's own hands becomes a social event and a reflection of needs and wishes. With *First Supper*, he addressed the individual's capacity to exert a shaping and controlling influence on one's surroundings by having all of the furniture for the meal at the show's opening built out of mundane materials, casting tabletops and seats out of synthetic resin, their marbling later echoed in the texture of the pumpkin soup. The kitchen acted as the "nucleus" of the whole situation, the source of everything required for sociable living, from wax warmed on the stove to the hot soup.

The piece also sheds light on the function of appropriating and structuring spaces in order to control social processes: Out of "nothing," a meeting place emerges where people can eat, drink, and talk together —expressing the social importance of shared mealtimes, as highlighted by Georg Simmel in his *Sociology of the Meal*.[22] After use, the setting is transformed back into "nothing," the food eaten, the tables and benches melted down again, their wooden parts gathered together, and it becomes clear: events come into being through the joint actions of social actors, with objects merely playing a supporting role as means and expressions of potentials for action.

The extent of these potentials for action is manifested in Seymour's *Amateur Chair*: Under industrial strength testing, the archaic-looking construction consisting of wooden laths stuck together at the corners with resin dismantled the illusion of the superiority of standardized industrial products in terms of stability, compared with the results of committed amateur efforts. The actual challenge to the actor developing his/her "potency" does not lie in a lack of potential. Instead, it is about a lack of awareness that these possibilities can actually be realized, and thus about the utopian idea of the non-place (*u-topos*), a geography and coordinates of identity.

Layers of space as evidence of identity work

In works of both art and design, critical analysis, alteration, and improvement of the life-world are recurring motifs. The main thematic areas in which this takes place resemble a mirror image of what actors in society have to deal with on a day-to-day basis, what causes them discomfort or pushes them to their limits. In the work of both artists and designers, such limits experienced—or proclaimed—as "given" and "immoveable" are crossed and transcended, and this fragmented limitation of one's own perceptions may lead to new discoveries. In this process, many possibilities are used to reinterpret places that were previously unconsidered and unimagined. Whereas in art such themes are viewed primarily in critical terms, to rob the seemingly clear of its aura of self-evidence and to demand new ways of seeing, non-applied design proposes an engagement with possible solutions.

Both disciplines apply a constructive, hands-on approach: Be it Slotawa or Seymour, the making of the work may already involve a social experiment. This creative process, then, also draws parallels between the individual's day-to-day dealings and the construction of identity. What takes place routinely and often unconsciously in everyday life is explicitly reinterpreted using life-world "tools" (from kitchen equipment through exercise machines) as the building bricks of identity. The use of these tools is thus subject to a rationalizing legitimization. What is constructed is no less than an edifice (of thoughts and ideas) housing the floating, splintered, and constantly recomposed "society" of possible selves out of which the person in search of identify defines him/herself.

1 Florian Slotawa interviewed by Burkhard Meltzer and Tido von Oppeln, 2009.
2 Alfred Schütz, Thomas Luckmann, *Strukturen der Lebenswelt*, Vol. 1 (Frankfurt 1979), p. 25.
3 Ibid., p. 27.
4 Ibid., p. 75 f.
5 Mamiko Otsubo interviewed by Burkhard Meltzer and Tido von Oppeln, pp. 63-65 in this volume.

6 See Pierre Bourdieu, *Distinction. A social critique of the judgment of taste* (1979) (Cambridge MA 1984).

7 Schütz, op. cit., p. 33.

8 Florian Slotawa interviewed by Burkhard Meltzer and Tido von Oppeln, p. 215 in this volume.

9 See Jean-Claude Kaufmann, *L'Invention du soi. Une théorie de l'identité* (The invention of self. A theory of identity, Paris 2004).

10 Peter Gross, *Ich-Jagd* (Frankfurt 1998), p. 93.

11 Florian Slotawa interviewed by Burkhard Meltzer and Tido von Oppeln, 2009.

12 See Erving Goffman, *The Presentation of Self in Everyday Life* (New York 1959).

13 Georg Simmel, *Sociology: inquiries into the construction of social forms* (1908) (Leiden/Boston 2009), p. 545 (with one minor alteration to the published translation to reflect actual meaning).

14 See Monika Kritzmöller, *Wohnen – Wie Menschen "sich einrichten,"* (Aitrang 2006).

15 See Monika Kritzmöller, "Ebenholz und schwarze Sterne. Der Körper als Abbild von Individuum und Gesellschaft," in: *Ernährung im Fokus*, Bonn 09-09, pp. 350-355.

16 David Renggli interviewed by Burkhard Meltzer and Tido von Oppeln, p. 230 in this volume.

17 See Heiner Keupp, *Identitätskonstruktionen. Das Patchwork der Identität in der Spätmoderne* (Reinbek 1999), p. 431.

18 David Renggli interviewed by Burkhard Meltzer and Tido von Oppeln, 2009.

19 Jerszy Seymour interviewed by Burkhard Meltzer and Tido von Oppeln, p. 213 in this volume.

20 See http://www.jerszyseymour.com/, visited January 19, 2011.

21 Monika Kritzmöller, "Hauswirtschaft als Lifestyle-Management," in: *Ernährung im Fokus*, Bonn 12-08, pp. 450-457: 454).

22 See Georg Simmel, "Sociology of the Meal," (1910) in: David Frisby, Mike Featherstone (eds.), *Simmel on Culture: Selected Writings* (London/Thousand Oaks 1997), p. 130.

Design Situations – Jerszy Seymour

The interview was conducted at Jerszy Seymour's Berlin studio on June 2, 2009.

Tido von Oppeln For a few years now you have been working with the concept of the "Amateur." How and where did that idea start and why did it become so important in your work?

Jerszy Seymour I started in 2003 with the series of projects called *Scum*, finishing with the *Brussels Brain* in 2005, which started from zero. It was a pre-Amateur project, but it set the context. It said OK, the history of design has arrived at a certain point where it has become only about the market. The old mandate of design—products for the people—has become completely devalued. So where do you find the point to start from again? I mean, in the seventies, people didn't know anything about design, in the eighties not much either, but then in the nineties everybody knew something about design. And I see that now everybody also knows a bit about art. 200 years ago art used to be in the hands of a super elite and now it's become a popular thing. The *Scum* project is really about creating a zero situation, which you design yourself. It started at a certain point with the question: "What is possible?" It is a lot about dealing with materials but also as a metaphor—actually contemporary materials but used in a very free way.
All that was leading to the project *Living Systems* at the Vitra Design Museum, which was about the "economy of the individual." A person finds himself in a situation where he doesn't find what he wants in contemporary society, and so he goes on to make it himself. He gets a piece of earth and grows his potatoes, and synthesizes plastic from them to make the things that he needs. The exhibition was an experiment and it almost worked—but it wasn't about selling the pieces. What came out was that we made this stuff and we made these shapes and this action was a kind of liberation.

Burkhard Meltzer It seems like an experiment with one's needs. You're searching for certain goods that you'll never find in the marketplace.

Jerszy Seymour No, it's actually about experiences, it doesn't need to be a product. The objects are testaments to an action, but they are not really necessary. And so we arrived at the idea of the "Amateur." By Amateur, I mean lover and "appassionato." I use a contemporary wax, a material that is a metaphor for changing and transforming desires. It arrives at the point where the "living systems" guy says: Let's start to talk about what an alternative could be. The Amateur creates a certain level of autonomy, which could make an alternative system work. On the website[1] there is a diagram with a lot of discussion about economy, energy and distribution. So, there was the first supper, which opened up the discussion, and that exhibition was a big table and a kitchen. The kitchen was the production center, the table was the consumption center. The furniture was made in the kitchen and the people ate the food cooked in the kitchen. It was the same thing. There was a library with all the books that I had been reading at that time. Then we had the supper and afterwards we melted down all the wax to be used for the next project.
In the introduction to the first supper I described the Amateur as an open-ended, utopian question mark. So the exhibition introduced the

idea of the Amateur but it didn't really produce any specific ideas of what the Amateur was about. The next exhibition was the *Salon des Amateurs* and this was a place for the Amateur to think about what an "amateur society" could be. So rather than have a big sofa or something, we thought the ultimate Amateur furniture would be a hot volcanic pool. With the lamp overhead, it looked a bit like the *Dr. Strangelove* War Room. There was a big diagram on the wall that was very explicit in its discussion of an Amateur society.

The last exhibition of the Amateur series was the *Coalition of Amateurs*. This was an exhibition as workshop: the wax material was available for everyone to use so the public could build things, but they could also change or deny the ideology. It was about doing, being and sharing, everybody was invited to come and participate. In a way, this should be the end of the Amateur series and become something else. Although I must admit, when I discovered the idea of making swimming pools, I think I could continue making swimming pools for the rest of my life.

Burkhard Meltzer I'm imagining the meeting between the Amateur and the Super Normal Object—a term that Jasper Morrison introduced into the design discourse. Are these two models that, at the moment, reconfigure the relation to objects and the economy of objects?

Jerszy Seymour The *Amateur* Project is not a solution, but the process is definitely going somewhere. We also thought about doing Amateur furniture as a product. To show that it can work. For instance, this chair is a production piece. And it has an economic value. Actually, for Vitra, we did a strategy presentation two months ago and presented Vitratopia. It's about people's lives, and we put in the Amateur values and created sections for them to work. So the Amateur project is really serious, it is not a fake. But Super Normal is a precise description of a status quo without changing anything. And if I would critique the Super Normal—it's not looking outside of the system. Instead, the Amateur is diving head first into a rocky pool, even naively just starting to deal with lots of unexpected territories and things.

Tido von Oppeln It is actually "situation design."

Jerszy Seymour Let's say design is the creation of life situations. And whatever is necessary to do that, has to do with design.

Burkhard Meltzer So it is a practice to spread the idea of how to do things and how to change situations, and to produce a piece maybe in co-production with Vitra.

Jerszy Seymour I wouldn't be qualified to talk about the alternative positions without knowing what it means to make a hairdryer that costs seven Euros in the marketplace. But I could talk about how to look at an object in another way. The next step is how to run an alternative business model, which is very complicated. On the other hand, a design project has to live. I really don't know what a design is doing in a gallery.

Tido von Oppeln But isn't it the same system? Making a seven Euro hairdryer means to be aware of the cost of its materials. The number of products is smaller but the logic seems to be completely the same in the gallery context.

Jerszy Seymour These places are absolutely critical for having the time to look at what the alternative positions can really be. The gallery situation is where I do experiments that I can't do in other situations. So it is very interesting. It's a place to do metaprojects.

Burkhard Meltzer Is it more like a test site?

Jerszy Seymour Yes, although the museum can be better. The museum is a Disneyland, really. That's something that artists hate about it. Funnily enough, for a designer it becomes very interesting. Because you know that you get a number of people coming and you can work with those people; and with the interaction inside the museum you stay outside the economic logic of the market. It gives a kind of free space.

Burkhard Meltzer Do you collaborate with artists?

Jerszy Seymour Yes, everybody is an artist! I have a simple story about art and design: A man is walking alone across the landscape when he sees the horizon and he is amazed by it. Until this point he has only ever lain down to sleep or stood up to hunt. But now, seeing a stone in front of him, he sits on it so he can think about it. Later, he goes back to his cave, and he was so taken by the horizon, that he looks for a stone and scratches his reflections up on the wall, because he needs to be able to visualize the effect the horizon had on him. Looking at what he has drawn, he is surprised and curious at this representation, and he needs to sit down but there is no stone, so he decides to make something to sit on. And then he looks at what he has made and is also surprised. So the chair also becomes a moment of reflection. And suddenly these two things are related to each other—impossible to separate them. It's not interesting to separate which one reflects on the other.

There is a text by Liam Gillick from an exhibition What If: Art on the Verge of Architecture and Design (Stockholm, 2000). It's nice because he goes through a critique of all the three disciplines. The artist full of potential but without being really effective, the designer quite effective but looking at the narrow view, and the architect trapped as a pop star politician. The conclusion was not how close the disciplines are, but about how much unexplored territory there is in between. That's great. For me, the Situationists International was quite "in between." They said: For art to get out of the gallery and affect the real world, let art be the real function and throw the stone.

Burkhard Meltzer Is it basically about being alive, then?

Jerszy Seymour It could be in the end: imagine the situation living in a cave and scratch my nuts, you know.

Burkhard Meltzer On a raw stone.

Jerszy Seymour It would be a great end.

1 http://amateurdiagram.blogspot.com/, visited February 21, 2011.

Property Pieces – Florian Slotawa

The interview was conducted at Florian Slotawa's Berlin apartment on June 3, 2009.

Florian Slotawa I began making the *Property Pieces* while I was studying sculpture. I decided to start with what was already there—meaning my personal belongings. I was given a room at the academy in Hamburg and into that room I put everything I owned. I went to my parents' house and fetched all my stuff, I moved out of the flat I was sharing and moved into that room. And then I lived there, because that's where my bed was. I changed the lock and gave everything a fresh coat of paint—that's how *Besitzarbeit I* (Property Piece #1) came about.[—> p. 195] I tried to make an initial inventory and took pictures of everything. Then I divided my belongings into the categories A, B, and C as a way of grading by relevance. A was important. B was also important, but stuff I didn't use regularly, things like toys that I'm keeping for my children but don't need at the moment because I don't play with them. Belongings in the C category I got rid of. Later, I decided to move to a different city.

Burkhard Meltzer What happened to the C-grade possessions?

Florian Slotawa It depended. Some I just threw away, some I gave to people as presents, some I sold. For *Besitzarbeit II* (Property Piece #2), I simply showed the move—in the form of a stack of packing cases in the middle of the room. The photographs of the things in the boxes were projected as slides onto one of the packing cases. Eventually, the property pieces became a series, which is still ongoing. They always

feature objects from my apartment. It's not completely empty here at the moment, but it is slightly reduced because some things are in New York for a show at PS1. From being objects of everyday use, things temporarily become material for art, before returning to use. So no material gets used up and no ballast is left over. This switching between everyday life and art, the way the objects circulate between the two worlds, is also a chance for me to work directly or personally.

Burkhard Meltzer With the Mannheim piece, you made a radical inventory and then parted with your former possessions.

Florian Slotawa That came about because a collector wanted to buy a work. Initially I said it was impossible because the objects are part of everything I own and these belongings must go on being used. The collector answered: "OK, then I'll just have to buy everything you own." And in 2002, I really did part with everything.

Burkhard Meltzer You didn't keep anything at all?

Florian Slotawa None of the old things. But it wasn't like I was left standing naked in an empty apartment with a pile of money. It was more of a drawn-out process. I agreed with the collector that I would keep everything until my exhibition at Kunsthalle Mannheim. This solo show was to be the handing-over point. After that, everything was taken away by the collector. In the meantime, I had the chance to buy myself a new bed and a refrigerator for the kitchen. In future, the work is only allowed to be shown in the packing cases. When he bought everything I owned, rather than buying a specific installation, he

actually bought all the installations I'd made up to that time. Apart from the car, he received my belongings in packing cases. In private, of course, he's perfectly entitled to unpack them and have a look at what he's bought.

Burkhard Meltzer In Kiel, you took a totally different approach: you took figures from the collection of the Kunsthalle and used items of furniture from the museum's offices as plinths.

Florian Slotawa That was for a group show called *No Money*. The artists who were invited work with cheap materials or with what's already there. My piece consisted entirely of material that was already present at the Kunsthalle. I explored the museum's collection, where I came across a number of interesting sculptures. But it was clear that I wouldn't just put them on plinths. Improvisation was called for. And I thought it would be interesting to go in search of material around the museum. I was there for ten days, working on my plinths and seeing what I could use for them. Like the mirror above the washbasin in the women's toilet. And I approached the project with the understanding that the museum is there for art— not just the exhibition space, but the whole building. Which means that as an artist, I have a right to this desk, because everything must serve art. The staff saw things differently, of course, and we had to discuss priorities. But as soon as people noticed that their typewriter desk was now part of an artwork, it suddenly took on a different value. At the opening, the local radio broadcaster interviewed them, and all of a sudden they thought it was great to be involved in the exhibition via their objects. In the end, Kunsthalle Kiel bought three of these works—

material already owned by the museum. Then the objects were not returned to the offices, but stored away in the depot. I liked this process.

Burkhard Meltzer Do you also work with models when you're planning exhibitions?

Florian Slotawa Not always, but for large works, yes, starting with the *Ersatzturm* in 2006.[→ p. VII] This work for the Berlin Biennale was made using not my own possessions, but things belonging to the collector who had bought everything I owned. He'd deprived me of all my working material, so to speak. Then I asked him if, in return, he might be able to put his stuff at my disposal. He understood the concept immediately, but he had to negotiate with his wife for quite some time. At their house, I then photographed every object, room by room, measured everything, and then built models— partly to conduct structural analysis of the 7.3-meter tower of furniture. Using the models, I discussed with them what I needed and what they were prepared to give me. I couldn't just go in and completely empty the house. There were limits.

Burkhard Meltzer For the plinths in Kiel and the furniture tower in Berlin, you actually reversed the principle of how property works. On an economic level, it sounds like you're proposing a barter. When you make a work somewhere, it has material consequences for the individuals and institutions involved. In this way, the artwork has a strong impact on the lives of other people and may have consequences on their specific life situations. How did it work with the collector? Did they immediately replace the objects so that nothing was missing?

Florian Slotawa They dealt with these things being missing. Just like I'm doing now. My refrigerator is currently in New York and I transferred the one from my studio to the apartment. So I've got one here now, but I don't have one at my studio. The kitchen table is missing and I've just got a small side table standing there instead. In some places you improvise, in others you just leave the gaps—at the moment, for example, I have no wardrobe, which is why the bedroom over there is in such chaos.

Burkhard Meltzer In a similar way to the plinths in Kiel, you combined the New York piece with a reference to other artworks.

Florian Slotawa I referred to Mondrian. One fascinating thing about his work is the way he makes the transition from figuration to abstraction. In my research, I came across a series of his drawings from 1914 and 1915 entitled *Pier and Ocean*. It's about what you see when you look out over the ocean at night, when the starry sky is mirrored in the water. On the one hand, it's a totally abstract picture with a grid structure, but when you know the title you can also read it as a representation. It walks the thin line between figuration and abstraction. That interested me, in terms of my own work, to say: "Right, I'm actually building an abstract image out of real objects: refrigerator, washing machine, kitchen table."

I first heard the word "Sitzmöglichkeit" in 1995 in the former East Berlin. I was visiting a furnished apartment with a view to renting it, and the landlady asked if there were enough "Sitzmöglichkeiten" (literally: "possibilities for sitting down"). I understood the question—or did I? "You mean chairs?" "Yes, Sitzmöglichkeiten." The word made a big impression on me and immediately took on a life of its own in my head, generating further variations: possibilities for smoking, for eating, for thinking, for doing nothing. These possibilities for discussion, or even for argument, concern both the sitting and the chair itself.

Although "Sitzmöglichkeiten" and the related term "Sitzgelegenheiten" (literally: opportunities for sitting) are still in common use, they remind me of several East German turns of phrase that have died out, in particular the tendency in the GDR to name things after their function rather than their form, preferring verb-based over noun-based terms. There are many

famous examples: instead of roast chicken, the East Germans ate "broiler"; at parades, instead of flags, they held "waving elements"; rather than a "Führerschein" (literally "driver's certificate"), the East Germans had a "Fahrerlaubnis"("permission to drive"). And when it was all over, they were buried not in a coffin, but in "earth furniture."

East German usage may have been a bureaucratic peculiarity, but these idioms also correspond with a restriction of private property and the shared values of the collective in a socialist state. Only *one* person can sit on *one* chair; but everyone has the possibility of sitting. In contrast to forms, functions exclude the issue of ownership, as functions are always shared and thus accessible to all.

As a first possibility for discussion, we could ask ourselves whether language itself influences or even defines our relationship to objects, the ways we perceive and use them. Were we to call cars "possibilities for motorized travel," might automobiles be designed differently and transport more than just one driver—as is now so often the case, reflecting the autonomy suggested by the "auto" in automobile. Could a "possibility for motorized travel" become a commodity fetish as easily as an automobile? Or a "walking element" as easily as a shoe? After all, the fetishist is looking for unique qualities and wants to have a singular relationship with his/her preferred object. Finally, "Städtische Beischlafmöglichkeiten" ("urban possibilities for sleeping together") doesn't sound as appealing as *Sex and the City*.

This linguistic distinction between a fixed, singular form and a moving, shared function not only reflects the difference between the capitalist west and the socialist east, but is also found in Kant's *Critique of Judgment* (1790). I don't mean to blame Kant for the building of the Berlin Wall—although this idea offers a great possibility for discussion. But in view of our

theme here, and the distinction between the viewer and the user of an artifact, I think it does make sense to go back to Kant. In a certain sense, Kant originated the distinction between modern art and design, and he conceived of the two fields (as well as artists and designers, viewers and users) as separate from each other.

Briefly: Kant privileges form over function by linking judgments of taste, and beauty itself, with a disinterested form of contemplation. What he calls a "representation" must be free of all interest, usefulness, and purpose in order to be worthy of a pure judgment of taste and to be judged "beautiful." Thanks to Kant, many artifacts—such as tapestry, furniture, clothing—are discounted and may only be viewed as "agreeable": only the ornament on such artifacts can be considered "beautiful." The philosopher describes the division between form and function (seeing and using) as follows: "Under painting in the wide sense I would reckon the decoration of rooms by the aid of tapestry, bric-a-brac, and all beautiful furniture which is merely available to be *looked* at. [...] The detailed work in all this decoration may be quite distinct in the different cases and may require very different artists; but the judgment of taste upon whatever is beautiful in these various arts is always determined in the same way: viz. it only judges the forms (without any reference to a purpose) as they present themselves to the eye either singly or in combination, according to the effect they produce upon the Imagination."[1]

The aim of many designers past and present is to overcome Kant's distinction between beautiful ornament and merely agreeable usage—or, in other words, to harmoniously reconcile ornament and utility in a perfectly beautiful object that is pleasing to the eye and to the touch in equal measure. The applied arts are not the only ones to have suffered from Kant's *Critique of Judgment*. The fine arts, too, were no longer allowed to be useful without jeopardizing the pure

judgment of taste and their own beauty. This raises a second possibility for discussion: Is Kant's third critique the origin of a tendency in today's design to privilege the viewer over the user—seeing over using, form over function? Although today, compared with Kant, we hold words like "taste" and "beauty" in lower esteem, seeing does still have a higher value than mere using. In my experience, works of design are often only classified, exhibited, or quoted by younger artists once their design has already become historical. Examples include Matti Suuronen, Buckminster Fuller, or, more recently, Janette Laverrière at the Berlin Biennale in 2008, who may have received greater recognition in the art scene than in the field of design. But does a design have to be historical—i.e., no longer in use—before it can be viewed as contemporary art? Must use value always be perceived retrospectively?

Since 1790, artists and designers alike have tried to overcome the Kantian division between form and function—if not to destroy it. In this endeavor, artists deployed interactive artworks that can be used, and designers deployed objects where hands-off contemplation is allowed. The 1990s, on the other hand, produced a generation of artists who, in a sense, merged form and function. *Esthétique relationnelle*[2] took countless viewers and turned them into users, too. All of a sudden, artworks could be eaten, taken home, slept in, used as a recording studio, or visited like a massage parlor, experienced as a meeting point, a party, or even a dance. At the beginning of the 1990s, many art viewers didn't dare touch Félix González-Torres' *Untitled* (1991), let alone take one of the posters from the pile home with them. In addition to *Esthétique relationnelle*, there was also a widespread crossover movement: the artist as "do-it-yourself" musician, DJ, graphic designer, editor-in-chief, film director, fashion designer, or architect. The old Kantian division seemed to have been overcome—at least for those artists who wished to turn design into an artwork.

The three examples I want to discuss—also with regard to the concept of the "work"—are from the decade that followed all this. First, Rotterdam-based Atelier van Lieshout, founded by artist Joep van Lieshout in 1995, which works as a group, like a firm of architects or designers, with a staff of twenty or thirty, from designers to craftspeople. The end product, the "work," remains collective and open. From the outset, Atelier van Lieshout did not distinguish between art and design, between an exhibition for a museum and a new interior for a doctor's surgery. The Atelier's first book was catalogue and manual in one; you could look at the works, or build them yourself. Sometimes—as at Rotterdam's Museum Boijmans van Beuningen, where Atelier van Lieshout installed toilets—it's hard to separate art from design and architecture. But in contrast to many architects, who tend to develop long-term building plans, Atelier van Lieshout took advantage of a loophole in architectural time: if a building has been standing for less than four weeks or three months —regulations vary from city to city—it is exempt from official inspections. Atelier van Lieshout has opened up additional scope within design by creating temporary or mobile constructions. An apartment on four wheels is no longer a house, but a caravan, even if it never moves an inch from its parking lot. Atelier van Lieshout's definition of a "work," then, includes aspects of the parasitic, the provisional, and the mobile.

Secondly: Carsten Höller's *The Double Club* (2008–2009) was a London "fusion club" that showcased the cultures of the Democratic Republic of the Congo and of the West. The space was divided into three areas: a dance floor, a bar, and a restaurant. Within each area—dancing, drinking, eating—both cultures and the gap between the Congo and the West could be felt, seen, and even tasted. On the circular dance floor, visitors could rotate—clockwise or anticlockwise—to the music of Papa Wemba or M.I.A. The bar was divided up into triangles and looked almost like a cake: there

was a slice from the West (Russian architect Georgi Krutikov's *Flying City* from 1928 printed on Portuguese azulejo tiles), one slice from the DRC (a makeshift shack with white Monobloc plastic chairs), and one slice from the Wild West (Two Horses Riders Club). The restaurant looked more like a chessboard, but instead of black and white there were Congolese and Western tables, chairs, walls, and artworks (the menu included, of course, both English partridge and Congolese fumbwa). Although the cultures were segregated, there was no separation among the guests, who came from DR Congo, Britain, and other countries. The opening of *The Double Club* was a special experience, above all in the art scene.

Atelier van Lieshout, *3M Minimal Multi Mobile*, 2002

Carsten Höller, *The Double Club*, London, 2008–09

As far as participation in the project by the Congolese community was concerned, the club was not so democratic. The opening took place during a refugee crisis in the DRC. Although the project's sponsor Prada donated part of the profits to a charity helping rape victims from the conflict, *The Double Club* was never used as a social or political meeting place by Congolese living in London. In contrast to Atelier van Lieshout, Höller only created the concept and not the exhibition itself. The conceptual artist became a contractor, hiring designers Clemens Weisshaar and Reed Kram, project manager Jan Kennedy, and chef Mourad Mazouz to execute his plan.

Thirdly: Bojan Šarčević's collages, such as his *1954* series (2004), differ from Atelier van Lieshout's installations and Carsten Höller's *Double Club* in not forming an interactive total artwork. Šarčević found some old issues from 1954 of the architecture magazine *Baumeister*. Rather than scanning the illustrations and processing them with Photoshop, Šarčević just used his hands to cut small geometrical pieces out of the pictures and stick them back on elsewhere in the image. Every illustration becomes a puzzle, except that every piece of the puzzle is in the wrong place so that the collages look a little like Op Art. As a result of Šarčević's interventions, the illustrations and even the photographs function not only as information but also as ornament. Function mixes with form. Thanks to Šarčević's collages, we can ask ourselves whether we might arrive here at a slightly more differentiated understanding of seeing and the viewer. They show that "mere seeing" sometimes also has a purely practical purpose—i.e., to transmit information—which can be represented ornamentally. Finally, we view these illustrations and the spaces they depict more attentively.

A third possibility for discussion: For me, many works produced in the context of *Esthétique relationnelle* were anti-retinal, by which I don't mean directed against seeing and the viewer, but against photography

and the communicability of images in the society of the spectacle. The aim was to criticize both the spectacle and the museum rule of "Do Not Touch!" People sitting around, eating soup, or talking about films don't make an interesting picture. Carsten Höller has often deployed optical tactics similar to those used by Šarčević to deprive photography of its power. Höller's works—e.g., the *Upside-Down Goggles*—can often not be photographed without turning the picture into an ornament, as the goggles generate an optical illusion.

Bojan Šarčević, *1954*, 2004

I've been speaking about hierarchical divisions—between seeing and using; form and function; Kant's "beautiful" and "merely agreeable"; the viewer and the user—which not only distinguish art from design, but also place art above design. But do these distinctions make sense, especially in our digital era? To answer this question, I want to look at the objects we use to listen to music. This presents an interesting interface between art and design, because music as an art is visually formless and immaterial, but the machines we use to listen to it belong to functional design—at least they used to be very functional and mechanical.

In an untitled photograph from 2009 by Leipzig-based artist Andrzej Steinbach, a young photographer still studying at the Leipzig Academy of Visual Arts, it's not immediately clear whether the subject is a woman

or a man—but we are definitely looking at a fashion victim, wearing the latest look with heavy glasses, '80s "red on red," and an aerodynamic cut'n'dry hairdo. She's wearing a tape cassette around her neck, like both a necklace and a USB stick, as jewelry and outdated technology. Since the cassette has been covered with gold paint, it's more decorative than functional because it's no longer possible to read the name of the band, the album, or the songs. This is a picture of the bygone analogue world of music and our own digital world. In the foreground, we see what killed the cassette: the glowing screen of a phone, camera, Blackberry, iPhone, or iPod—which bring many functions together through digitization. Who can wear a *memento mori* better than a fashion victim?

After seeing this photograph, I read a report on the BBC website about the Sony Walkman's 30th anniversary last summer. A British teenager was invited to trade his iPod for a classic Sony Walkman for one week. The teenager had many criticisms about the Walkman: too heavy, too bulky, too few songs, too short battery life, too many buttons that he had to "push" with a "clunk."[3] It took him three days to figure out that he could turn the cassette over, although this was awkward. The extra songs on Side B could never compete with the thousands on an iPod, which doesn't even have a button. I'm not sure what to call the control ring on the iPod, but it creates an effortless interaction with the user. Can one speak about function here? The iPod is almost pure form, on the verge of disappearing.

Besides Walkman versus iPod, one could compare an old-fashioned door with an automatic door, usually made of glass. Or touch screen versus keyboard on ATMs. Or a ten-speed racer with these new bikes that have been stripped of everything, including brakes. These objects aim for an effortless interface, fusing touch and sight. This interface seems to transform the object into information, which goes hand in hand with digitization (a map versus Google Street

View). The teenager also didn't realize that the "metal" button on the Walkman referred to a type of tape cassette, not to a type of rock music. The Walkman's failings against the iPod show an object and a user as information interfaces, with little bodily contact, less materiality, and no mechanics. The user is like a viewer.

Andrzej Steinbach, *Untitled,* Slide projection, 2009

One last possibility for discussion: When a mechanical object becomes an information interface, what information is being conveyed: fashion, story, status, psychological associations? An advertising agency like Sid Lee—who did ads for Adidas Legends and Cirque du Soleil—is interested only in telling stories about commodities; they create durability through narrative, not through the durability of the object, because they want you to buy the product several times over, even though running shoes and circuses are not digital commodities. Deyan Sudjic argues that Apple's designs create visual obsolescence to push its products.[4] My first Walkman lasted years; I spent money on the music. Today, teenagers spend money on equipment, not on music. If you throw out objects more quickly, then you can't create your own narratives about them, so the designers and ad people do that for you. Compare this with wearing a watch owned by your grandfather. And think again about Ettore Sottsass's "Valen-

tine" typewriter for Olivetti. That's the kind of name an *owner* should bestow.

Now I'd like to return to "possibilities for sitting" and chairs. Is there another possibility—perhaps ecological or political—for this breed of object-as-information-interface spawned by digitization? Two brief examples: First, Martino Gamper's *100 Chairs in 100 Days* project from 2006–2007. Gamper salvaged discarded chairs all over London and put the broken parts together to make new hybrid chairs. This is a project that could only be done by someone who knows computers and digitization, because it's design as cut-and-paste or Photoshop. Gamper describes his project as "a three-dimensional sketchbook,"[5] although it's a cross between a sketchbook and a screen. You can sit on these chairs, but you perceive them as visual information by recognizing and then trying to identify the different parts. That's an information interface with an ecological side.

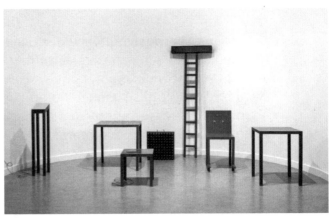

Compare this with Dunne and Raby's *Placebo Project* from 2001, especially the *Nipple Chair*. The London-based designers placed "placebos" in people's homes to interact with the electromagnetic fields created by electronic devices. The *Nipple Chair* has little nipples on the back, which vibrate when radiation passes through the sitter's upper body. This chair is also an information interface, but it works with the sense

Burkhard Meltzer You call it "Inquisition Style," so are you the inquisitor who passes a final judgment on the replica styles that people use?

David Renggli No. Well—maybe I do actually, because I take the liberty of judging. But I'm more interested in taking these pictures that stand for something and mixing them with something else.

Burkhard Meltzer These are all styles that are still available from furniture stores today.

David Renggli Have you ever been to a furniture store? In my experience, all you can buy in furniture stores today is this contemporary architecture style—big windows, the Tyler Brulé concept of furniture, very plain. You hardly find romantic furniture at all.

Burkhard Meltzer That's true, the old-style heavyweight, mock-rustic sideboard has almost disappeared. Or something like this children's bed. A certain impression of modernism has taken over.

David Renggli Yes, austere, minimal design. Knoll, everything's really so Knoll-like.

Burkhard Meltzer So you're referring more to the kind of items one might find in a used furniture store or things people may still have standing around at home.

David Renggli With these pieces of furniture, I do refer to the interiors of a reactionary milieu. This may be based on a false image, and it might not be especially up-to-date. Yes, this brown, stuffy feeling—ugh! Somewhere in Bülach, a small apartment on the first floor. If we're talking about the picture of the bed, then the picture itself already contains

an element of unease, because it stands for something that makes me feel uneasy.

Tido von Oppeln This milieu seems to me to be something of an imaginary figure, too—as in the case you mentioned of the teenager with his bed.

David Renggli There's usually a background story that I can tell. Mostly it refers to a fictional person, or perhaps to myself.

Burkhard Meltzer Your points of reference in art are mainly older things, from the Middle Ages, the eighteenth and nineteenth centuries, Romanticism, still life painting. Are you more interested in styles than artists, or do the art references work in a totally different way?

David Renggli Hard to say. In the case of the blanket, for example, the reference is to Op Art.[—> p. 202] It's really more about little moments of mischief for me, it's not about in-depth, considered engagement. Talking about it now, I notice that it's about a kind of "look at this!" effect, a formal similarity. Like the Op Art blanket: it's not carefully positioned to look good, which is why it has this effect, as a way of generating a random link from within the domain of white trash. As a way of taking something out of this realm of design referred to as non-design and giving it a different value, a different charge.

Burkhard Meltzer That sounds like a process of experimenting with a limit. When, by slight alterations, does it become possible to read an object as part of a certain artistic or stylistic current. Like the blanket, or this flickering heater here as being related to Op Art. But it's always only almost, nearly.

David Renggli It's not about the ready-made effect of "I take a thing and put it on a plinth and now it's art." More about a possibility, perhaps also about chance phenomenological observations and a coincidence.

Burkhard Meltzer Your work as I've encountered it to date has always been sculptural, where the viewer must keep a distance.

David Renggli In this case, the idea was to really sit on it and try it out to find the best position. The joints are very badly welded, but the material has a super high-end finish with a shiny, nickel-plated surface. The machines do have functions, of course. One of them, for example, is like a half-open window where you can sit down. And when you look out, you can surrender to your thoughts while training your biceps on the machine. I must mention the metal cobwebs on the machines again. You resolve to do something: I'm too fat, I'll get myself some equipment. You use it three times, and then it becomes an item of furniture that's taken over by spiders. It stands for something more— for these resolutions that people don't keep. A good example is all the exercise bikes that end up standing around in junk shops.

Burkhard Meltzer Did the people at the exhibition sit on it?

David Renggli At Kunsthaus Zürich, I wanted that to be possible, but it didn't work out due to security concerns. It was in a gallery together with Old Masters. What I liked about that room was that the paintings featured many naked figures, portrayed according to a different aesthetic of physical beauty. At the gym, people today prepare their bodies so that outside, in public, they correspond to an image. Suddenly, the abstract quality of the exercise machines brought out references to the composition of the old paintings. Strange similarities emerged in the ways the works guided the viewer's eye.

The Lasting Void – Julia Lohmann

The interview was conducted at Julia Lohmann's studio in London on May 12, 2009.

Julia Lohmann Every cow was made by hand.[—> p. XXIII] Individuality is important, and distinctive features in the leather should ensure it. I noted all birthmarks and scars, as well as taking photographs as soon as each cow was upholstered—before it got any wear and tear. Each cow is also supposed to have its own passport.

Burkhard Meltzer May I sit down?

Julia Lohmann Sure. It doesn't feel quite the same now as when it's finished —the strengtheners are still missing in some places. It's been exhibited around the world, and most people actually react in the same way. They start by touching, feeling their way, before they sit down.

Tido von Oppeln I saw one in Basel.

Julia Lohmann That was *Anoushka*. I'd like every journey and every exhibition to be entered in the passport. As I see it, their value increases when scars and wear and tear become visible. Normally, these scars are all cut out, and in the production process, everything possible is done to make sure the animal remains hidden.

Burkhard Meltzer The recording of exhibition venues and details of ownership in a passport is exactly what happens when museums and collections document the provenance of an artwork. This should actually cause the works to gain added value.

Julia Lohmann But there are also buyers who ask for the price to be reduced if a work has already been shown somewhere. Furniture is usually more likely to lose value in this way. And the galleries have the same tolerance levels: scratches from the animals themselves are OK, but not scratches made by humans. But it's interesting when traces of the animal's life are then joined by traces of its life as a sofa.

Tido von Oppeln Do the objects get used as sofas at all?

Julia Lohmann Marc Newson has a cow and apparently his daughter is a big fan. The children of collectors especially react in this way, saying: "That mustn't disappear into storage." I know that the daughters of one Paris collector have adopted the cow as a pet. Another one, so I've heard, is now in a chalet in someone's second home on a tropical island. I find that quite hard to imagine.

Burkhard Meltzer When I first encountered one of the cows, I found it pretty gruesome as an image. It was photographed from the front to show the severed head. That's actually quite alarming.

Julia Lohmann That's the point—not just cuteness and beauty. The idea is that people see it in the newspaper, for example, identify it as a sofa, and then ask themselves questions: "There's no backrest, how am I supposed to watch TV?" There's a connection to the world that people actually live in. Most ordinary people, if they see an article about a sculpture by such and such an artist, then they probably won't read any further. But if it says: this leather sofa by such and such an artist—that immediately raises questions. And there's automatically a link to their own sofa. In the production process, I work with the hide exactly as it comes from the

slaughterhouse. Something very strange happens in our relationship to dead animals: It's accepted that we kill animals for meat and for leather, but not for anything else, like for animal testing, or for an artwork. If you have a product that doesn't conform to those two uses, then people don't actually know what to do with a dead animal, as all other uses are not accepted by society.

Burkhard Meltzer The object already has this kind of tension—and if I then imagine that it also feels like animal skin...

Julia Lohmann In exhibitions there are often spotlights that heat up the leather. When you sit down on it, it's warm. It really feels very much like an animal. Although it's quite small for a two-seater sofa, it actually looks very big. People read it as a very large animal lying there in the space.

Burkhard Meltzer You still refer to them as furniture?

Julia Lohmann The cow I do, yes, but I wouldn't want to use *Lasting Void* as furniture.

Tido von Oppeln Why do you so often photograph the objects on a lawn-- when you actually link them more with everyday life and domesticity?

Julia Lohmann There are various reasons: Firstly, there's a piece of land next to the upholstery workshop, so it's always the simplest option to carry them out onto the lawn and photograph them in natural light as soon as they're finished. Perhaps it's an attempt to bring them back to their roots to a certain extent. I also now have good pictures of a cow in a Victorian interior, in front of the fireplace. Gallery settings I find

problematic, it looks too much like an artwork. I'm in the design context, but sometimes I work at the limits. And if you don't draw a line, then of course you can't work close to the edge. Many of my works are probably more interesting in the design context, because that way they're closer to everyday life. I'm interested in the manufacturing process, in how we produce our materials—an absolute design issue.

Burkhard Meltzer Your objects are far removed from classical definitions of design and furniture.

Julia Lohmann I don't normally begin by saying, "I want to design a stool." Instead, I start with a cultural phenomenon that interests me. In the case of the cows, I wanted to mix the most fashionable leather object with the presence of a farm animal. And to evoke this sense of disconcertment about what it is we use every day. At art college, I wrote my final dissertation on the killing of animals in contemporary art. When Damien Hirst shows his cow, people ask: "You killed a cow for art?" In the design context, no one ever asks whether such a sacrifice was worthwhile. A few years ago, there was an interesting legal dispute over an artwork by Marco Evaristti who showed goldfish in blenders in an exhibition. People tried it out and during the opening a few fish got liquidized. In court, a veterinarian testified that this was probably the most humane way to kill a small fish. It's not removed from its natural element, and death comes in a millisecond. Whereas thousands of people sit by rivers every day, throwing fish back into the water with their mouths torn to pieces.

Burkhard Meltzer That sounds like design ecology.

Tido von Oppeln And economy. I recently visited the ethnological museum built by Jean Nouvel in Paris, and the entire interior is fitted out in leather. The walls, the banisters, and the exhibition architecture are made of leather, and done so badly that it's really striking. Shoddily stuck together with some kind of hot glue—and using thousands of hides.

Julia Lohmann I think that within society, the task of making people think usually falls to art. Although design does this less, it is capable of doing it. I recently had a conversation about narrative in design. And I realized that over the last fifty years, design has lost something. Take record players, for example: on the one hand, their design fulfills the function of playing back recorded music. On the other hand, however, there's always also been a function that we didn't consider to be so important. It's about understanding, a process of communication, the longer you focus your attention on the object. Such approaches are also important in art. If you take a close look, you gain a different understanding. Design used to have this on a very pragmatic level. You understand a record player in terms of its functioning—ah, this part rotates, and here's the groove. With CD players, this became more difficult. But I think this kind of accessibility is incredibly important, and it's not taken properly into consideration. In this way, an understanding of the object on a technical level is replaced by a narrative.

Tido von Oppeln Since the 1970s, moving into the information age, we've seen the emergence of a whole series of mainly electronic objects whose functions no longer allow a form to be derived from them—in principle, they could all look exactly the same. As part of this development, ergonomics have become important, the man-machine interface.

Julia Lohmann The iPhone is fascinating in this respect—so intuitive that you have the feeling the telephone understands you.

Burkhard Meltzer Then understanding goes in the exact opposite direction—the object understands me so well that eventually I don't even need to touch the object, pointing is enough.

Julia Lohmann The iPhone knows so much about you that it gives you the feeling you can deal with it intuitively. This contrasts with the mass of objects that are not so intuitively designed. They might be the reason why consumers have become so boring. Why they no longer switch on their brains. Why they no longer ask: "What is this thing?" And even if this question is raised, there's nothing to find. Even if you open it up, you can't understand it. And I think this has only become important since the arrival of non-mechanical objects.

Burkhard Meltzer Might this be a pedagogical approach to consumer education?

Julia Lohmann I believe we've done the exact opposite. For a long time, we simply didn't take into account that preserving comprehensibility is an important function of design, at the same time as encouraging people to question things.

The interior as a narrative format:
Case studies from the collection of the migros
museum für gegenwartskunst Zürich
Judith Welter

How has artistic engagement with interiors
influenced the relationship between design and art?
Which distinctive features of this relationship are
revealed in a collection of contemporary art? Within
the context of works selected for a collection, this re-
lationship can be viewed in the sense of a historical
development on the one hand and, on the other, from
a work-specific point of view. By paradigms of inclu-
sion and exclusion, a collection establishes a canonical
narrative consisting of different artworks and obeying
an immanent logic. In the following, narrative is under-
stood beyond its literary meaning, in the sense intro-
duced by cultural theorist Mieke Bal, as a "cultural
force."[1] What do the collected works tell us about the
times in which they were created; why were they
selected for the collection and how does their meaning
shift in each historically specific context? These funda-
mental questions on collecting serve as a frame of
reference for what follows. The collection of the migros
museum für gegenwartskunst exemplifies specific

positions adopted by art with regard to various design discourses. Many pieces of furniture used in artworks during the 1990s, for example, were given a function that called for some kind of action from the visitor. In more recent art, by contrast, they take on a quasi-symbolic character: they point to something, act as a placeholder, transport references to content, or can be read as art about design.

Design as reference to everyday life

In all of his work, beginning in the 1960s, Marc Camille Chaimowicz (born 1947 in Paris) addressed the question of the relation between art and design—in particular the Arts & Crafts movement and modernism's separation of art and applied art. Essays about his work are often embellished with descriptions of interiors: a catalogue essay by Anette Freudenberger, for example, opens with a description of a hotel room, and its furniture, visited by the author.[2] In her essay on the Chaimowicz retrospective in Düsseldorf, Catherine Wood recounts her visit to the artist's apartment. The furnishings and atmosphere of the room where they drink coffee, she writes, reflect Chaimowicz's artistic praxis.[3] Using and making furniture, through the creation of whole interiors, is a key aspect of this praxis. Pieces of furniture, but also other everyday domestic items, undergo aesthetic sublimation and "function" in the exhibition space as references and substitutes.

Partial Eclipse (1980–2003) is a slideshow consisting of a sequence of 80 pictures. Addressing the gesture of arrangement as a form of memory, the work focuses this idea in a two-part projection. It is an almost meditative contemplation of the loss of a past experience. The work of memory is supported by visual fragments: still-life-like pictures of flowers alternate with perfectly staged interiors, occasionally inhabited by people, taken at the artist's former studio on Approach Road in London. Arranging objects charged with personal significance is a way of remembering and paying

homage to things that can often not be grasped or defined. This melancholic gesture itself becomes a placeholder for something that may never have existed, and it occupies a central place in Chaimowicz's oeuvre. At the same time, this poetic language for the construction of memory highlights the relation of the artist's individual works to each other. Linked with his staged private life, the objects, installations, photographs, and sculptures—often including fragments of text—form a self-generating, processual whole. Motifs from *Partial Eclipse* or sculptural works are re-used in later works (e.g., in his screen objects). Where his work fuses art, design references, and decorative objects into a unified whole, Chaimowicz refers to the concept of the total artwork or *Gesamtkunstwerk*. The décor of his apartment, including fabrics and wallpaper printed with his own designs, shapes the environment in which he lives and can also be read as a fragment of the "total artwork that is Marc Camille Chaimowicz." This reflects an interest in concepts that reached their high point in the European avant-gardes, as with the ideas of the Bauhaus.[4]

Marc Camille Chaimowicz, *Partial Eclipse*, Slide projection, 1980–2003

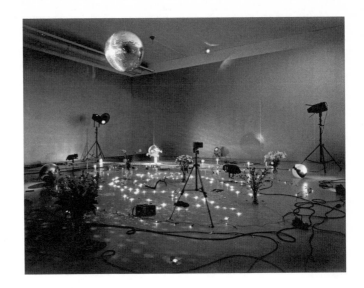

Marc Camille Chaimowicz, *Celebration? Realife Revisited*, 1972–2000, Installation view, migros museum für gegenwartskunst Zürich, 2000

The notion of a blending of art and life, for example, finds expression in Chaimowicz's interest in interior design. When a home feature about the artist appeared in *World of Interiors*, his works gained exposure beyond the borders of the art world—evidence that an overlapping of the two levels really does take place.[5]

Chaimowicz uses a similar approach in *Celebration? Realife Revisited* (1972–2002), a work also present in the collection of the migros museum für gegenwartskunst. Here, instead of furniture, the artist uses decorative objects. Nonetheless, the work is interesting in our context because Chaimowicz deals with design and thus with the aesthetic of various everyday objects belonging to a particular lifestyle. The installation combines relic-like objects into a fragmentary interior whose elements point to the aesthetic and lifestyle of the early 1970s. Spinning disco balls and spotlights submerge the silver-painted room in a theatrical light and scatter reflections over the candles, flowers, pictures, and items of clothing spread over the floor. Music playing in the background heightens this atmosphere, featuring a sequence of albums by Janis Joplin, The Who, David Bowie, Bob Dylan, and The Doors. The whole space appears constantly in motion: bouquets

of flowers, transformed by wilting, are replaced with fresh ones throughout the show; all of the viewer's modes of perception move back and forth between the individual objects—a small model bicycle, masks, a page from a glossy magazine, little decorative items—and the space that surrounds them. This piece synthesizes a performative installation shown in three different versions in 1972 under the title *Celebration? Realife*, considered one of the artist's key works. *Celebration? Realife Revisited* reconstructs the situation of the original installation in which the artist was present, thus reflecting, on an additional level, the potential of the relics of performances. Just as Chaimowicz inhabits the spaces of his installation in *Celebration? Realife*, and his real life penetrates the sphere of the artwork, so too his private space is interwoven with art. Here, too, artistic work overlaps with processes and objects of everyday life. As in *Partial Eclipse*, the interior elements point to something absent and fragmentary, and to the artist who is no longer present.

Marc Camille Chaimowicz, *Celebration? Realife Revisited,* 1972–2000, Installation view, migros museum für gegenwartskunst Zürich, 2000

Functionality as a paradigm

Celebration? Realife Revisited reflects and comments on the notion of an exhibition as a place of social interaction by allowing a show to continue existing in the form of a still life. The original form of the work as a participatory and performative installation is situated within the art historical context of walk-in interiors

or "environments." This phenomenon, which became established in the 1960s and 1970s as a central topos both in theory and as an artistic strategy, was picked up again in the art of the 1990s when participatory formats made a comeback.[6]

At this time, the migros museum für gegenwartskunst acquired a number of works that use pieces of furniture as functional objects. These participatory installations were paradigmatic and trend-setting for the museum's pioneering period during the 1990s, characterized by attempts to break free of classical museum modes of viewing. In Nicolas Bourriaud's concept of *Esthétique relationnelle*,[7] the artistic strategies of that time for involving and activating the viewer are combined with a concept of the work that views art as a "social space."[8] *Office/Reception Unit* (1996) by artist group Atelier van Lieshout, whose work constantly explores the borders between design, art, and architecture, is one response to the question of how museums should look. The work—a blue booth on wheels—is a practical object that was positioned outside the museum for a while to fulfill its purpose. At the *Office/Reception Unit*, which soon became the trademark of the still-young museum, visitors were welcomed and could buy tickets, get information, or purchase catalogs.

Atelier van Lieshout, *Office/Reception Unit*, Installation view, migros museum für gegenwartskunst Zürich, 1996

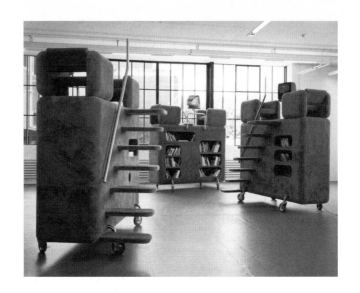

Various other artistic situations and models of space also served as platforms for interaction between work and recipient: from the *Infomobile* (1999) by artist group L/B (Lang/Baumann), a place to read magazines and catalogs or access email, through Douglas Gordon's *Reading Room* (1996), Angela Bulloch's *Club Berlin* (1994–1997)—a place for listening and relaxing, with large cushions and an audio system, and on to Alicia Framis's *Contemplation Room* (1998), the installations recreate familiar everyday settings. In Framis's mini-malist glass cube—installed in the middle of the exhibition space—visitors can smoke and view art at the same time. This is also a reference to the look of the kind of smoking lounges that have recently appeared at airports.

Tom Holert calls such translations of wider social and cultural conditions into the institutional setting of the museum "metaphorical realism," thus defining a typical, period-specific phenomenon of the 1990s.[9] By transferring design objects, but also a specific set of behaviors, into the museum, the artwork is brought into interaction with other fields of life and culture. With its functional and ready-to-use fittings, Douglas Gordon's *Reading Room* recalls a lounge—a kind of

relaxation zone that became established in the bar and club culture of the time. The only thing distinguishing these situations from an everyday setting is their location in the museum. Seated on beanbags under warm lamplight, visitors can look at books, magazines, and films, or listen to music. As in the case of the *Info-mobile* by L/B, the selection of reading material and films is supplemented and adapted to the specific context of each exhibition. Another key aspect is the use of titles implying instructions for use, pointing to the functional character of the work, inviting viewers to read, inform themselves, or linger in contemplation.

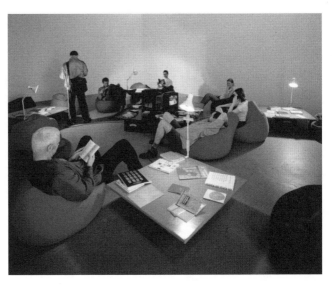

Douglas Gordon, *Reading Room*,
Installation view, migros museum für
gegenwartskunst Zürich, 1996

Should these works be exhibited again today, the remove in time alone gives them a historical connotation, as they refer, via formal strategies but also due to their specific aesthetic, to a time past. The collection at the migros museum für gegenwartskunst, which focuses on contemporary art, exemplifies this issue: today, the works are primarily relics whose former function evokes a specific disposition of the art system in the 1990s. The works must now be reevaluated in their function as objects. The questions formulated by Holger Kube Ventura in his seminal study of the partici-

patory and political art of the 1990s are still critically relevant: Can context-specific art projects "function" today, in the form of "decontextualized artifacts" without their original exhibition setting, for example as part of a show offering an overview of a collection?[10] The objects originally intended for use are now characterized primarily by their referential quality.

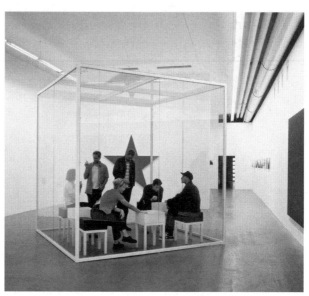

Alicia Framis, *Contemplation Room*, Installation view, migros museum für gegenwartskunst Zürich, 1998

In the spirit of the 1960s, the intended usage of the furniture as part of a participation refers to a model of democratizing art and countering its elitism. In terms of a claim to critique society or culture, they often go no further than "just being there." Is the participatory imperative primarily a trend of the 1990s, or has it also created a model for critical artistic praxis?[11] Though the trend towards exhibition-as-theater has long since brought forth an omnipresent type of work, the often more or less banal forms of audience participation reveal themselves as utopian. In their *mises en scène*, artists promise visitors the role of active protagonists, but often enough grant them only a walk-on part. Whether such constellations are capable of being re-staged in museums at all is highly doubtful.[12]

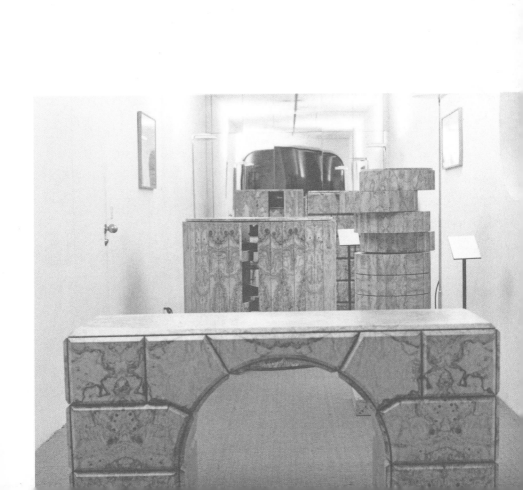

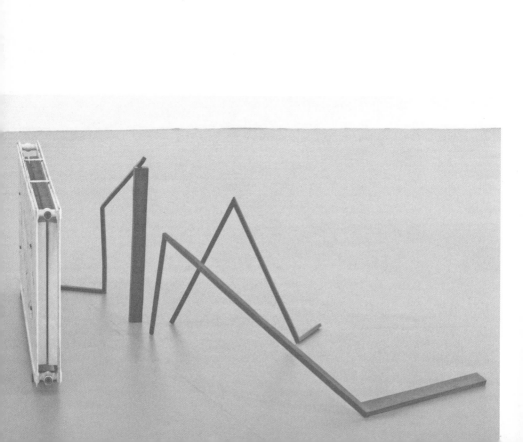

Angela Bulloch, *Club Berlin*, 1994–1997,
Installation view, migros museum für
gegenwartskunst Zürich, 1997

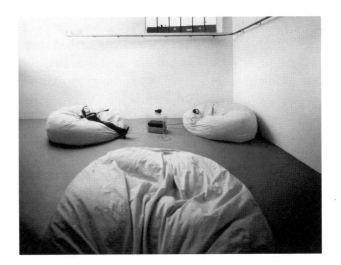

Items of furniture as fragments of narrative spaces

Aspects of the relationship between art and design discussed in this book can be illustrated by interior situations in works from the collection of the migros museum für gegenwartskunst. As well as a changed understanding of design, the art of the 1990s and the related functional usage of furniture were instrumental in raising levels of reference between the two fields. Today, this rapprochement forms the basis for artistic production. The potential of aesthetic formulations in both fields refers to a specific life setting, social strata, or zeitgeist. They are among the possible forms of expression for a lifestyle and a personality. The fetishization of aesthetic (luxury) goods, found in both spheres to an equal extent, lends them a shared cultural meaning. This affinity is a significant factor in the mutual interest and influence between design and art.[13]

The participatory models of the 1990s were followed by a more diversified approach to elements of interior design. As in the case of Chaimowicz, works by Swiss artists Urs Fischer (born 1973 in Zurich) and Emmanuelle Antille (born 1972 in Lausanne) perform a referential "usage," with furniture in spatial constellations and arrangements playing a major role. Fischer's

works are characterized by the use of heterogeneous materials and techniques referring to a range of artistic and art-historical styles and currents. Playfully, using humor and subtle irony, he quotes and collages every-day objects and scenarios, as well as familiar motifs from popular and high culture. In his installations and sculptures, pieces of furniture have a peculiar signifi-cance; chairs, for example, are a constantly recurring motif. Fischer's chairs are not "readymades," and thus not real objects made to be used. Instead, he recon-structs them and renders them unfamiliar at the same time. Crudely cobbled together, the objects are re-moved from their conventional function and relieved of their utility. In a theatrical setting, the installation *Frozen* (1998) stages an abandoned dining table. Fischer is referring to the art-historical category of the still life. The tables and chairs belonging to the installation are linked by a net-like system of woolen strands that connect the various different objects and liberate them from their functionality. In Fischer's works, the furniture is timeless, and the design does not point to any spe-cific reference. Equally, they have no use value. Instead, these items of furniture are sculptural objects that belong to the artist's regular vocabulary of forms, repre-senting a narrative competence immanent in the work.

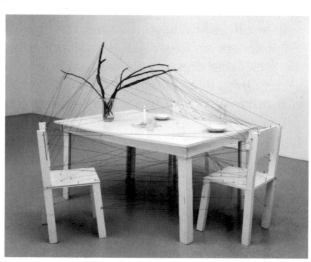

Urs Fischer, *Frozen*, Installation view, migros museum für gegenwartskunst Zürich, 1998

This spatio-narrative "function" of furniture is also clearly visible in other works in the collection, as in the video installation *Radiant Spirits* by Emmanuelle Antille. The artist came to prominence with her video works that tell mysterious, distressing stories and have a strange, dense atmosphere. Her oeuvre revolves around existential themes of emotional processes and situations such as love, death, family, growing up, and sexuality. *Radiant Spirits* recounts a dream-like episode that takes place in an abandoned hotel and that is woven into a narrative on three wall-filling projections in the totally dark exhibition space. Desire and the despairing search of a bored, disoriented bourgeoisie for closeness and encounters are the topics here. The barely perceivable touches and erotically charged gestures in the film build up a tension which is never discharged, and which is amplified by the uncanniness —in the Freudian sense, located on the border between the real and the imagined—of the vacant, shadowy architecture.[14] Central to *Radiant Spirits* is a voyeuristic aspect that is addressed in the film itself, but also via the involvement of the viewer. In supposed privacy, the details of individual scenes can be viewed via a video headset while reclining on a lounger. When the viewers lie down on the loungers provided, the emptiness and shadowy architectural structure of the film is extended into the exhibition space. As in Fischer's work, these items of furniture perform a narrative function. Rather than referring to a specific life setting, they point back to the film, serving to immerse the viewer.

Fischer and Antille are moving in their work towards an artwork characterized by this tendency to extend out into the space. Constellations of objects, artifacts, and architectural components create installations whose quality is often described as "atmospheric."[15] These constellations "resist an objectivist concept of the work."[16] As a result of this expansion, which can even go beyond the limits of the institution, the work extends to institutional, cultural, or social

contexts.[17] The spatial narrative shapes the ways the work is perceived, with objects of interior design becoming protagonists as well as representing narrative content.

On the basis of the works discussed above, Chaimowicz's artistic career and the changing reception of his oeuvre provide a clear illustration of the ways the relationship between art and design has changed and become more involved. Since the beginning of his activity as an artist, Chaimowicz has worked with the aesthetic of interior design and its forms of production, thus questioning the borders between art and applied art. This questioning of décor and its relation to art is exemplified by screen works such as *Festivity* and *Laura Street, for Georgy* (both 1987). They are sculptural objects that recall items of furniture but which at the same time appear detached from their function. One side of the concave screen is decorated with inlaid wood in abstract patterns; on the other is an appliquéd painting. On the one hand, Chaimowicz questions the principle of appliqué work as an applied art and, on the other, the classical function of the panel picture.

Other sculptural works by the artist can be read as prototypes for items of furniture. Or classical elements of interior design such as rugs become artworks when they are woven from the artist's sketches. But Chaimowicz also oversteps the limits of traditional artistic activity by making designs for commercial textiles, or accepting and carrying out commissions such as the church ceiling in Cluny. This is more of a playfully lived-out position than a theoretical discourse accompanying his work.[18] The artist's interest in the Arts and Crafts Movement began at a time when the division between fine and applied art was considered a historical paradigm and when the deliberate use of techniques from the applied arts was a polarizing issue, as shown by the reception of work by feminist artists like Judy Chicago. Similarly, his referencing of the decorative function of applied art and the domestic context,

traditionally associated with the attribute of femininity, contrasted with the dominant macho gestures in painting at the time, and movements in art such as Minimalism, which refers to industrial design. Chaimowicz's oeuvre is currently undergoing a reappraisal, as shown by the many exhibitions and publications on the artist.[19] In his work, objects of interior décor refer on the one hand to imaginary and fictional narratives on which the works are based, acting as placeholders for their absent protagonists. On the other hand, they bear witness to the artist's position and specific interest in various interior design styles and movements, constituting a commentary on the relationship between art and design.

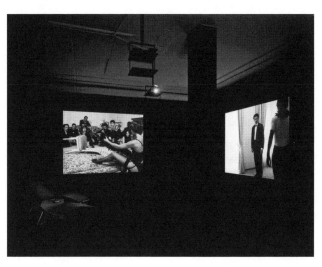

Emmanuelle Antille, *Radiant Spirits*, Video installation, migros museum für gegenwartskunst Zürich, 2000

From the point of view of a collection, it is interesting that design is increasingly embedded in a reflexive and referential framework and is capable of performing narrative functions that point equally to the context in which the works were made and to specific life settings. How does the understanding of design and art shift when artworks that were once used functionally enter the museum as part of a collection? The function of the interior with respect to the artwork cannot be read as a static, historic fact. Instead, the objects re-

main mobile and transformable in their meanings; today, the once functional pieces of furniture in works from the 1990s have taken on a primarily narrative role. Detached from the context in which they originally emerged, they are now narrative relics. Individual positions in the collection of the migros museum für gegenwartskunst and the shifts in their reception at specific moments in time are paradigmatic for general trends in artistic production and reception. On the other hand, the various functions of the interior from the viewpoint of a collection can also be subsumed and focused under the common denominator of narrative: interior objects tell us something about the context in which an artwork was created, pointing to an historical life setting and a narrative meaning. Equally, these spatial constellations bear witness to a specific artistic approach to design.

The founding of the migros museum für gegenwartskunst and the consolidation of its collection fall within a period when there was a particular emphasis on seeing contemporary art in relation to a social context. Exchange with other fields of culture was explicitly aspired to. A programmatic rapprochement with the field of design is thus anchored from the outset in the institution's conceptual foundations.

1 See Mieke Bal, "Vielsagende Objekte. Das Sammeln aus narrativer Perspektive," in: Mieke Bal, Thomas Fechner-Smarsly, *Kulturanalyse* (Frankfurt 2002), pp. 117-145. See also Boris Groys, *Die Logik der Sammlung. Am Ende des musealen Zeitalters* (Munich 1997).

2 See Anette Freudenberger, "Zwischentöne," A. Freudenberger (ed.) *Marc Camille Chaimowicz* [catalog of exhibition at Kunstverein für die Rheinlande und Westfalen Düsseldorf 10.09.–06.11.2005] (Düsseldorf 2005), pp. 7-9.

3 Catherine Wood, "In Gebrauch: Ein Essay über das Werk von Marc Camille Chaimowicz," in: Freudenberger, ibid., pp. 15-21.

4 See Roger Fornoff, *Die Sehnsucht nach dem Gesamtkunstwerk – Studien zu einer ästhetischen Konzeption der Moderne* (Hildesheim/Zurich 2004), pp. 477-535.

5 See "Marc Camille Chaimowicz – This is not a flat," in: *World of Interiors*, April 2006, pp. 181-185.

6 On the reactivation of the concept of the participatory and its links to historical precursors in the 1960s and 1970s, see also the following essay: Melitta Kliege, "Zwischen Bewusstseins-

arbeit und ästhetischem Zitat, Engagierte Kunstformen der siebziger und neunziger Jahre im Vergleich," in: *70/90 Engagierte Kunst*, published by the Neues Museum Nürnberg, Staatliches Museum für Kunst und Design in Nürnberg, [catalog for the exhibition of the same name from October 13, 2004–January 16, 2005] (Nuremberg 2004), pp. 9-23.

7 See Nicolas Bourriaud, *Esthétique relationnelle* (Dijon 1998).

8 Nina Möntmann describes participatory strategies in the 1990s as "differentiations of social space." See Nina Möntmann, *Kunst als sozialer Raum* (Cologne 1998). See also Stella Rollig (ed.), *Dürfen die das? Kunst als sozialer Raum* (Vienna 2002).

9 Tom Holert, "Die paradoxe Institution. Über die Gegenwart des Museums, metaphorischen Realismus, soziale Skulpturen und psychische Räume," in: Heike Munder (ed.), *Sammlung/ Collection: migros museum für gegenwartskunst Zürich, 1978–2008* (Zurich 2008), pp. 29-36.

10 See Holger Kube Ventura, *Politische Kunst Begriffe* (Vienna 2002), pp. 65-70.

11 See also: Christian Janecke, "Bei sich selbst ankommende Betrachter," in: Lars Blunck (ed.), *Werke im Wandel? Zeitgenössische Kunst zwischen Werk und Wirkung* (Munich 2005), pp. 65-85.

12 See Peter J. Schneemann, "Wenn Kunst stattfindet! Über die Ausstellung als Ort und Ereignis der Kunst – Polemik oder Apotheose?," in: *Kunstforum International*, Vol. 186, June–July 2007, pp. 65-81.

13 Isabelle Graw examines this overlapping and rapprochement of the two fields, especially concerning luxury goods, where design also plays a part. See Isabelle Graw, *High Price: Art Between the Market and Celebrity Culture* (Berlin/New York 2010).

14 Sigmund Freud, "The Uncanny," (1919), in James Strachey (ed. & trans.), *The Standard Edition of the Complete Psychological Works of Sigmund Freud*, vol. XVII (London 1953), pp. 219-252.

15 On atmosphere as an aesthetic concept, see Gernot Böhme, *Atmosphäre. Essays zur neuen Ästhetik* (Frankfurt 1995), pp. 34 ff.

16 In her philosophical study of the aesthetic of the installation, under the headings "theatricality," "intermediality" and "site-specificity," Juliane Rebentisch examines concepts that have arisen in reaction to installation art. See Juliane Rebentisch, *Ästhetik der Installation* (Frankfurt 2003), p. 15.

17 Ibid. pp. 7-25.

18 See Catherine Wood, "In Gebrauch: Ein Essay über das Werk von Marc Camille Chaimowicz," in: Freudenberger, op. cit., pp. 17-18; Marc Camille Chaimowicz and Frank Gautherot (ed.), *Marc Camille Chaimowicz à Cluny* (Dijon 2003).

19 See for example Annelie Pohlen, "Marc Camille Chaimowicz," in *Kunstforum International*, issue 178, 2006, pp. 316-317.

This public discussion took place on November 21, 2009 on the occasion of the symposium "It's Not a Garden Table" at the migros museum für gegenwartskunst Zürich.

Max Borka From 1985 until 1999, I'd been working as a journalist, writing on almost every subject imaginable. However, there was one particular subject I had been specializing in: contemporary art. But when I dropped journalism at the end of the nineties, I also decided to quit the art world, which seemed to have become too much of a bubble. I embraced design, and became director of the Interieur Foundation and organizer of the Interieur Biennale. I've been stuck into design ever since. But it doesn't prevent me from feeling slightly embarrassed when I'm asked about my recent activities, especially by people who haven't seen me since the time when I still was an art critic. And it often comes to the point where I feel as if I had dropped this noble profession to become a pimp.

It's an uneasiness that stems from the fact that I soon discovered that design is a bastard, in every sense of the word. It was born as a bastard child, when in the first half of the 19th century the name was coined as a synonym for all tools for living. Everyone knew the mother: the Industrial Revolution. Her lovers were many, going from philosophy and psychology, to engineering and technology. None of them claimed paternity. But each of them kept supporting the child that turned into a ruthless World Emperor, controlling our daily life in almost every detail. True to his bastard nature, the motto on his coat of arms, that once read "Form follows Function," slowly turned into: "Sell Whatever to Whoever in Whatever Way."

Long gone are the pre-industrial times when, although judged by words such as Applied Arts or Decorative Arts, art and craft could still live in perfect symbiosis. With the coming of the Industrial Revolution, each went its own way. One became a bastard, and the other a rebel, turning autonomy, refusal, and the sublime into its highest aims.

All this may sound somewhat far-fetched, I admit, and clichéd. But there's a core of truth in it, as I know from my daily experience. Some designers have recently turned to the fine arts, in their search for alternatives, a new-found freedom to create, and a route of escape, trading function for a series of other F-words, such as fiction and friction, fantasy and fragility, famine and fury, or fun, fuck and funk. I think maybe the fascination of that turn towards fine art is that it's a lot about negation. Yesterday Martin Boyce said during a conversation, there is also something that design cannot express: Tragedy. Freedom is another thing. Art became primarily about freedom, design about constraints. The problem is that many of these utilitarian constraints, and especially the functional and utilitarian, economic and ergonomic ones, have become so obsolete and suffocating that design today is left in the kind of vacuum where art was before. Not

only despite but also because of its otherworldliness—art seems even to have become one of the few, if not the only antidote, to bring design to its senses again.

We have seen many examples today, many pieces of furniture. But there was one piece of furniture that was omnipresent in almost all presentations: the Monobloc garden chair. A book was published about it a few years ago, in which Verner Panton and Dieter Rams were interviewed about it. I imagine that the organizers thought that they would criticize it. But both said: it's the ultimate chair. Both agreed that the Monobloc really is what design deserves today, answering all the criteria defended by modernism including the fact that it's available for everybody. Panton, who had always dreamed of making a plastic chair in one flow, even said: "This anonymous piece of furniture is the ultimate result of design history." I think that's also the reason why it has become a source of inspiration for so many young designers today. It has become the "Nullpunkt" of design, from where you can start to develop new things again.

Martin Boyce In my own practice I started by looking at the history of mid-century modernism and thinking about the condition of certain design objects in relation to time. The idea of utopian projects and the desire for the mass production of good design at affordable prices in the post-war situation was very interesting to me. Then I started to look at these objects as they exist in the world now. It became clear that through time their original ethos or ideology had been stripped away and essentially replaced by an ideology of value and taste: they become decorative, collectible, expensive. I also then became interested in the landscapes that these objects might occupy.

One installation in 2002 contains a number of chairs that I made. All of the elements of the installation are fabricated—for the purposes of this conversation I hesitate to use the word "designed"—they

were fabricated to my specifications. I decided to invent a fictional occasion and then make a chair for it. The installation is titled *For 1959 Capital Avenue*, an address from an imaginary metropolis. The situation I imagined was a generic corporate lobby. So I needed a lobby chair. The presence and typology of the chair I made in a sense produces the lobby, the lobby produces the architecture, the architecture the city, and so on. A painted text on the wall reads, "Punching Through the Clouds," which is a quote attributed to Mies van der Rohe. It is a description of the soaring optimism of the glass tower. But post 9/11, of course, "Punching Through the Clouds" has taken on a slightly more chilling possibility—certainly in relationship to the sky-scraper.

Since 2005 I have been working almost exclu-sively with a body of work that refers back to a source image that shows four concrete trees that were made by Jan and Joël Martel for an exhibition in Paris in 1925. I was very interested in how they represented this collapse of architecture and nature. The first piece I made in relation to the Martel tree was the photogra-phic piece *Concrete Autumn (Phantom Tree)*. My desire was not to revisit the tree, but that the tree was now reappearing as a phantom. I started to make models of the trees in order to understand their system of con-struction, and the component shapes of the trees slowly became a lexicon, a modular system or a language from which sculptural works developed. From the shapes and forms of the trees I also developed a linear repeat pattern, a graphic forest of abstract trees. Again, slowly and over time, letters of the alphabet began to emerge from the lines of the repeat and so a typo-graphy appeared from these found forms.

Frédéric Dedelley I am trained as an industrial designer, and as an industrial designer you mostly have to do with constraints that come from the client or from the brief or from the material you are working

with or from the function the object you are designing has to fulfill. As a designer you have to find the best possible answer around those imposed constraints. Which is actually the beauty of design. But sometimes as a designer you just wish you could be completely free. That is when designers envy artists. You feel like generating your own brief in working on themes or finding your own constraints completely independently from a client or from a brief, and that is something that I started doing a few years ago. I felt the need to add a different category of projects in my work. Not only working for the furniture industry, for instance, or conceiving exhibition architecture for museums or conceiving furniture for very specific places, but developing objects that would be for me a kind of laboratory.

I would like to introduce [he indicates a photograph projected on the wall behind him] the *Deeply Superficial Objects*. These are objects made from Styrofoam and are covered with a two-component glaze. I came to do this almost by accident, because the first of these objects I made as furniture for an exhibition but I didn't glaze it. It was just the bare Styrofoam, and I thought it was appropriate for a temporary exhibition because it would deteriorate with time. It could make a statement about time passing, and the fact that this furniture was not forever. But I liked these pieces so much that after that exhibition was over I looked for a solution to make them more stable. I found this two-component glaze that fulfils the function of stabilizing the surface. But that was not enough. I didn't just want to coat the objects to make them last longer. I thought I would have to build another meaning into them by the way this glaze is applied. These objects are titled *Deeply Superficial Objects*, which is a paradox. How can you be deep and superficial at the same time? But that's exactly what I was interested in. Build a paradox or a contradiction into the appearance of these objects. The shapes are very precise. They are computer-aided cut. And then I poured the glaze by hand myself

like a craftsman onto the objects and the glaze flowed along these shapes, contrasting with the precision of those shapes. These objects remind me of ceramic objects, but they are not. Glazed, but not ceramics. They look heavy, but they are light. I was interested in making a theme out of all these contradictions, which is something that we usually don't do in design. So this was trying to contradict my own field of work.

But I don't see this as art. These objects can be used as small side tables. That's what I see them as. I am still a designer. For a certain type of design that cannot be sold in a furniture store you need to find the right way to get your audience. I am working with a design gallery in Zurich now, Franziska Kessler Gallery. It's interesting for me see that the awareness of design, whether you show it in a gallery or in a furniture store, is a totally different one.

[Showing another photograph, of *Island*, a large seating element]: This is a one-off-piece that I designed for the Mark Müller Gallery here in Zurich. The reason why it is unique is that the shape of this seat is defined by the leather skin that I was using. I designed the shape of the seat avoiding all the mistakes in that leather skin. So the shape is basically due to the defects in that skin. This is not voluntary. It's almost by chance. What happened to this object is that it was integrated into an art installation by the artist Katharina Grosse, so we are back to the context of Martin Boyce in a way. I must confess I was quite shocked at first when I saw what happened to my piece of furniture.

Max Borka Did she use the covers?

Frédéric Dedelley She sprayed the piece of furniture. First I was totally shocked. I had no idea that she was going to do this. But I quite liked the result. Well, I think I like the entire installation more than I like the intervention on my piece of furniture specifically.[—> p. XVIII]

Question from the audience So you didn't like it specifically?

Frédéric Dedelley No, I am just trying to be precise. Because what happened is that after the installation was dismantled, my sprayed piece of furniture was in the space by itself and it didn't really work anymore. It only worked in the context of the entire installation. So, actually it should now go back to its original surface. But it worked as a part of the installation. For me it was interesting to observe how I reacted to this kind of rape of my work. It had something very violent, in a way that I did not expect.

Question from the audience What did you like about that?

Frédéric Dedelley I thought it was interesting what was happening. Whether I liked it or not was not important. It's not relevant. But it was definitely interesting, because all of a sudden there was another level of meaning added to my work. So I thought this was an interesting phenomenon.

Max Borka On the other hand you make *Deeply Superficial Objects*. It was Warhol who called himself a deeply superficial person. That's a clear reference. Why do you call them deeply superficial, apart from this reference? It makes me think of another major opposition in any discussion on design and art: the "Ornament and Crime" discussion, in which ornament was declared a crime because it was superficial from an industrial, western point of view. Is it also a celebration of surface?

Frédéric Dedelley It's more the celebration of this contradiction. But it is also the celebration of surface because there are two surfaces on top of each other. There is the perfect surface of the Styrofoam geome-

trical object, and then the random surface of the glaze applied onto it. The glaze has a transparency that gives the object a depth as well.

Max Borka How important are ideas like randomness or imperfection for you, Martin?

Martin Boyce Randomness doesn't figure so much in what I do, but there is the idea of things being broken that really interests me. I made a number of objects that are broken or damaged. By doing this you potentially introduce a narrative and also an emotional possibility. I am very interested in the idea that an object can embody an emotional or a psychological make-up. Can you make a paranoid chair or a lonely table?

Max Borka You just put into the space one naked tree and some metal pieces and neon lights and it turns the whole gallery into a desert, in a way. You also work a lot with fences. They define and divide the space.

Martin Boyce I make fences and I've also made *Ventilation Grill* pieces. These things function in a similar way, they function as thresholds, as filters. In the case of the fence pieces you have to negotiate it physically but also it alters the view of whatever lies on the other side of it. And in the case of the ventilation grills, there is this notion of introducing you to the unseen guts of the architecture. It spatially extends the room you are in and also introduces the possibility of the room breathing. So you are actually altering the architecture by the presence of these objects.

Max Borka They are functional elements in space. Would you be hurt as an artist if I say that this could then become design?

Martin Boyce I don't think it's as simple as that. It's more this question of tension that I am interested in.

To try to define the limits of art and design compromises the possibilities of both. Of course there are points where both practices get close, but it depends what we are talking about: about the radical edges of design practice or about the mainstream of industrial design? If I were an architect—even if I was really good— I wouldn't want to be called an artist. This does happen but it's descriptively inaccurate. A great deal of the language that I am using comes from public spaces, from street furniture, an outdoor situation. As soon as you put these sculptural works outdoors that tension is gone, because a bench sculpture becomes a bench. So there is a fragility. It is the context of the body of work that keeps it grounded.

Frédéric Dedelley Art has been using the tools of design and a lot of other disciplines for a long time. Design is a little bit behind time and is only now starting to discover that it can use tools from other disciplines as well.

Martin Boyce You know, design is almost every-thing now in the built environment. When was the last time you saw something that wasn't designed? You can go into a forest, but it might not be a natural forest, you know. It might be a park. For me it just feels like it is a way of creating space, of articulating space or describing possibilities by the use of the objects. You know what kind of room you are in by the chair that is in it. The space between two objects is as important as the objects themselves. And that's how my sculp-tures function.

Jennifer Allen (born Toronto, CA) studied economics and literature at McGill University and gained a doctorate in literary studies in 1998 from the Université de Montréal. In 1995, a DAAD scholarship brought her to Berlin, where since 2001 she has been working as an art critic and journalist, and has published in many magazines: *Parkett, Domus, Artforum, frieze, Mousse, Afterall, Les temps modernes*. She has also written monographic essays on artists including Candice Breitz, Omer Fast, and Barbara Visser. In 2009 she was awarded the ADKV Art Cologne Prize for art criticism.

Jurgen Bey (b. 1965, Utrecht, NL) studied at Eindhoven Design Academy in the 1980s and belonged to the first generation of the Droog design collective. In 2002, he founded the multidisciplinary Studio Makkink & Bey with architect Rianne Makkink. Works by Studio Makkink & Bey have since been acquired by institutions including Centre Pompidou, Paris, V & A Museum, London, and Stedelijk Museum, Amsterdam. Bey addresses not only individual products but also spatial concepts that examine forms of living between public and private spaces from a designer's viewpoint. Bey lives and works in Rotterdam and lectures at the Royal College of Art in London.

Max Borka (b. 1954, Ghent, BE) studied literature and political science before working as a journalist writing on politics and culture. He became director of the Interieur Foundation in Kortrijik, organizing the Interieur biennial *design brussels* for the first time in 2005 as its artistic director. Today, he works as a writer and curator in the fields of art, design, and architecture. He teaches at University College Ghent, Faculty of Fine Arts (KASK). His most recent publications include *New Talents, Stand der Dinge* (ed. Hansjerg Maier-Aichen, Av Edition, 2009), and *Null, Nieuwe German Gestaltung* (kerber artbooks, 2009).

Martin Boyce (b. 1967, Hamilton, GB) began his studies at Glasgow School of Art in 1986, graduating with an MFA from CalArts in Los Angeles in 1997. Since then he has exhibited internationally, including at Museum für Moderne Kunst Frankfurt (2002), Modern Institute Glasgow (2004), and Centre d'art Contemporain Genève (2007). His large-scale installations refer to modernist projects dealing critically with social and aesthetic aspects of design and architecture. In 2009, Boyce represented Scotland at the Venice Biennale. He lives and works in Glasgow.

Frédéric Dedelley (b. 1964, Freiburg, CH) studied industrial design at ECAL, Lausanne (1985–87) and then, until 1990, product design at Art Center College of Design (Pasadena CA, USA). In 1995, he opened his design studio in Zurich. From 2001 through 2008, he was professor of furniture design at Basel School of Design. His works have been shown in many exhibitions including *Nature Design* (Museum für Gestaltung, Zurich, 2008) and *Deeply Superficial Objects* (Galerie Franziska Kessler, 2007). The monograph *Frédéric Dedelley. Design Detective* (Lars Müller Publishers) appeared in 2008.

Alexander García Düttmann (b. 1961, Barcelona, ES) teaches philosophy at Goldsmiths College, University of London. As a writer, he engages with the aesthetic philosophies of Adorno, Heidegger, and Benjamin. Recent publications focus on, among others, Visconti's film oeuvre (Kadmos Kulturverlag, 2006), the problem of deconstruction in Derrida (Transcript, 2008), and the question of participation in art and politics (Konstanz University Press, 2011).

Martino Gamper (b. 1971, Meran, IT) first trained as a carpenter before studying at the Academy of Fine Arts in Vienna under Michelangelo Pistoletto. In 1994, at the Matteo Thun design studio in Milan, he began developing furniture and interiors. From 1997, he studied product design at the Royal College of Art, London, founding his own studio in 2000. In projects like *100 Chairs in 100 Days* (London, 2007), *If Gio Only Knew* (DesignMiami, Basel, 2007) and *Total Trattoria* (London, 2008) he collages fragments of furniture from design history or designs settings for specific social events. He lives and works in London, where he runs Studio Martino Gamper.

Mateo Kries (b. 1974, Müllheim/Baden, DE) studied art history and sociology, and has curated exhibitions on Mies van der Rohe, the culture of Arab homes, Joe Colombo, and Le Corbusier. He is the co-founder of the *Designmai* festival, teaches design theory, and has published many essays and other works on the history and theory of design. In his latest book *Total Design* (Nicolai Verlag, 2010), he critiques a designer society whose concept of design now sprawls across all areas of life. In 2011, Kries became director of the Vitra Design Museum, where he has worked since 1995.

Monika Kritzmöller (b. 1968, Kempten/Allgäu, DE) studied economics and social sciences and gained a doctorate in psychology in 1996. In 2004, she obtained professorial status at St. Gallen University with a study of domestic interiors entitled *Bis der Geschmack euch scheidet. (Ziel-) Gruppen und ihre Open Choice-Strategien* (Flabelli Verlag, 2004). Her work focuses on developmental processes within society, researched at the intersection between consumer society and visual culture. Kritzmöller teaches at St. Gallen University, and has founded a research and consulting bureau under the name Trends + Positionen.

Sofia Lagerkvist (b. 1976, Eskilstuna, SE) is a member of the Front design group, which she founded in 2003 with Anna Lindgren, Katja Sävström, and Charlotte von der Lancken. Their collaboration began during their studies at the Konstfack Stockholm. Today, their activities range from industrial design products and one-off pieces to spatial concepts for clients including Ikea, Moroso, and Droog, as well as exhibitions for Tensta Konsthall (2004) and Galerie Kreo Paris (2008). Front makes the production process of design visible in its works, thus referring to the visual strategies of its own discipline.

Julia Lohmann (b. 1974, Hildesheim, DE) studied graphic design at Surrey Institute of Art & Design. She received a DAAD prize for product development and graduated from the Royal College of Art in London in 2004 with a Masters in product design. The same year, with Gero Grundmann, she founded the interdisciplinary Studio Bec. Since then, Lohmann has focused above all on individual objects and exhibition situations for venues including Galeria Nilufar (Milan, 2008) and the Museum of Modern Art (New York, 2009). She addresses the theme of humankind's ambivalent relationship to farm animals by using and processing materials often treated as waste in industrial manufacturing. Lohmann lives and works in London.

Sven Lütticken (b. 1971, Kempen, DE) is an art critic publishing regularly in magazines including *Artforum, New Left Review, Afterimage, Texte zur Kunst*, and *e-flux*. At present, he is particularly interested in the themes of iconoclasm and the economics of art—for example as curator of *The Art of Iconoclasm* (Basis voor Actuele Kunst, Utrecht, 2009) and editor of *Return of Religion and Other Myths* (Basis voor Actuele Kunst, Utrecht, 2008–09) and *Idols of the Market. Modern Iconoclasm and the Fundamentalist Spectacle*

(Sternberg Press, 2009). He teaches art history at the Vrije Universiteit Amsterdam.

Burkhard Meltzer (b. 1979, Halle, DE) studied photography in Dortmund and Zurich (1998–2003) and was part of the curatorial team at Neue Kunst Halle St. Gallen (2003–07). He has been working since 2006 as a lecturer at Zurich University of the Arts and since 2007 as a freelance curator. He is a founding member of the curatorial collective The John Institute. As a writer, he publishes regularly in magazines including *kunstbulletin*, *frieze*, and *spike*, and in books on issues in contemporary art. Meltzer lives in Zurich.

Heike Munder (b. 1969, Stuttgart, DE) studied cultural theory, business management, and Romance philology in Lüneburg and Göttingen. With Bernd Milla, she founded Halle für Kunst Lüneburg e. V., whose co-director she was from 1995–2001. Since 2001, she has been director of the migros museum für gegenwartskunst Zürich. She has curated many group exhibitions examining psychological notions of space, hedonistic and glamorous strategies and art's relationship with design. Since 2000, she has taught at Lüneburg University, Goldsmiths College London, Bern University, and Zurich University of the Arts.

Tido von Oppeln (b. 1974, Aurich, DE), studied cultural theory and philosophy at the Humboldt University, Berlin. Since 2002, he has been on the board of the Werkbundarchiv – Museum der Dinge, and in 2003 he co-founded the echtzeit-institut. Since 2005, he has been working as a writer and curator, as well as being involved in various shows on design, art, and architecture at the Werkbundarchiv, the Vitra Design Museum, and MARTa Herford. He is a regular contributor to the Belgian art, architecture, and design magazine *DAMN*. Since 2009 he has also lectured on design theory and history in Lucerne, Zurich, and Potsdam.

Mamiko Otsubo (b. 1974, Nishinomiya City, JP) lives and works in Brooklyn (NY). She studied economics in San Diego and then art in Pasadena (CA) and New Haven (CT). Her works combine materials and forms from industrial design into two- or three-dimensional assemblages. She has participated in group shows at venues including Artists' Space (2006) and the Sculpture Center (2007) in New York. Her first solo show in Europe took place in 2006 at Galerie Mark Müller (Zurich).

David Renggli (b. 1974, Zurich, CH) began his studies at Zurich School of Design, completing them at the Gerrit Rietveld Academie Amsterdam. The solo show *Retrospektive David Renggli* (Messagesalon, Zurich, 2002) marked the start of his exhibition practice. Since then, his work has been shown in many solo and group shows at venues including the Swiss Institute, New York (2006), Tate Britain (2008), migros museum für gegenwartskunst Zürich (2008), Kunsthaus Zürich (2008), and Art Basel Miami Beach (2010). Between 1997 and 2007, he also traveled around the world playing with the band Waldorf. Renggli lives and works in Zurich.

Jerszy Seymour (b. 1968, Berlin, DE) grew up in London where he first studied engineering at South Bank Polytechnic (1987–90) and then industrial design at the Royal College of Art (1991–93). Projects like *House in a Box* (2002), *Scum* (2003), and *Tape* (2003) occupy a central place in his oeuvre, whose social and political components extend to his most recent work. He has exhibited at venues including Design Museum, London, Vitra Design Museum, Weil am Rhein, Palais de Tokyo and Galerie Kreo, Paris, and the Museum of Applied Arts, Vienna. Seymour lectures at institutions including the Royal College of Art, London, Domus Academy, Milan, and ECAL, Lausanne. Since 2004 he has been living and working in Berlin, where he directs the Jerszy Seymour Design Workshop.

Florian Slotawa (b. 1972, Rosenheim, DE) studied at Hamburg University of Fine Arts. In 1996, he began to develop a radical artistic concept: exchanging and lending personal property to public exhibition spaces. International solo shows at venues including Kunstmuseum Thun (2003), Bonner Kunstverein (2004), and PS1 New York (2009). Slotawa lives and works in Berlin.

Matthew Smith (b. 1976, Burton-on-Trent, GB) lives and works in London. He studied sociology (1995–98) and painting in Sheffield (2000–03) and London (2004–05). His artistic process addresses the revaluation of everyday objects. International solo shows at galleries include Limoncello (London 2010), Lüttgenmeijer (Berlin, 2009), Rivington Arms (London, 2008), and White Columns (New York, 2008).

Klaus Spechtenhauser (b. 1969, Baden, CH) is an art historian and Slavist. From 2002–07 he was an assistant to Prof. Arthur Rüegg in the architecture department at ETH

Zurich; a research team member and project manager at ETH Wohnforum – ETH CASE (2002–09). From 2009 to the present he has worked for the Grisons Canton historic monuments office. His writing covers the architecture and cultural history of the 20th century, and he has also edited many publications, including *Die Küche. Lebenswelt – Nutzung – Perspektiven* (Birkhäuser, 2006), and *Charles-Edouard Jeanneret/Le Corbusier. Maison Blanche. Geschichte und Restaurierung der Villa Jeanneret-Perret 1912–2005* (Birkhäuser, 2007).

Judith Welter (b. 1980, Berne, CH) lives and works in Zurich. She studied art history, Spanish philology, and religious studies at Bern University (2001–08). She has been working at migros museum für gegenwartskunst Zürich, since 2004, first as registrar and exhibition coordinator, and since 2007 as curator of the museum's collection. Since 2009, she has been working on a PhD at the University of Bern Institute of Art History. She has published various pieces on contemporary art and on the collection of the migros museum für gegenwartskunst, including "Formate und Lektüren des Autobiographischen," in Kathleen Bühler, Matthias Frehner (eds.): *Ego Documents – Das Autobiografische in der Gegenwartskunst*, Kehrer Verlag, 2008), and "De Crepusculum Aurora – Über das Werk Julia Steiners" (forthcoming 2011).

All works of art and documentation photographs are reproduced by kind permission of the owners. As far as possible, the editors have contacted the copyright owners of the images used in this publication. In cases where this has not been possible we apologize and request the copyright owners to contact the editor or the publisher. Specific acknowledgements are as follows:

Cover: © 2011, ProLitteris, Zurich; p. 11 top: © Marcel Breuer / Courtesy Embru Archive; 11 bottom: © Xabier Salaberria; 24: © Studio Makkink & Bey / Photo: Studio Marsel Loermans; 26: © Martino Gamper / Courtesy Nilufar, Milan; 27: © Marc Camille Chaimowicz / Courtesy migros museum für gegenwartskunst Zürich / Photo: Stefan Altenburger Photography, Zurich; 28: Courtesy Archive teo jakob; 29 left: © Martino Gamper / Courtesy Nilufar, Milan / Photo: Åbäke / Martino Gamper; 29 right: © Martino Gamper / Courtesy Nilufar, Milan / Photo: Åbäke / Martino Gamper; 30 top: © Front Design; 30 bottom: © Front Design / Photo: Anna Lönnerstam; 48: © FLC / 2011, ProLitteris, Zurich; 49: Courtesy Vitra Design Museum / Photo: Thomas Dix; 50: © Marc Camille Chaimowicz / Courtesy migros museum für gegenwartskunst Zürich / Photo: Stefan Altenburger Photography, Zurich; 51: © FLC / 2011, ProLitteris, Zurich; 53: © Österreichische Friedrich und Lillian Kiesler-Privatstiftung, Vienna; 54: © Independent Group; 55: Courtesy Archive teo jakob; 56: © Art & Language / Courtesy migros museum für gegenwartskunst Zürich / Photo: Stefan Altenburger Photography, Zurich; 57: © 2011, ProLitteris, Zurich; 58: © Studio Museo Achille Castiglioni; 59 top: © Jasper Morrison Studio, London; 59 bottom: © Jasper Morrison Studio, London / Photo: Studio One; 75: Courtesy Vitra Design Museum / Photo: Studio Frei ; 76: Courtesy Archive teo jakob; 78 : © Martino Gamper; 79: © Martino Gamper / Courtesy Nilufar, Milan / Photo: Angus Mill Photography; 80: © Martino Gamper / Photo: Wolfgang Träger; 83: © Martino Gamper / Courtesy Nilufar, Milan / Photo: Nilufar, Milan; 86: © Bruno Munari, 1950. Corraini Edizioni; 91: DIGITAL IMAGE © 2011 Museum of Modern Art, New York / Scala, Florence / Photo: Soichi Sunami; 92: © Art © Judd Foundation / 2011, ProLitteris, Zurich; 97: © 2011, ProLitteris, Zurich / Courtesy The Modern Institute/Toby Webster Ltd, Glasgow / Private Collection, Munich; 98: © 2011, ProLitteris, Zurich / Courtesy The Modern Institute/Toby Webster Ltd, Glasgow / Photo: Guiseppe Schianvinotto; 99: © Marc Camille Chaimowicz / Courtesy migros museum für gegenwartskunst Zürich / Photo: FBM Studio, Zurich; 100: Courtesy Vitra Design Museum / Photo: Thomas Dix; 101: © Liam Gillick / Courtesy Maureen Paley, London; 103: © Liam Gillick / Courtesy Maureen Paley, London; 104: © Liam Gillick / Courtesy Casey Kaplan, New York; 109: © Barbara Visser / Courtesy Annet Gelink Gallery, Amsterdam; 112: © 2011, ProLitteris, Zurich / Kunstmuseum Basel, Kupferstichkabinett / Photo: Martin P. Bühler; 114: © John Armleder / Photo: Snug-Studio; 115: © 2011, ProLitteris, Zurich / Courtesy Vitra Design Museum / Photo: Thomas Dix; 116: © Verner Panton / Courtesy Vitra Design Museum / Photo: Thomas Dix; 117: © Tobias Rehberger / Courtesy Grässlin Collection, St. Georgen / Photo: Wolfgang Günzel; 118: © Liam Gillick; 120: © 2011, ProLitteris, Zurich / Courtesy The Renaissance Society, Chicago; 125: © Natascha Sadr Haghighian / Courtesy Johann König, Berlin / Photo: Wilfried Petzl; 127: © Allan Sekula, Noël Burch; 128: © Dan Peterman / Courtesy CEAAC, Strasbourg / Andrea Rosen Gallery, New York / Photo: Klaus Stöber

I: © 2011, ProLitteris, Zurich / Courtesy The Modern Institute/Toby Webster Ltd, Glasgow / The Arts Council Collection, Southbank Centre, London / Photo: Guiseppe Schianvinotto; II-III: © Andrea Zittel / Courtesy Andrea Rosen Gallery, New York / Photo: Oren Slor; IV-V: © 2011, ProLitteris, Zurich / Photo: Annette Kradisch; VI: © 2011, ProLitteris, Zurich / Photo: Uwe Walter; VII: © 2011, ProLitteris, Zurich / Courtesy The Modern Institute/Toby Webster Ltd, Glasgow / Ikon Gallery, Birmingham / Photo: Stuart Whipps; VIII-IX: © Studio Makkink & Bey / Photo: Stijn Brakkee; X-XI: © Andrea Zittel / Courtesy Andrea Rosen Gallery, New York / Schaulager, Basel / Photo: Tom Bisig; XII: © 2011, ProLitteris, Zurich / Courtesy The Modern Institute/Toby Webster Ltd, Glasgow / Photo: Gilmar Ribeiro; XIII

Exhibition views from the archives of
teo jakob, Berne;
migros museum für gegenwartskunst
Zürich;
Vitra Design Museum, Weil am Rhein

p. 27: Marc Camille Chaimowicz, *Corner Table*, 2000; 28: Exhibition view, teo jakob, Berne, 1985–86; 49: Exhibition view, *Achille Castiglioni*, Vitra Design Museum, Weil am Rhein, 1990; 50: Marc Camille Chaimowicz, *The Cocteau Room*, Installation view, migros museum für gegenwartskunst Zürich, 2006; 55: Exhibition view, teo jakob, Berne, 1983; 56: Art & Language, *Sighs Trapped by Liars 373-391, 413-507*, Installation view, migros museum für gegenwartskunst Zürich, 2003; 75: Exhibition view, *Plastic Furniture*, Vitra Design Museum, Weil am Rhein, 1991; 76: Exhibition view, teo jakob, Berne, 1988–89; 99: Marc Camille Chaimowicz, *Desk...on Decline*, 1982, Installation view, migros museum für gegenwartskunst Zürich, 2003; 100: Exhibition view, *Rooms in Time. Design from the 1950s, 1960s, 1970s and 1980s*, Vitra Design Museum, Weil am Rhein, 1996–97; 115: Exhibition view, *Isamu Noguchi. Sculptural Design*, Vitra Design Museum, Weil am Rhein, 2002; 116, Exhibition view: *Verner Panton. Collected Works*, Vitra Design Museum, Weil am Rhein, 2000; 179: Exhibition view, *Czech Cubism. Architecture and Design 1910–1925*, Vitra Design Museum, Weil am Rhein, 1991; 180: Alicia Framis, *Bloodsushibank*, Installation view, migros museum für gegenwartskunst Zürich, 2000; 191: Exhibition view, teo jakob, Berne, 1983; 192: Exhibition view, *Ron Arad. Sticks & Stones 1980–1990*, Vitra Design Museum, Weil am Rhein, 1990; 203: Exhibition view, *Citizen Office*, Vitra Design Museum, Weil am Rhein, 1993; 204: Exhibition view, teo jakob, Berne, 1983; 245: Exhibition view, teo jakob, Berne, 1987; 246: Cathy Wilkes, *Precision*, 2001, Installation view, migros museum für gegenwartskunst Zürich, 2002

With thanks to the archives for their support and their courtesy in supplying the images.

Imprint

This publication is part of the research project *Prototyp* of the Institute for Critical Theory (ith) and is co-published by:

Institute for Critical Theory (ith)
Zurich University of the Arts (ZHdK)
Hafnerstrasse 39
CH-8005 Zurich
T +41 (0)43 446 65 00
F +41 (0)43 446 45 39
info.ith@zhdk.ch
www.ith-z.ch

migrosmuseum für gegenwartskunst
Zürich
Albisriederstrasse 199A
CH-8047 Zurich
T +41 (0)44 277 20 50
F +41 (0)44 277 62 86
info@migrosmuseum.ch
www.migrosmuseum.ch

Editors
Jörg Huber, Burkhard Meltzer, Heike Munder, Tido von Oppeln

Editorial Concept
Burkhard Meltzer, Tido von Oppeln

Picture Editor
Christoph Blaas

Editorial Adviser
Raphael Gygax

Transcription
Dennis Eden, Burkhard Meltzer, Tido von Oppeln, Stefan Wagner

Translation
From German to English: Nicolas Grindell (Foreword, Preface, Allen, Düttmann, Kries, Kritzmöller, Meltzer, von Oppeln, Spechtenhauser, Welter, Interviews Slotawa, Renggli, Lohmann)

Copy-Editing and Proofreading
Louise Stein

Graphic Design
FLAG Aubry/Broquard (www.flag.cc)

Typeface
Univers (Linotype)

Cover Picture
Florian Slotawa, *KS.027*, 2007

Color Separation
Daniele Kaehr

Printing and Binding
DZA Druckerei zu Altenburg GmbH, Altenburg, Deutschland

Paper
Munken Lynx 1.13, 300 g/qm
Munken Print White 1.5, 100 g/qm
MultiArt Silk, 135 g/qm